The Cultural Battlefield

The Cultural Battlefield

Art Censorship & Public Funding

Edited by Jennifer A. Peter &
Louis M. Crosier

1995
AVOCUS PUBLISHING, INC.
GILSUM, N.H.

The Cultural Battlefield:
Art Censorship & Public Funding
Edited by Jennifer A. Peter & Louis M. Crosier

Published by:
Avocus Publishing, Inc.
Lower Village
Gilsum, NH 03448 USA
603-357-0236
FAX: 603-357-2073
ORDERS: 1-800-345-6665

Disclaimer:

Nothing contained in this book is intended in any way to be libelous in nature. Neither is it the intent of Avocus Publishing, Inc. to publish any accusatory statement, direct or implied, of improper motives or illegal actions by any individual, group or institution. We do not believe and have not intended to assert that anything contained herein represents a sinister movement, or that persons associated therewith are a disgrace to themselves or to society. Any other interpretation of our printing is erroneous and therefore misunderstood.

Library of Congress Catalogue Card Number:

ISBN 0-9627671-7-4

For Mom, Pop
& the randoms

— Jennifer A. Peter

For Peter, Jessica, Sandy, and Mom
Peter for your endless generosity and love of people;
Jessica for gently and warmly opening my
mind to new possibilities;
Sandy for your sense of humor and spontaneity;
Mom for your kindness and insight.
You all taught me how fun it is to be curious and creative.

— Louis M. Crosier

Contents

The Cultural Battlefield

Preface

Since the Corcoran Gallery canceled the Robert Mapplethorpe retrospective in 1989, much has been written and said about art censorship and public funding of the arts. Newspaper articles explored and analysed these issues; books documented their breadth and hypothesized about their implications; politicians batted around rhetoric, incorporating art and taxpayer funding of culture into both the Republican and Democratic platforms.

At the center of all this clamor, however, there has been a conspicuous silence. Little has been heard from the front lines, from the people who have been targeted by censorship and the arts advocates who have spent enormous energy and time working to defend freedom of expression. In *The Cultural Battlefield*, we have gathered those voices together for the first time to tell their very personal side of the story.

The authors of this book come from many different walks of life and bring a variety of perspectives to the discussion. Some have chosen to analyse a specific facet of the issue of censorship. Others have taken a creative approach to make their point. Many have simply told their story: the photographer who one day found himself under seige by the FBI; the student who learned that academic freedom extends only so far; the arts administrator whose funding was revoked.

The arts are once again center stage as the newly elected Republican majority begins its work in the 104th Congress. What better time to examine the role of public funding of culture in a democracy and the broad implications of censorship in our own lives.

—Jennifer A. Peter & Louis M. Crosier

Foreword

Rebuilding the Public Consensus Behind Free Expression

by Jill Bond, Artsave director, and Virginia Witt, senior writer and public information coordinator, People For the American Way

Art often surprises, provokes, and even angers the viewer. By definition, artists seek to express thoughts, feelings, and perspectives that may never have been seen or heard before. In applying their unique lens to the society around them, they can bring its problems and flaws into sharper focus. Just as they can be the catalysts of debate and conflict, their insight can also promote understanding.

The artist's voice is crucial to our society because it informs how we think about our own lives and provides a bridge to understanding others. In a 1993 speech, former Congresswoman Barbara Jordan saluted the "wonderful universality" of the arts. Said Jordan: "Art has the potential to unify. It can speak in many languages without a translator."

But the artist's vital role is becoming more difficult in today's angry climate. On both ends of the political spectrum, across the full range of American society, it is now becoming almost routine to challenge and attempt to suppress any kind of expression one finds objectionable for any reason. Art is just one of many forms of expression threatened by the rising tide of intolerance in America today. These battles are becoming a proxy for political differences and social conflicts that should be discussed openly and worked out rather than acted out by removing art from the public view.

Of course, attacks on the fine arts are only one facet of challenges to ex-

3

pression during the 1990s. Also under fire are elements of our nation's popular culture, including music, television, and motion pictures. Often, the urge to censor stems from a legitimate and understandable concern about a severe social problem; the push for legislation to curb television violence is one notable case in point. However well-intentioned, such efforts miss their mark, taking aim at the reflection of a particular problem rather than the problem itself. All forms of art have always explored the darker sides of the human spirit. Sweeping attempts to expunge such portrayals will inevitably sweep away much art that is of value. And, ultimately, such draconian measures will serve to undermine all Americans' right to free expression.

Ironically, efforts to silence artists only exacerbate tensions and drive Americans farther apart. Every act of censorship represents a lost opportunity to engage the public in a dialogue about the issues involved and about the larger principles represented by the First Amendment.

There is a better alternative when communities clash over values. In the wake of the banning of a high school production of the Pulitzer Prize-winning play *The Shadow Box,* the city of Tucson, Arizona came together for an extraordinary community dialogue sponsored in part by People For the American Way, and focused on the importance of free expression. Following a reading of the play by nationally known actors, Tucson citizens gathered at a public forum that featured a diverse panel of leaders and also engaged hundreds of local citizens in the audience and through a live telecast. In the wake of the event, a volunteer Citizens Committee made up of prominent local citizens plans to continue the public dialogue and expand it across the state.

Another positive example of community response occurred in connection with the touring exhibit about the Vietnam War, *As Seen by Both Sides.* The exhibit attracted criticism from members of the Vietnamese community in several cities for allegedly reflecting too heavily a North Vietnamese point of view. Rather than canceling the show, as other museums had done, the Atlanta College of Art used the controversy as an opportunity to hold an open forum where all sides were invited to present their viewpoints.

These communities point the way toward a new approach to clashes over culture: to use debate over the arts as an opportunity to bring more of the American public into a broader discussion that encompasses the principles that formed this nation—free expression, mutual respect, and tolerance. Conflicts over expression, instead of leading to the end point of censorship, can become a starting point for probing the difficult issues that

divide us. Conflict over art poses a unique challenge to our society, one that cannot be dodged by scoring narrow legal or political "victories" in the "culture war." As President Clinton has said: "At a time when our society faces new and profound challenges, at a time when we are losing so many of our children, at a time when so many of our people feel insecure in the face of change, the arts and humanities must remain a vital part of our lives—as individuals and as a nation."

Introduction

The Raw Nerve in Politics

by Thomas Birch

Birch is legislative counsel and lobbyist in Washington, D.C. to nonprofit organizations in the arts and human services. In his work on Capitol Hill as an advocate for public support of the arts, he represents state arts councils and the interests of artists, arts organizations and audiences in promoting access to the best in artistic and cultural expression.

Ronald Reagan took office in 1981 wanting to eliminate the National Endowment for the Arts (NEA), and he began the first year of his presidency by proposing a 50 percent cut in the budget for the federal arts agency. The new administration argued that spending on the arts was an inappropriate use of federal tax dollars. Proponents of the Reagan cut contended that grants from the NEA were immaterial to the survival of the nation's arts institutions, and besides, the money could easily be replaced by foundation and corporate contributions and the largesse of the well-heeled arts audience. The federal government, it was claimed, had no business subsidizing the cultural appetites of the American middle and upper classes.

Promptly, a group of influential individuals from the worlds of culture, philanthropy, and business, led by prominent Republicans, prevailed upon Reagan to appoint a task force on the arts and humanities which would make recommendations to the White House on cultural policy. The task force's members—such figures as corporate leaders Joseph Coors, David Packard, and Gordon Hanes; arts establishment personalities Beverly Sills, Roger Stevens, and Charlton Heston; and philanthropists Richard M. Scaife and Anne Bass—in their report delivered to the president in October 1981, unequivocally and not unsurprisingly endorsed federal spending on the arts. In good, establishment, Republican terms, the report talked about the "critical catalytic action" of federal arts funds in encouraging private support, and of the "clear public purpose" in supporting the arts and the "shared responsibilities" of government and private philanthropy in funding the arts.

While the blue ribbon task force succeeded in persuading the Reagan administration to keep the NEA, President Reagan continued to recommend cuts in the arts budget, and the defenders of the National Endowment for the Arts from around the country each year urged Congress to resist cutting the agency's budget. The supporters of the arts endowment were generally successful in their advocacy for federal spending on the arts. After suffering a reduction of almost 10 percent in the first year of the Reagan administration, the arts budget grew modestly over the next seven years, increasing by almost 18 percent by the time President Reagan retired from office.

Thanks to the steadfast support of a handful of legislators in the House and Senate, the National Endowment for the Arts held its own, immune for the time from the politically divisive debates characterizing so many other domestic issues to which the right-wing extremists, emboldened by their president in the White House, had attached themselves. The arguments against budget cuts made by the NEA's partisans focused on the importance of financial stability for the nation's arts institutions and the need to bring the arts to all Americans despite economic or geographical barriers. The content of the art that was funded by the NEA was simply not raised as an important issue on either side of the debate.

Fundamentalist Outrage

"Piss Christ" changed everything. In 1989, the question of public support for the arts turned controversial in a way it never was before, revealing the entrenched strength of the right-wing fundamentalist political philosophy realized during the Reagan years. The clash of forces that burst into angry debate and controversy over federal arts spending reflected a pivotal transformation in national politics.

Since the election of 1980, when the Moral Majority worked its political apparatus to defeat enough liberal, Democratic senators to bring a Republican majority to the Senate for the first time in decades and help put Ronald Reagan in the White House, the radical right and fundamentalist evangelicals have become highly involved in politics. They have elected their supporters to public office, they have developed leaders all over the country, and they have succeeded in defining the debate on a number of public issues, including public spending on the arts. Most important, the radical, fundamentalist right has staked out a visible, vocal position, suggesting to politicians that they are numerous. The same cannot be said, at

least on the issue of tax support for the arts, for the millions of Americans who enjoy publicly sponsored arts programs.

On May 18, 1989, Senator Alfonse D'Amato, a Republican from New York, stood on the Senate floor and denounced the funding of the work of Andres Serrano by the National Endowment for the Arts. He said he was responding to the letters, phone calls, and postcards he had received from constituents who were shocked and outraged that their money was "being used for a piece of so-called art work . . . a deplorable, despicable display of vulgarity." The work by Serrano, "Piss Christ," a photograph of an image of a crucified Christ floating in urine, had been part of a traveling exhibition organized by the Southeastern Center for Contemporary Arts (SECCA) in Winston-Salem, North Carolina, and funded in part by the NEA.

In a letter to acting NEA Chairman Hugh Southern, signed by twenty-three senators, D'Amato demanded a review of the procedures used by the arts endowment to award and support artists. The letter called the Serrano work "shocking, abhorrent, and completely undeserving of any recognition whatsoever," and made the point that the issue was "not a question of free speech" but "a question of taxpayers' money." Over the next several weeks, over two hundred congressional offices contacted the NEA either protesting the grant or asking for some explanation. Congress had never, in the almost twenty-five years since federal support for the arts was established, so seriously tested its own commitment to subsidizing the arts. The intensity of the legislators' response to the issue illustrates the strength of the grassroots constituency that had developed on the religious right and was ready to fight wherever it felt threatened.

The controversy over "Piss Christ" was instigated by Rev. Donald E. Wildmon, director of the American Family Association in Tupelo, Mississippi, who a year earlier had taken credit for leading a fight against the film, "The Last Temptation of Christ." Wildmon and his organization commanded a highly sophisticated direct-mail operation and a mailing list of over 300,000 names, all of whom were now exhorted to express to their federal legislators their outrage over "Piss Christ." Within weeks, Senate and House offices were receiving hundreds of letters and preprinted postcards objecting to federal tax dollars spent on the exhibition of the Serrano work.

Defense of the NEA

When Sen. D'Amato and others on Capitol Hill objected to "Piss Christ" and the content of NEA-funded work, Hugh Southern at the NEA replied to the legislators in a letter saying, "I most certainly can understand that the work in question has offended many people and appreciate the feelings of those who have protested it. I personally found it offensive." He then explained that NEA's legislation forbids the agency "from interfering with the content of the work it supports" and suggested that the grant to SECCA be considered in the context of the 4,500 grants awarded each year by the NEA.

This then was the official response, the explanation, and the defense of the NEA: to agree with the discomfort that some individuals might experience in confronting the artwork, to understand their offended outrage, and to beg indulgence in the interest of all the other projects supported by federal grants. The advocates who had defended federal spending on the arts since the first budget attacks from Ronald Reagan tried to encase the controversy in perspective. The NEA dollars, it was emphasized, funded thousands of worthwhile activities all over the country that did not deserve to be jeopardized by "Piss Christ." Congress needed to be convinced with a positive message about the NEA. Little breath was lost on trying to defend Serrano or explain his art.

Andres Serrano had a reasoned explanation of his piece, about the degradation of the true meaning of religious symbols at the hands of organized religion, referring in part, one might assume, to the very televangelists who were so happily damning his work to the delighted reaction of their audience congregations. Serrano's explanations were ignored in the debate. The radical right was deaf to the artist's interpretation of what he was trying to convey through his work. The televangelists and their political friends were too busy using their own "reading" of "Piss Christ" as a way to undermine the cultural establishment with attacks on the NEA. They were busy, too, raising money through direct-mail campaigns in their fight against the artists and the NEA, money enough to finance other battles on issues like abortion, gay rights, and school prayer, and on efforts to defeat legislators who disagreed with them.

Targeting the Artists

In the controversy over federal arts spending, the wrath of outraged politicians fell hardest on the work of individual artists, but the arts institutions

had more to lose in the attacks on federal tax dollars for the arts. It is the arts institutions that get most of the grants, because public support for the arts has usually meant support for arts institutions. That was the idea for the NEA in the first place.

Unlike the Depression-era WPA arts project to employ artists, the NEA was set up to give grants to institutions, with some support going to artists. Pressure in the 1960s to pass legislation and establish government funding to the arts came from the major arts institutions—the museums, the symphony orchestras, the established treasures of urban American civilization. Little attention was paid at the time by artists to the possibility of government grants for artists' work, except for a fear quietly expressed by some that government money could mean governmental control over the content of one's work.

Much has changed in the last twenty-five years. While the institutional grantee—the dance company, the theater, the art museum—is still the principal direct beneficiary of federal funding, artists enjoy a modest but important share of support, about 5 percent of the grant funds awarded by the National Endowment for the Arts. Nonetheless, the established response to the savaging attacks on the NEA was not in defense of the artists. The rallying cry for the arts world focused on the essential good of federal funding to arts institutions.

During the recent years of controversy over the federal role in the arts, the NEA's critics have exaggerated the scope of NEA support to individual artists. Artists have been thrust into the middle of the controversy about public arts spending, though the actual grants at issue have almost all been to support institutional projects. Recall that in the initial controversies, the artist was not the recipient of federal funds, neither Mapplethorpe whose homoerotic photographs were included in an exhibition supported by a grant to the Philadelphia Institute of Contemporary Art, nor Serrano, featured in the NEA-supported show organized by SECCA. Indeed, it is appropriate that the artists and their work have become the focus of controversy, because it is the art—and the public to whom the art is presented—for which the institutions exist in the first place.

In 1989 during the first flash of controversy over SECCA's presentation of "Piss Christ" and the Mapplethorpe exhibition organized by the Institute of Contemporary Art (ICA) in Philadelphia, the two institutions were actually singled out for censure. An amendment passed by the Senate put a five-year ban on Arts Endowment funding to SECCA and ICA. The ban, which was considered an unconstitutional bill of attainder, was eventually dropped from the legislation by a House-Senate conference committee.

Addressing the five-year ban amendment, Senator Daniel Patrick Moynihan, Democrat from New York, came closest to touching on the real issue of artistic expression. In floor debate, he questioned whether the U.S. Senate is "so insensible to the traditions of liberty in our land, so fearful of what is different and new and intentionally disturbing, so anxious to record our timidity that we would sanction institutions for acting precisely as they are meant to act? Which is to say, art institutions supporting artists and exhibiting their work?"

Artists as Advocates

As a consequence, artists have become the most vocal proponents of unfettered public spending on the arts. It is their freedom at stake (and that of arts institutions as well) to express ideas, challenge the norm, and hold society up to self-examination. The work of Robert Mapplethorpe and Andres Serrano, or of performance artists like Karen Finley and Tim Miller, who were denied grants as individual artists, raises issues society needs to confront, issues of social victimization, sexuality, oppression, inclusion, and caring. Because of the controversy engendered by public spending on these artists' works, many more people have been exposed to the power of their message, though that message is often misunderstood, misinterpreted, and ridiculed.

It is the artists who have taken the lead in advocacy and lobbying Congress on behalf of the artwork, organizing new leadership through groups like the National Campaign for Freedom of Expression and the National Association of Artists Organizations. The mission statement from the National Campaign makes it clear: "The Campaign's work is committed to the understanding that true democracy is dependent on the right to free artistic expression for all, including those censored due to racism, sexism, homophobia and all other forms of invidious discrimination."

Other organizations not dedicated solely to arts advocacy have joined in the fight. Groups like the American Civil Liberties Union and People For the American Way quickly recognized that, with "Piss Christ," the attacks on the NEA were more than simple matters of budget priorities. The slap at the NEA delivered by President Reagan in his first budget proposal was now a blast at the First Amendment. When Senator Jesse Helms attacked the NEA for funding the Mapplethorpe exhibition, the Human Rights Campaign Fund and the National Gay and Lesbian Task Force took up the NEA fight too, understanding the true homophobic nature of the religious right's attention to the arts.

Art and Society

Art has a special capacity to touch the raw nerve in society. A work of contemporary art has the power to expose to a community a whole set of social, moral, and ethical issues which might otherwise remain unexpressed or avoided.

Contemporary art in the 1980s and 1990s is art with raw feelings, art with a confrontational message, art with a messy look and crabby content. This was not the sort of contemporary artistic expression that enjoyed acceptance in the 1950s when the abstract expressionists found themselves in the embrace of the established art world of critics, collectors, and curators, and the public they influenced. Whatever content seeped through the abstractions was calmly tolerated so long as the artists kept their ragged emotions somewhere beneath the surface of all that agitated paint on the canvas. If meaning in art was lost on the public, no matter. The establishment would defend and justify art that was new though inaccessible.

Still, there has always been something about contemporary art that makes the public feel qualified to comment, that turns ordinary citizens into virulent art critics. Take abstract art—incomprehensible to many—because it doesn't seem to be about drawing, it looks like something anyone can do. Its value in the public mind is thereby easily diminished. The same can be said about conceptual art—work using "nonart" media to express ideas that often go undiscovered by the average viewer; it easily becomes a target of derision and sometimes outrage.

In another vector of contemporary art is photography—a medium so accessible, so explicit that it can interfere with the individual's ability to look beyond what the photograph is of to understand what the work is about. This was certainly the case with the contemporary artworks—the photographs of Serrano and Mapplethorpe—that created such political heat in 1989.

Of course, artists should not be above judgment. Some attempts by artists fail, and the National Endowment for the Arts has no business funding bad art, but art that perplexes, enrages, or disorients, if excellent, should be all the more powerful and worthy of public attention. The issues presented in the work of many of today's artists are the very issues many Americans would rather ignore and deny. Because of a desire to quarantine the issues in art, any information or knowledge conveyed by the art is reviled and rejected.

At this new level of political visibility the arts take on an even greater vulnerability. Congress chooses to reject art that it finds controversial or

unpleasant, and to repudiate art that so challenges ideas and sensibilities as to infuriate someone's sensibility—all of this in the face of the Endowment's statute, written in 1965, forbidding the government from interfering with the content of the work it supports. So-called pornographic poetry funded by the NEA was an issue in the early 1980s. Before that, legislators were offended to find that Erica Jong had written her book *Fear of Flying* with its sexual passages while enjoying a literature fellowship from the NEA. Whatever projects raised controversies in the past resulted from a single legislator's personal objection. This time the intensity of the debate and its origin are different. This time, not a politician's personal offense but constituent opposition, highly manipulated by right-wing organizations, sparks the controversy, and the resulting outcry has been much louder and sustained.

Visual Artists' Rights

While dumping political bile on artists and their work, and debating legislation to restrict the content of art funded by the NEA, Congress was quietly moving forward on an important measure actually to protect artists. The Visual Artists Rights Act, championed for several years by Massachusetts Democratic Senator Edward M. Kennedy, was passed into law as part of a civil court reform measure after several years of hearings and bill drafting. Without the obvious potential for homophobic, anti-religious, anti-minority sensationalism, the right-wing extremists either were not paying attention or simply saw no opportunity to enflame their grassroots adherents into opposition over such legislation.

The Visual Artists Rights Act, signed into law on December 1, 1990, grants artists the right to claim authorship of their works and the right to prevent the intentional distortion, mutilation, or modification of their work by future owners which might prejudice their reputation and honor. The law also grants artists the right to prevent the use of their names as the authors of work they did not create and of their own work that has been distorted or mutilated in a way which would prejudice their honor or reputation.

The law protects paintings, drawings, prints, and sculpture. Photographs are also covered by the law if they were produced for exhibition and in limited editions. This law was passed in order that visual artists in the United States would have protection similar to that granted to artists in most other countries. In the past, artists had no grounds to sue, except under statutes in a handful of states.

David Wojnarowicz later used copyright protection to successfully sue the American Family Association's Wildmon for misrepresenting his artwork. NEA grant funds had gone to support "Tongues of Flame," the exhibition of his articulate, disturbing, enlightening work dealing with such issues as homosexuality, memory, gender, and AIDS. Wildmon, criticizing the arts endowment for funding the exhibition, portrayed out-of-context details of the Wojnarowicz work in an attempt to sensationalize the issue and whip up the angry opposition of the uninformed. His misrepresentation of the artwork was found by the court to be an illegal violation of the artist's right to his art.

Grassroots Pressure

Earlier controversies over NEA-funded projects were not as organized, not as orchestrated or as well-funded as the cultural war now being waged. The sustained firestorm that has raged since the attacks on the NEA occasioned by "Piss Christ"—when difficult, vulnerable art turned up on the conservative political agenda—speaks to the strength of the outraged constituents and grassroots organizing potential of cable television and computerized mailings. Since politicians react to their constituents, much of what is happening comes out of the changing political climate. Posturing over public funding for the arts has reached a low point when politicians willingly link the public's nonspecific discomfort, fear, anger, and confusion about issues of pornography, homosexuality, obscenity, and art with the National Endowment for the Arts. Legislators seem to be picking on the arts because they think it plays well with their supporters.

Indeed, when Congress takes on standards of morality and artistic content, as it has in the controversy over the NEA, legislators are concluding that their constituents are against federal funding of the fullest range of artistic expression. Federal legislators opposing federal arts spending have labored to make the point that the issue is "not a question of free speech" but "a question of taxpayers' money," and the artwork itself, which hardly any foe of the NEA has seen except in grainy reproductions, has been called in the U.S. Senate "shocking, abhorrent, and completely undeserving of any recognition whatsoever."

The way U.S. senators and representatives see it is simple: taxpayers are outraged that federal money can be spent to support the making of art that they find offensive. Therefore, taxpayers should not have to foot the bill for art that "offends" them or their "community." Nobody, however, has gone the next step to explain what is meant by taxpayers, or whose com-

munity is being offended. In the congressional debate about federal support for the arts, artists—themselves taxpayers and often vibrant members of a community— time after time take the beating. They are repudiated on Capitol Hill, their artwork is dismissed as trash, and the federal grants for their work are universally treated as mistakes.

The real issues here are deeper than anger over allocating federal money. So intimidating is the power of the conservative wing in American politics, especially when the subject is sex or religion, that pro-NEA legislators in Congress, while defending the work of the agency, generally walked away from the opportunity to defend the artist's work. There was little attempt even during the initial rounds of the NEA controversy to defend a discomforting, misunderstood cultural expression, particularly in view of the Serrano and Mapplethorpe attacks—one Hispanic, the other gay—each representing a minority cultural voice speaking to a heterogeneous American society undergoing momentous demographic changes in these last decades of the twentieth century.

It was plain that homophobia was the raw nerve, the vulnerable target of attack that drove Helms and the right-wing extremists to stir up the grassroots and strike fear on Capitol Hill. The amendment Helms proposed—and Congress eventually adopted in a slightly changed format—prohibited the NEA from funding "obscene and indecent materials," listing as examples "depictions of sadomasochism, homoeroticism, the exploitation of children, or individuals engaged in sex acts." So strong is the fear of the right-wing's use of politically damning sound-bites that no Senator questioned what was meant by homoeroticism and why it was singled out for attention.

Eventually, it became politically absurd, even if a member of Congress might have tried, to express intellectual disagreement about the art—you were either on the side of those who were vocally and self-righteously revolted by the art, or you were a partisan for pornography and blasphemy. At the height of the battle over the Helms amendment in the NEA funding bill in 1989, Phyllis Schlafly, Paul Weyrich, and other heads of some twenty right-wing organizations raised the political stakes in a letter to members of Congress warning that opposition to the Helms amendment would be interpreted by constituents as a vote in favor of government spending on "obscene and indecent art."

A similar lack of courage to defend the artist's expression showed in the decision by the NEA, with John Frohnmayer's debut as chairman, to deny a grant already approved to fund the exhibition about AIDS at Artists

Space in New York. The political climate nullified any opportunity by the NEA to weigh the artistic value of the work presented. Was the topic of AIDS and its inherent homosexuality so upsetting to the federal arts bureaucrats? Was there actually a need to "protect" the admitted homophobes in Congress from the ranting imagination of David Wojnarowicz? As a piece of insight into the mind of a person racked by the actuality of AIDS, Wojnarowicz's essay in the Artists Space's exhibition catalog is masterfully enlightening. But there was no rush from the NEA leadership to understand or interpret or defend the artist.

Social Issues

We should not be surprised that art today stirs debate and arouses contention. Indeed, the role of art, in part, is to raise the issues that percolate below the surface of contemporary society, issues we should confront but are not yet comfortable addressing.

Consider some of the changes in American society in the last twenty years that influence the shape of those issues lurking in our collective subconscious and that propel the arrival of those issues onto the public agenda: women have entered the work force in greater numbers and in more various occupations and positions of authority than in any previous generation; African Americans have become part of middle-class, professional, and political American life in ways not thought possible forty years ago; homosexuals are more visible in far greater numbers, including politically, than at any other time; and, the largest wave of immigration in this century occurred during the 1980s, and, significantly, the majority of new immigrants are not from Europe as in the past but from Asia and Latin America. Much of this makes many people uncomfortable as they see their familiar world changing. When society changes and the attendant cultural expression confronts the public, the art touches those raw nerves of discomfort and exposes to frustrated argument the social issues that lie within our body politic.

At the same time, society is baffled by problems of racism, poverty, AIDS, sexism, and homophobia that seem insoluble and will not go away. It is no wonder then that much of the art produced today is socially engaged; it is about the issues and concerns we recognize but do not want to acknowledge.

In attacking the issue, the critics attack the sponsor of the art for allowing the artist the opportunity to confront an issue which might not other-

wise be raised. But artists have always talked about their own lives and de-
picted what they see in their surroundings, often with a sense of urgency to
grapple with issues ahead of our own schedule.

Artistic Challenge

Congress needs to recognize that when government supports the arts in a
free society, there will be times when someone is offended. In the mean-
time, the atmosphere created by the congressional debate and the conse-
quent mandate to the NEA to apply standards of decency to grantmaking
decisions causes artists and arts organizations to engage in a political
guessing-game about artistic content. We cannot be so worried, either as
individual artists or as arts institutions, about pleasing everyone that we
have nothing substantial to say.

If the Arts Endowment finds itself forced to restrain from entertaining
applications to support the broadest possible artistic expression, and artists
restrain themselves from proposing work that is indeed excellent by artis-
tic standards but risky or provocative, public support for the arts would be-
come no more than a source of dollars available only to the most broadly
acceptable. Only safe art will be funded, and stimulating and challenging
work will be left out. Our objective should be just the opposite. The gov-
ernment's role should be to support all voices, controversial or not.

Elected public officials must be made to recognize that the creative ex-
pression challenges us to look in new ways at the human condition. The re-
sult will not always be to everyone's liking or consistent with everyone's
sense of propriety. Legislators need the encouragement of their con-
stituents, including the artists who so forcefully make the case, to ensure
the integrity and financial health of the arts through public support. For the
debate to move away from the extremist opinions that currently prevail, it
is essential that the voices of those who appreciate and enjoy the arts join
with artists and move forward to speak clearly and unequivocally on be-
half of the place of artists in society, in support of their sometimes dis-
comforting role in our daily lives, and in favor of public funds to finance
the artwork that contributes mightily to public dialogue on issues of prime
importance in our culture. We must no longer tolerate the unbridled attacks
on artists who would, through their art, hold up a mirror to ourselves for
our consideration and discussion.

1

Chronicle of an Invasion: A Personal Account

by Jock Sturges

*Sturges, a fine art photographer who divides his time be-
tween San Francisco and Europe, was the subject of a two-
year investigation by the FBI for suspected violation of
pornography statutes. The investigation was terminated
when a grand jury refused to indict for lack of any com-
pelling evidence. Sturges's first monograph, "The Last Day
of Summer" was released by Aperture in 1992, and is now in
its third printing. He released three other monographs in
1994.*

In April of 1990 my career as a photographer was going remarkably well.
After almost twenty-five years in the medium, I was experiencing a broad
spectrum of successes. I had four major shows coming up with important
galleries in San Francisco, Chicago, Philadelphia, and Boston. I'd been in-
vited to teach a summer workshop for the "Rencontres Internationales de
Photographie" in south France and I'd just been commissioned to do a
major editorial project for *Vogue*. In France I was working on a monograph
of my fine art work with the French publisher, Contrejour, and, perhaps
most importantly, my work had recently been added to the collections of
the Museum of Modern Art and the Metropolitan Museum of Art in New
York and the Bibliotheque Nationale in Paris.

None of this had come overnight. I first began making pictures in the
fifties and had since spent many, many thousands of hours wrestling with
both the mechanics and aesthetics of the medium. I had also been working
for years (as I continue to do now) as a commercial dance and fashion pho-
tographer.

So, on April 25, 1990, I was a thoroughly happy man. In fact, I had just
written an old friend that on a day-to-day basis, I was feeling such a fine,
ebullient satisfaction with life that my emotional state put me in mind of

how I'd felt when, as a fifth grader many years before, I'd vaulted down the school steps on the first day of summer—full of eager and limitless prospects. That particular afternoon I'd just ridden my bike twenty-five hilly blocks from the University of San Francisco's Koret Recreation Center where I'd been swimming laps. I was pleasantly exhausted and about to take a shower when at 1:15 in the afternoon my doorbell rang. It sounded a second time and I assumed it was the mail. Still wearing my sweats, down the steps I went and opened the door onto a new life.

On my front porch were half a dozen plainclothes law enforcement officers. Upon opening the door, three of them, detective sergeant Thomas Eisenman, and special agents Ross and Madden of the FBI immediately began peppering me with questions. Could they come in? What did I know about child pornography? Would I cooperate with them? Did I know that Joe Semien had been arrested? And many more. I was bewildered. Not only was their presence a total surprise, they were giving me no time to think let alone respond to their questions. I remembered thinking even then that there was clearly method to their aggressiveness—that I was being kept off balance intentionally. After a few minutes of "whats?" I came to my senses a bit and asked them if they had a warrant to be there— what exactly was I facing? Well, no, they didn't have a warrant but they could get one and it would sure go easier on me if I just cooperated and let them in. Feeling completely over my head with the situation, I told them I was going to go upstairs to call an attorney because I clearly wasn't competent to deal with them on my own. I went to shut the door but agent Ross snaked out his foot and jammed it in the door. "That stays open," he said. I was incredulous. I started to say something about their not having a warrant, but before I could get more than a syllable or two out, agent Ross said, "We're protecting you from harming yourself. Or destroying evidence." The nightmare was underway.

I went up the stairs and got on the phone. I didn't know any attorneys in the Bay Area so it took extensive calling for me to scare someone up. Meanwhile, the law had come up the stairs and infested my house. I use the word infested advisedly. I was incredulous to turn around and see four of them looking around my kitchen. As they did not have a warrant I asked them to leave. They were "protecting me from harming myself, etc." and wouldn't budge. Then the attorney I had managed to contact, Ephrahim Margolin, arrived. He exchanged business cards with the law and sat down next to me on my couch and patted my knee. His first words to me were indelible. "My boy," he said, "the first thing you have to know about this

business is that for all intents and purposes, the Fourth Amendment is dead."

My heart sank on hearing this. I remember as well sitting there during the next several hours trying to figure out what was happening to me. High school civics had been a weak point for me—I'd never been a good student and my memory has ever been a leaky vessel at best—but still, nothing that was happening seemed right. The Fourth Amendment dead? My apartment full of police without a warrant? How had this come to pass? What were these bastards doing in my home?

Margolin spoke with me for a few minutes and then told the law that I would most certainly not be "cooperating" with them. Several of them left to get a warrant. Unbeknownst to me, they would use the fact that I had been sweating when I answered the door (from my bike ride) and looked nervous (faced with a horde of aggressive, unsmiling police, who wouldn't have been?) as well as the presence on my walls of several photographs of "partially nude juveniles" to justify their application for the warrant. By coincidence, the specific pictures they were referring to were the images that the Metropolitan in New York had just added to its collection. That they were used as grounds to justify the warrant was ultimately rendered all the more absurd by the fact that despite the enormous volume of my possessions that were seized and carried away, they were left untouched.

The "raid" became more and more Kafkaesque minute by minute. Mr. Margolin needed urgently for me to try and give him some idea of what I thought was happening but the police would not leave us alone. Bewildered by this, I asked him if there wasn't some sort of privilege of communication between clients and attorneys but he simply replied, "Posh, these people don't care anything about that . . ." He was clearly right. Finally, from his accent I realized that he was of Russian descent so, as I still retained something of the language from a four-year enlistment in the military, we conversed in Russian for a while, ultimately repairing to the bathroom for privacy. I turned on the water in the sink as I'd once seen done in a movie because it was obvious that the feds were listening at the door. I knew even then that this was all incredibly absurd but I promise that at the time it was not in the least bit funny. It seemed altogether too much like a chapter out of George Orwell.

In the bathroom I tried to make some sense of the situation for both Mr. Margolin and myself. The police had mentioned that Joe Semien had been arrested from which it was not difficult to surmise that for some reason work that he had been doing for me had not been to the law's liking. But I

couldn't imagine why or, for that matter, how even it could have come to their attention. The naturist photographs I do are taken in broad daylight in conspicuously public places and are by no stretch of the imagination pornographic—there was no sexual activity of any kind depicted in the photographs. When I photograph children they are usually with their parents or at the very least in their parents' presence. Joe had been making "inter-negatives" for me of a handful of color slides of this sort of work so that I might make enlargements of them for the families in question. Racking my brains, I remembered that he had called me to tell me that the last batch of pictures I had given him had been delayed because he had had to take them to a different lab. His regular lab had problems with its film processor. Had there been a problem with the new lab? We could only guess. Meanwhile, after three and a half hours, the warrant arrived along with a moving van and another half dozen police officers.

When I was handed the warrant I experienced something that I've never succeeded in communicating adequately. I tried to read it but it was twenty-three pages long. I didn't come across my name until page seventeen or so. The first long section of it seemed to be the very disturbing vitae of one detective sergeant Thomas Eisenman who had clearly made it his business to train himself very exhaustively indeed over many years in all aspects of child pornography. His credentials were detailed to justify his judgments that I might reasonably be considered suspicious, but to me they revealed a grimly obsessive man. After his resume there was page after page of what the government was allowed to seize within the scope of the warrant. It's not hard to sum up because, frankly, there was nothing in my house that one parameter or another of the warrant did not fit. They were empowered to take any article of clothing that might have been worn by a juvenile, any piece of paper that might ever have been used to store the name of a juvenile, any piece of equipment that might ever have been used to process or store a photograph, all files, all computer equipment, etc, etc. In effect they could have seized my kitchen sink because it could have been used to process photographs. I was aghast—I had no idea that the police had such sweeping and invasive license. What indeed had become of the Fourth Amendment?

Liberated by the warrant, the police attacked my apartment with a vengeance. They were busy in every room at once. One of them began pulling all my computer connections apart without first unscrewing the jacks so I took over and helped him dismantle my office equipment to do my best to limit the damage. To no avail. The computer, when returned almost two years later, was irreparable. Meanwhile my darkroom was gut-

ted. I never even saw them carry out my 8x10 enlarger—a huge piece of equipment. They also took the various easels and timer and all the light fixtures including the light bulbs but, curiously, they left the safelights. But the worst damage was being done in the room I call my "dry processing" room where I store and matte prints (with great attention paid to careful filing and archival handling). Once the computer was carried away I went to see what I could do to limit damage there and was appalled to see people going through all my archival exhibition prints, damaging every single picture they touched because of their careless and uneducated handling of the work. I did everything I could to intervene, even demonstrating the correct way to handle fine prints to avoid buckling the fragile emulsions. The officer in question elbowed me out of the way with a laconic "I'm just doing my job." This was a litany I was to hear again and again throughout the afternoon.

To my dismay I noticed a large pile of orange boxes which had obviously just been opened and "searched." They were my last stock of an Agfa paper that no longer existed and was therefore priceless to me. Because the boxes were only supposed to be opened under safelight in a darkroom (and were clearly marked that this was the case) all the paper was ruined.

Back in the kitchen my negatives were being gone through and carted off. There was also a large cooler there of 5x7 negatives that belonged to a photographer named Ken Miller. Ken shared my lab for years and had all his best work at my apartment because he was in the midst of printing a major show. I attempted to explain that it was not my work, that I didn't even work in the 5x7 format and that anyone could clearly see that all the notations on the negative boxes were in a totally different handwriting. Opening a box, I showed the officers that Ken's work is of street alcoholics, prostitutes, homeless people, etc.—nothing even remotely like mine. Eisenman's response was: "It's here, it goes."[1]

In my bedroom a few moments later Eisenman went through all my books and seized from a complete set of Vladimir Nabokov's work a copy of his novel "Lolita." Meanwhile officers in the living room were packing off thousands of plastic envelopes of ballet photographs that were orders from families who had been photographed at the opera house with members of the cast of San Francisco Ballet's annual production of "The Nutcracker."[2] "It's here, it goes."

As the afternoon wore on into evening I became increasingly stunned at the scope of the damage that was being done to everything I owned. Furniture was pulled away from walls and damaged, all my drawers and shelves were gone through and many emptied onto the floor and pawed

through. Years of collation and editing were being destroyed before my eyes. My cameras were all taken, my address books, my gallery files; indeed, my file cabinet was not even searched—they simply took the whole thing without even opening it.[3]

There were ten or more officers working in every room of the house at once and there was simply no way to keep track of what they were doing. Mr. Margolin tried to talk reason to them. I tried to talk reason to them but they were brute, deaf, and blind. Finally, after eight and a half hours they were done. They had filled a van about the size of a large UPS truck.

At this point I fully expected to be arrested. If Joe Semien had already been arrested earlier the same day for photographs which I freely admitted to having taken, it only made sense. I put a toothbrush in my back pocket and braced myself for what I knew would be an experience I would be a long time forgetting. But nothing happened. The law gave us a long, completely unspecific inventory of what had been seized and left.

Mr. Margolin and I quietly surveyed the ruins of my life and business. The apartment was pillaged. It is not an exaggeration to say that more thorough damage could not have been done by a criminal gang. The debris on the floor of my print storage room was three feet deep. The ruin actually seemed malicious in its scope. What was all the more staggering to me was the thoroughness with which I had been put out of business. Darkroom gear, cameras, files, address books, computer, printers, orders waiting to be delivered, correspondence, negative archive, print archive; everything I needed to make a living was gone and taken in such a way as to almost ensure that its material and organizational value was at least seriously compromised and more likely completely lost. It was too depressing to contemplate. I took Mr. Margolin to dinner to thank him for having responded so quickly to my call and to try to arrive at some sort of comprehension as to what had happened. I was also very anxious to know what might happen next. His response was essentially that it was impossible to know. Anything.

The weeks that followed were easily the most difficult of my life. Joe Semien was in jail for three days before being released on his own recognizance. I eventually learned that in seeking his "cooperation" the police and the federal agents had threatened to charge him with twenty-seven felonies and twenty-seven misdemeanors (one for each picture seized at the lab that had asked the police to come look at the work) and had set his bail at $81,000.

Before being let go, he'd been told that unless he cooperated with the police, he faced the permanent loss of all the possessions he'd had seized

from him during the raid on his house which had been a mirror copy of the one conducted on mine later the same day. But, in addition to the indignities that I would be subjected to, he and his roommates and their girl-friends had been rousted out of bed, many of them naked, and made to stand against a wall before he'd been arrested and led away in handcuffs. It was clear that he also had been intentionally "put out of business." Joe's case subsequently took months and two-thirds of his father's life savings to resolve. Though guilty of nothing, he ultimately plea-bargained to a much reduced charge so that he could accept a "deferred sentence" which in turn meant that after six months (during which he was prohibited from being in the company of minors!) his arrest record would be expunged and he could attempt to put his life back together again. Meanwhile my life had become an exhausting blizzard.

In the weeks following the raid I was able to piece together what had happened to me even if I could not know on a day-to-day basis what the future would deliver. Joe Semien had a small business making copy negatives for professional photographers who wanted exceptionally "true" color inter-negatives made from their transparencies. Joe and his business were both young and doing very well and he'd never done anything less than excellent work for me. Essentially though, he was a technician whom I'd employed to perform a specific technical task that I could not do myself. Apart from that, he had nothing whatsoever to do with the content of my work. That was and remains uniquely my responsibility. Neither Joe, I, nor anyone else had ever thought my color photographs particularly worthy of note, not to mention legally problematic, so neither of us thought anything of it when the processor at the lab that he regularly used went down for repairs forcing him to find another shop to job the film to. Unfortunately, someone at the second lab was of a more puritanical frame of mind than we had ever encountered before and had thought my European naturist nudes troublesome enough to ask the police to come have a look at them. That was what had landed them on first Joe's and then my doorstep. Why Joe and not I had been arrested remains a point of conjecture to this day. Unfortunately it is impossible not to surmise that the fact that I am white and Joe is an African American might well have functioned in the police's sad mathematics.

Meanwhile on the legal front the battle was properly joined. In Ephrahim Margolin I had stumbled on representation of very substantial stature. The more I came to know about him, the luckier I felt I'd been in a friend's quick referral. He was known and considered brilliant everywhere—he had a national reputation. In fact he came back with motions to

the warrant-issuing judge and the district attorney so quickly and aggressively that within two days I'd had all my cameras returned to me (though not before I'd been obliged to rent a significant amount of gear for the *Vogue* commission). The cameras were ultimately the only thing I was ever to receive back from the government undamaged and for this I owe thanks to the personal intervention of a sergeant named Nakanishi—the only police officer involved in the incursion into my affairs who behaved in a professional manner.

Margolin's initial advice was to allow him to insist on the return of my property at once and not otherwise to talk to the press about what had happened. This was far from easy because Joe Semien and I were both fairly well-known in the photo community and many people knew that "something" had happened. Some days I had as many as forty calls on my answering machine and, unbeknownst to me, there was a very substantial and spontaneous effort to organize a defense committee underway within hours. But Margolin felt that it would be a mistake to antagonize the government by assailing them with the tide of negative publicity that would result should events to date be described to the press. He viewed the photographs that had led to the raid and felt that there was a good chance that, if left to themselves, the government might come to its senses and realize that they had made a major mistake. Then everything changed yet again.

Approximately four weeks after the raid, several things happened at once: in response to our motions, a San Francisco judge ordered all my property returned which prompted the FBI and the U.S. Justice Department to take the case away from the local police. I changed attorneys, a formal defense committee was assembled, and agents of the FBI began going through my address books and calling or visiting almost everyone I'd ever known personally or through business.

The wresting of my case from the local police was a blow. It had begun to seem that there was considerable sentiment to let it drop from the district attorney's end and I had begun to hope that it would all die a natural death and that I could get back to my life. When the judge ordered the return of all my property my heart lifted only to be brought back down hard a few hours later when the justice department subpoenaed all my affairs directly from the police. Dropped entirely by San Francisco, the case was now federal. I didn't know it then but my future was now in the hands of one of Edmund Meese's anti-pornography task forces and my troubles were only beginning.

Meanwhile I'd also changed attorneys. I was happy with Mr. Margolin but had been advised by a number of friends and family as well that a

lawyer by the name of Michael Metzger might be more appropriate for a hard-fought criminal defense at the federal level. At the time, I had no idea how right they would prove to be. Michael, who has since become one of my best friends, is an enormously inventive, aggressive, black-hearted son of a bitch. The federals hate him and I love him. The point was that from day one he was my son of a bitch. Having been a prosecutor himself for seven years, he knew the criminal justice system inside out. His legal aggressiveness and the emotional support that he and his wife, Kyle, extended to me made an enormous difference in how I felt about my prospects. He immediately began laying the ground work for a motion for return of my property under rule 41E of the federal statutes. Apart from the speed and intelligence he brought to bear, what was still more heartening was the fact that, after an initial retainer, he never again charged me for anything beyond court costs for his long and extraordinary efforts on my behalf. He took the case pro bono.

The defense committee came into being at about this point too, although, ironically, it was not my idea. Indeed, it held several meetings before I was even aware it had been organized. Once the story had become public, the response from the Bay Area and from all across the country had overwhelmed me almost at once. Happily there was a photographer in San Francisco with strong political principles named David Reinhardt who headed a nonprofit organization named "Photography 501-C3." He jumped in and lent both his space and his considerable organizational talents to efforts on my and Joe's behalf. Also Vision Gallery's Joe Folberg (my principal representative in San Francisco and an immediate and generous contributor to the defense committee) put me in touch with a collector and lifelong activist/socialist named Rod Holt who was to prove extraordinarily generous in all aspects of the defense effort. Simultaneously, Matt Herron of the ASMP began a series of meetings to discuss the issue of lab intervention in photographers' work which ultimately resulted in the formation of the "Bear Skin Rug Committee" which remains active to this day.

Then the telephone calls began.

The first one that I became aware of was to a family south of San Francisco whose youngest child, a girl, I'd photographed on her mother's lap many years before when she was but six weeks old. The baby was without clothes so I suppose the photograph was technically a nude but, if so, about as salacious as a Christmas card. An agent from the FBI called this family when the daughter, now twelve, was home alone. He questioned her for almost twenty minutes before identifying himself as an agent of the FBI. He

asked her if she knew me (she remembered me vaguely—I hadn't seen her family in some years) and whether she had ever "posed naked" for me, etc. When her parents returned later that evening they found their daughter enormously upset by the call. She felt that she was somehow or other in serious trouble with the law because of naked baby pictures of her. They in turn called me to express their concern and their fury that an agent of the government would consider interrogating their child without their knowledge or permission. Happily, they remain my good friends but that specific incident brought me to the realization that the gloves were off—it was time to talk to the press before a continuing series of such pejorative and invasive calls succeeded in assassinating my character by insinuation and innuendo.

So I began returning calls and the deluge began. I immediately found myself doing print, radio, and TV interviews at both the local and national level almost every day. The press without exception was very much on my side of the issue which was encouraging but also exhausting. The committee began at once to help me with logistics of all this and the relief was enormous. At its peak, I would receive seventy-four phone messages in a single day. The effect of all the coverage was positive on one level—it engendered an enormous amount of support. But, unfortunately, coins have two sides. Despite over ten years of problem-free professional association, the several ballet companies for whom I photographed effectively let me go. They didn't want the children in their schools associating with so notorious a photographer. . . .

The FBI agents were driven to a frenzy by this media attention. Clearly they hated it. They began to interview all my business associates in San Francisco, in the course of which "interviews" (an ugly euphemism in their hands) they were rude and aggressive, often to the point that they moved some people to tears and others to throw them out of their houses. The phone calls continued all across the country. They were speaking to people whom, in some cases, I hadn't seen for over twenty years. "We're investigating Jock Sturges for child pornography. What can you tell about his sexual proclivities?"

Meanwhile in San Francisco a city supervisor named Terrance Hallinan introduced a resolution before the board of supervisors urging both the local and federal authorities to get out of the art police business and to drop my case. The resolution passed almost unanimously. This and the positive anger on my behalf from friends, well-wishers, and the media were all encouraging to me but seemed to do nothing to discourage the task force that

was at my throat. And I wasn't doing well with it. My personal resources were overwhelmed.

Asked by me to sketch the worse case scenario, Michael Metzger had looked up the applicable federal sentencing statutes and told me that if the feds succeeded in convincing a jury that my work was pornographic, I was facing ten years in prison. My imagination made ruinous work of this. It is common knowledge that prisoners convicted of crimes against children fare very poorly indeed in inmate populations; ten years sounded to me essentially like a death sentence. I owed very substantial attorney fees to Mr. Margolin at this point and had essentially been deprived of the wherewithal to make a living. I'd lost my appetite completely (ultimately I lost just over forty pounds) and was getting no sleep because, no matter how late I stayed up, I would wake up with my heart racing every night at 3 A.M. and would not be able to get back to sleep at all. And every time my doorbell rang I would jump like an electrified frog leg. Depressed and completely over my head, my emotional condition degraded so far that at one point I even began thinking of suicide. That is no easier to admit now than it was then, but I do so with the hope that I can convey at least in some small part how very under attack I was.

The most ironic thing about my situation at that point was that I still had never been accused of any crime! Indeed, since their departure with all my possessions, I was never, throughout the entire history of the case, to receive any communication of any kind from the feds again—except those that they were absolutely obliged to file in reply to our formal motions. From my perspective, they'd come, taken almost everything I owned, and left; too bad if I didn't like it. Both Mr. Margolin and Michael Metzger were to draft many, many letters but no replies were received. Michael was amused by my outrage over this fact—apparently it's standard federal procedure.

So, in June, under assault and feeling vastly outnumbered by the limitless resources of the federal government, I finally had to admit to myself that I needed some help—at the very least, something to let me sleep. Mr. Margolin was kind enough to recommend a psychiatrist whom he knew, Dr. Wolf Lederer. So I took myself off to a head doctor for the first time in my life. Happily Dr. L's intelligent attentiveness made an immediate difference and I began winning back lost ground at once, aided not least of all by the sudden realization that I had been responding to date precisely how the feds wanted me to. To continue to do so was to allow them a victory which they in no way deserved. My psychological state had evolved from

shock through fear to deep depression, but, dating from these meetings, it progressed to a far more productive posture—anger.

In early July, just before I was to leave for France to teach a workshop at Arles, I received a call from the San Francisco Police Department who wanted me to come down and reclaim those of my possessions that had not been taken by the feds. That this call came on a Sunday afternoon just a day before the city supervisors were to vote on the resolution urging the dropping of my case, was just local politics, I suppose. I had to rent a truck to get my gear (the police take away but they don't deliver . . .) but even though I had been braced for bad news, I was totally unprepared for the terrible condition my effects would be in. The most obvious damage was to the enlarger from my darkroom (half mine and half Ken Miller's). It had obviously been dropped from a height upside down onto its head which was caved in and looked like it had been on the losing end of a bad automobile accident. The interior optics were all shattered. I still can't imagine how they managed to so damage such an expensive and delicate instrument unless they had specifically intended to do so. The condition of the rest of what was returned then was little better, though for the most part the damage was less conspicuous. Some of my negative albums were returned as well, though none of the most recent books that included commercial work in progress. They had all been written on in indelible ink. Along with government inventory numbers was the prominent legend "NO PORN SEEN." My file cabinet was returned minus three-quarters of its contents.

I left for Europe the next day in an attempt to carry on with my life and work. It wasn't easy. Fortunately the story had not gotten to France at all so I never had to deal with the media there—a huge relief. I love teaching and was pleased that my workshop seemed to go very well. My girlfriend, Maia, was with me, modeling for the workshop and photographing as well. She'd been of enormous support to me in the States and the chance to have some quiet time with her in the French countryside we both so love was enormously renewing. But still, I was a long way from happy. I was attempting to continue my work as a fine art photographer but I found myself constantly censoring myself. This was nothing I was doing willingly or happily. The simple fact is that my work is above all intuitive—which is to say that I take pictures that most feel like they want to be taken. And, clearly, the trauma I associated with any younger subjects was more than enough to pollute any instincts to continue in that vein. So, apart from not taking many photographs that I previously would have made without thought, everything else that I was doing was by definition work that I was

doing because I wasn't doing something else—that is to say that it was understandable as reactive, not natural work. Perhaps that distinction is abstruse but the point for me was that my whole existence as an artist had been seriously undermined. Fortunately I had a new tool to use—the anger I mentioned earlier. I became very much driven by the desire to make photographs so beautiful that people would smite themselves in their collective forehead and say to themselves, "Why on earth is the government bugging this guy?" It wasn't the most satisfying basis on which to advance my photography but it seemed to work.

Unfortunately I had to cut my trip to Europe much shorter than was my usual practice. The logistics of dealing with my case simply wouldn't be left alone for long and I had to get back. I hated leaving France and reentering the U.S.[4]

Back in the States I quickly learned that the feds had not been idle in my absence. They had attempted to subpoena the records of the three galleries that then represented me on the East Coast and in Chicago. The galleries had successfully resisted these subpoenas because, typical of federal efficiency, the documents had been out-of-date when served. All three had retained counsel and had subsequently written the prosecutor in San Francisco seeking a clarification of what specifically the government wanted to see. They never received any reply to their letters.

In New York an agent had called the Museum of Modern Art to confirm the presence of my work in its collection. When asked by the museum to submit her questions in writing, the agent replied with words to the effect, "We're the FBI, we don't have to do that." End of conversation.

On the West Coast, more sinister events had transpired. The same two agents who had been in my apartment had been on a tour of the northern California communities where I had been photographing since the mid-seventies. They had "interviewed" a number of the families that I photograph there—including the children. Their effect had been a long way from benign. One particularly sensitive thirteen year old (a child I know well from photographing her and her family most of her life) who was at a very self-conscious age had been asked point-blank if I had ever told her to "spread her legs" when I photographed her.[5]

But the FBI did have its way to one unfortunate extent. Their visits so traumatized some of the children that they "interviewed" that they abandoned their habit of being and swimming without clothes in hot weather. Several weeks after the FBI's visit I was to photograph the same girl mentioned above—a beautiful, uninhibited soul whom I had been shooting since she was quite small. She was swimming with all her clothes on.

She'd furthermore asked her mother to take all the family pictures that I'd done of them off the walls of their house and put them in a trunk.

Back in San Francisco the FBI visited Vision—the gallery that represents me in my hometown. Their first two questions to Nik Planchon, the gallery director, were "Did you know that Jock Sturges is a divorced man?" and "Did you know that Jock Sturges's girlfriend is considerably younger than he is?" Her reply to these questions was "So what?"—as is mine, more or less. I hadn't been aware that either of these two factors were indicative of criminal tendencies. . . . Though their broadcasting such information to my friends and associates did not embarrass me in fact, in principle I did not enjoy their arbitrary and inane dissemination of personal information—particularly because they'd attempted to render sinister the most absurd irrelevancies.

The campaign continued. In San Francisco I have a friend named Jim Hendrickson who publishes a quarterly photography newsletter entitled "The Lover of the Image." He kindly dedicated the whole of the spring '91 issue to my and Joe's cases. Included were a variety of editorial pieces plus a draft of a longer piece that I'd been working on describing events to date in my case. Two weeks after it came out Jim received a call from an agent of the FBI. The agent identified himself and asked if Jim would answer some questions. Jim complied and was asked "How many children do you have living in your household under the age of sixteen?" Jim lives alone and has no children so naturally he replied, "None." Then, "How many children do you have living in your household under the age of fifteen?" Again, "None." Again, "How many children . . . ?" etc., etc. The question was posed sixteen times despite the fact that each time Jim was still more strident in his response of "None!" End of conversation. An hour later Jim received a second call, this time from a marketing agency doing a "survey." The same questions were asked in the same manner by the same voice.

What was going on was simple, of course. The feds were letting Jim know that he had come to their attention and that he defended me at his peril.

Meanwhile on the legal front, Michael Metzger filed our motion for return of property (rule 41E). Our argument, put simply, was that the warrant used to seize my effects was no good because (1) the photographs were clearly not pornographic and (2) the warrant was drastically flawed because of its dramatic over-breadth. A decision handed down in the ninth circuit court of appeals just a few months earlier was cited. The warrant in that case was identical to the warrant in mine. The case had been thrown

out and the warrant cited as "an egregious violation of the Fourth Amendment" by the ninth circuit justices, so we were very optimistic about our motion. But the government counterattacked in an entirely unforeseen fashion.

The government had all along been hugely discomfited by the attention of the press. Apart from being on many national news programs (*20/20, 48 Hours, This Morning, Nightwatch* etc . . .) there had been a huge amount of print as well. Many reporters had come through, interviewed me, looked at the pictures, and made up their own minds. Fortunately for me, their opinions were unanimous and scathing—the reporting was all heavily in my favor. So the feds struck back.

The opportunity that presented itself to them was the occasion when they had to file papers with the court in response to our motion. Technically they were constrained by due process to reply only to the arguments that we had raised in our motion. This they did not do. In fact, they made only the most superficial reference to our motion in their reply document. What they did instead was to use their opportunity to file a document in the public domain to attempt to discredit me in the eyes of the press. They attempted to justify their search by an enormously pejorative and inaccurate description of what was seized. Their language was ugly and damning. They had seized the photographs where the genitalia were "graphically displayed" etc., etc. What they knew was that the truth of their verbal depictions was all but irrelevant—the point was that, as part of publicly filed documents, they got in print. Apart from the fact that it's inadmissible in any court in the land to attempt to justify a search by its fruits, their arguments were nothing more than a hopeless tirade. To add insult to injury, they filed a separate brief asking the court for a gag order that would prevent me from talking to the press.

Metzger was furious. He immediately filed a motion to have the prosecutor found in contempt. A law professor from Harvard opined that he hadn't seen such a document from the government since the McCarthy era. I was personally set back as well because now there had been a seed of doubt sewn in the media and I was thrown on the defensive.

Several weeks later we had our hearing and our motion was granted. The government was instructed to return everything. The prosecutor lobbied vigorously for the retention of my computer and several of the photographs which he considered "contraband." He even went so far as to argue that copies of them should not be released to my attorney. The judge dismissed this notion, remarking parenthetically that in his view the pho-

tographs contained no sexual activity. He ordered that we receive everything in original or copied form. He further made a specific point of instructing the prosecution to copy my software if they wanted to but to give me back all my computer equipment, including my hard disk. They were given three weeks to comply but it would be closer to a year before the last of my pictures and equipment came back to me.

The hearing had been in January of 1991. The media was putting constant pressure on the Justice Department. They replied time and again that the investigation was continuing and that there would be an indictment "real soon." And then I began to hear from friends in France and Germany.

Obviously frustrated at not having found anything in the States, the feds had extended their investigation abroad. The French and German police had been enlisted because of cooperation agreements and had gone and interviewed all those named in my European address books: friends, families, business associates, editors—the works. In Paris they raided the home of Claude Nori, the editor of Contrejour, the French publishing house that was preparing my first book. Claude and his girlfriend were rousted out of bed naked (sound familiar?) at a very early hour. He was taken in for questioning. Contrejour's offices were raided later the same day and all the prints that I had there in preparation for the book were seized. None of them have ever been seen since.[6]

Elsewhere in France, family after family was interviewed. I subsequently learned that the French police had been telling all these families that they were investigating me because I had a criminal record in the United States—that I had been convicted of incest! They told people that they didn't mind the pictures, really, they even liked them but, "This Jock Sturges, he's a dangerous man, you know . . ."

Fortunately my friends in Europe have known me for many years—well enough to know that I have no children and that therefore a conviction for incest was improbable at best. In fact, I have no criminal record whatsoever. I inadvertently ran a red light in San Francisco in 1983, which I'm not proud of, but otherwise my record is unblemished. The "Police Judiciare" did some checking on their own and discovered that they had been "misled." They were subsequently kind enough to call back the families they had visited and apologize. The last family they spoke to was told that as far as the French police were concerned, "le dossier de ce Monsieur Sturges est impecable"—my file is impeccable.

I don't know who had "misled" the French, though obviously I have my suspicions. The danger to me there was extraordinary because if the in-

vestigators had succeeded in jaundicing the French's view of me and my work I could conceivably have been barred from working further in France. As this is where the vast bulk of my extended series of fine art portraits are done, my work would have effectively been censored into nonexistence.

Back in the States, spring had come and the investigation groaned on into its second year. I became aware of interviews that had been held with people whom I had not seen in over twenty-five years. Patterns of visitations made it clear that my phone had been tapped—and for a long time. The prosecutor subpoenaed a number of collectors, gallery owners, and business associates to appear before the grand jury. He one day stopped my attorney in the hall in the federal building and complained bitterly to him that "all these people like your client." The news of the grand jury interviews actually encouraged me because everyone that had been called reported to me that they had been asked sympathetic questions by the members of the jury. I asked Michael Metzger about this and he did his best to keep my hopes from getting out of hand. "Grand juries always do what the prosecutor wants." He quoted a New York State justice: "A grand jury would indict a ham sandwich if asked by a prosecutor."

Summer rolled around again and I went back to France, not knowing what I would find there. I spent the entire summer explaining to family after family why they had been visited by the police and what the status of the case was. They were incredulous. Some of them were, indeed, very angry because they understood that the feds were alleging that photographs that I had taken of them and their children were pornographic which meant to them that they were considered to be somehow or another inherently pornographic. My work is unposed and always very natural and matter-of-fact. They'd seen the pictures and liked them. Then at the end of August I called home to check in with my family in Rhode Island.

The first thing they said to me was, "Isn't it wonderful that the grand jury threw out your case?" They didn't realize that I hadn't heard. It had happened two weeks before and I hadn't known. It was over.

Grand jury proceedings are secret so I'll never know exactly what happened. The case was before the jury for fifteen months so I know they knew a lot about me. Michael has since spoken with the prosecutors enough to discover that the jury just wasn't buying that my photographs were pornographic. The prosecutor later complained to a journalist, "Well, these things are very subjective, you know."

I know.

Afterword

In January 1992 I recovered the last of the photographs that the Justice Department was willing to return to me. They retained about a dozen images which they considered contraband and wished to destroy. Of the hundreds of other prints they returned, one was salvageable. All the others had surface abrasions, tears, dents, paper clip marks, and in a few cases looked like they'd been crumpled up and smoothed out again. That any or all of them might have been art objects was clearly something the Justice Department was incapable of imagining.

They returned my hard disk at last, nearly a year after having been instructed to do so by the judge. Its data and the majority of the data on my backup disks had been unsalvageably scrambled. In total, I lost four and a half years of writing and business records. One disk that did survive was a game program called Star Raiders. Someone at the FBI ran up much better scores than I was ever able to. . . .

My life continues. I had strong summers of work in 1992 and 1993 and have many shows scheduled and a very successful recent book, *The Last Day of Summer*, Aperture, 1992. Two more monographs were published in 1994 as well. I can't resist saying that it's a brilliant and predictable irony that the federal government has succeeded best at promoting precisely that which it would most admire to have repressed.

It had been my hope to achieve another measure of vengeance by naming names and pursuing the specific agents and police officers who had wrought such havoc in my life and in the lives of my friends and their children. The team of lawyers that had assembled to represent me pro bono were anxious to proceed with a countersuit which would have resulted in what they felt was a certain and symbolic victory. But, finally, their explanation that such a case can take up to ten years to resolve proved too much for me. I wanted my life back. Enough was enough. I let it go.

Literally thousands of people came to my defense, most of them complete strangers. I wrestle constantly with the sense that I owe them something back. The one thing that I am left able to do is to continue strongly in my art with the hope that it both discomfits and educates the agents and officers who assigned themselves the task of being my nightmare. With luck the word will filter back to the locker rooms of the right: leave the Bill of Rights alone, leave the arts alone. They are our grand gift to posterity. They are what makes us great.

I am changed from two years ago. I am more cautious, more cynical, and often frankly paranoid. There's a good chance I will move to Europe

in the near future. I am mindful of the fact that this country owes much of its strength to people who came here fleeing foreign tyrannies. I am saddened by the notion that this migration, at least as manifest in my own life, may now reverse.

Notes

1. It took Ken months and several thousand dollars in legal fees to finally reclaim his negatives. When he did he was told by the police to distance himself from me because if he didn't they would take him down with me. He was also told that he should not associate with me because "every time a little girl goes up those stairs to your friend's apartment there is a good chance she's being molested." This statement was absolutely gratuitous as it has no foundation in fact whatsoever. The police also kept six of Ken's negatives "for the investigation"—harmless images of newborn babies. These pictures have since been lost or destroyed because the police now deny ever having had them.

2. What possible interest these might have had to the police remains a mystery to me. The images are utterly innocuous clothed portraits of families posing on a studio backdrop with dancers between a Christmas tree and a Nutcracker. The work was so clearly a standard commercial project that I can only surmise in retrospect that its confiscation was intended to impede me economically. This they certainly did achieve.

3. In response to a question from a journalist, the FBI spokesperson in San Francisco denied that my filing cabinet had ever even been seized. Ironically, the spokesperson in question, special agent Barbara Madden, was precisely the agent who had been in my apartment and who had condoned and overseen the seizure.

4. My fine art work is made during an annual average of 90 days of actual shooting. Because of "the case" I was only able to devote a total of nine days to new work in 1990.

5. When she and her family refused to confirm the agents' malicious suspicions about me and would not abandon me as friends, the agents were clearly vexed. At the very end of their interview they said, "Well, clearly you still like Jock, but we want you to know what he really thinks about you." They then pulled out a document and read it to them as if it were my opinion of them. It took me a while to figure out what it could have been but I was finally able to trace it. In 1982 I'd had a show at the MOMING gallery in Chicago. Peter Hales, the curator of the show and an old friend, had sent me a draft of a press release which he had written for the show. It was his take on the work and I'd vetoed it instantly as being far too negative and unkind and Peter had subsequently rewritten it. But the original draft had been in my files and, despite the fact that it was clearly not my writing, that is what the feds had been reading to people as my opinion of them. The attempt to

isolate me from my friends would gradually emerge as a principal federal tactic. It happened again and again as time wore on, but, happily for me, my greatest fortune in life is the quality of the people I know. Not a single one of my friends would abandon me.

6. Contrejour subsequently decided that doing a book with me was too risky and the project was dropped.

2

The Recurring Nightmare

by Martha Wilson

Wilson is director of New York City's Franklin Furnace, an avant-garde exhibition space.

Franklin Furnace's philosophy has not changed since I founded the organization in my TriBeCa living loft in 1976. The climate in which Franklin Furnace has been operating, however, has changed 180 degrees during the last seventeen years.

I did not know Franklin Furnace would become a museum for the "difficult" forms of art which employed time itself to convey the uncertain quality of twentieth century experience. Franklin Furnace was a bookstore/permanent collection for its first three months of life until Printed Matter took on bookselling. When Martine Aballea wanted to read from her book, the performance program was born. Karen Shaw's dictionary of word and numerical equivalents (If A=1, B=2, etc.) was among the first book/installations. The whole organization fit into a 15' x 15' area near the door; the rest of the loft was occupied by two roommates and lumber. I'm relating all of this to suggest the homemade, uninstitutional feel of the '70s. And one more thing—both the director of the Visual Arts Program of the National Endowment for the Arts (NEA) and two program offices from the New York State Council on the Arts (NYSCA) encouraged me to apply for funding.

Franklin Furnace's philosophy remains simple—trust artists. Artists from all over the world donated their work to the permanent collection, expressing the idea, ideals, and anxieties of their personal, local lives. As the quantity of artists producing performance and installations mounted, Franklin Furnace installed its annual spring peer review panels which place authority for identifying the next important ideas firmly into the hands of artists. The Board does not interfere with Franklin Furnace's selection process; it is the same peer panel process in use at the NEA since its inception that is being gutted within the agency.

Carnival Knowledge

In January 1984, Franklin Furnace hosted an exhibit proposed by seven women curators which asked, could there be feminist pornography? Books, installations, saxophone dancing, mud wrestling, real prostitutes talking about their real lives—this show had everything. So many people came to the opening that Franklin Street was impassable for traffic. The show also had its detractors: The Morality Action Committee, a Christian group, was alerted by the use of the word "pornography." After the exhibition closed (clever move) all of Franklin Furnace's funding sources (handily listed on our membership brochure) received letters and cards charging that Franklin Furnace had shown pornography to 500 children a day.

This was the first time I was to experience the effect of such accusations. Two corporate funding sources, Exxon and Woolworth, dropped Franklin Furnace instantaneously. The NEA dispatched Hugh Southern, then deputy chairman, along with Benny Andrews, director of the Visual Arts Program, to New York to meet with me and the members of my board. The message was that the NEA would appreciate getting credit only for exhibitions it had expressly funded. In other words, Franklin Furnace's own peer panels might select shows which could embarrass the federal agency. (Meanwhile the Europeans sitting around the table, the NEA's Hugh Southern, and the Franklin Furnace board members Coosje Van Bruggen and Fredrieke S. Taylor, had a laugh about how puritanical Americans can be.)

What struck me later was that the charge of pornography, like child molestation, I suppose, rendered Franklin Furnace guilty until proven innocent. Franklin Furnace would have lost a third corporate supporter, Con Edison, had Lisa Frigand not brought the senior officer to Franklin Furnace and lobbied heavily for it to be held in good stead. Only one supporter, Jerome Foundation, wrote a letter praising Franklin Furnace for taking the risks necessary to present emerging artists.

About a year after "Carnival Knowledge" I got a call from the NEA Museum Program that Franklin Furnace had been selected to be audited by the NEA Audit Division. The basic idea was that although the NEA was not questioning that Franklin Furnace had completed the programs for which it had received federal support, it would have to repay approximately a quarter of a million dollars if it could not prove that funds were matched privately and that adequate record keeping (of, say, time and effort reports) was in place. This interesting process took five years and four business managers to resolve; Franklin Furnace did not have to repay any

funds. To this day, however, Franklin Furnace remains on the "Working Capital Advance" method of payment. Under this program, we receive an award letter notifying Franklin Furnace of a grant and amount, say $10,000. We can request "working capital" up front, say $5,000 to launch the program. In order to receive the remaining $5,000, Franklin Furnace must show a total of $20,000 ($10,000 matched by $10,000 private money) in checks copied front and back, stapled to invoices organized in the same budgeted amounts as indicated in the award letter. So far, Franklin Furnace has been responsible for cutting down acres of trees to comply with the paper trail required by the NEA. In the final analysis, I believe this has been the most effective means of censorship yet: Who would cry to other funding sources that the NEA is investigating for financial impropriety? The net result of this process is that David ends up lending money to Goliath.

Karen Finley

Franklin Furnace premiered Karen Finley's performance work in New York in 1983. Some years later she had achieved visibility as a performance artist and wanted to try her hand at installation. As Franklin Furnace specializes in "emerging" artists and ideas, Franklin Furnace's panel eagerly selected "A Woman's Life Isn't Worth Much," texts and figures painted directly on the wall, books, and drawings.

Before Karen's show opened in May 1990, Franklin Furnace heard from People For the American Way that something strange might happen at Karen's opening. Before this date, a grant awarded to Karen by the NEA solo theater peer panel was overturned by Chairman John Frohnmayer, along with grants to Holly Hughes, John Fleck, and Tim Miller; these artists became known as the "NEA Four," and sued the NEA for its politically motivated reversal.

Something strange happened all right: the night of Karen Finley's opening (and Diane Torr's performance) an anonymous caller phoned the NYC Fire Department to report that Franklin Furnace was an "illegal social club" (the Happy Land Social Club fire had killed eighty-five people a month before). Franklin Furnace is not an illegal social club, so I invited Engine 77 to attend Diane Torr's performance the following night to see for themselves. They counted sixty-five people, below the legal limit of seventy-five, but found three violations and sealed Franklin Furnace's performance space. Franklin Furnace agreed to supply performance artists to Fire Prevention Day rather than pay a fine.

At this early point in 1990, the staff of Franklin Furnace was evenly divided as to whether the anonymous call was politically motivated. Should we blab to the press? Eric Bogosian suggested I call Joseph Papp, who told me to blab to anyone who would listen—that in the '50s the success of Joseph McCarthy was assured by the silence of the accused. But if I had had any doubts that there were those "out to get" Franklin Furnace, these doubts were dispelled in June 1990 when I got a call from a lawyer at the General Accounting Office (GAO) asking at the behest of Senator Jesse Helms, when and how often since 1985 Franklin Furnace had presented Karen Finley, Johanna Went, Frank Moore and Cheri Gaulke. My lawyer, Paul M. Gulielmetti, told me to "get it in writing." When the letter arrived he requested a copy of the congressional inquiry, which never arrived; consequently Franklin Furnace never provided the information requested by the GAO.

While Franklin Furnace's correspondence with the GAO was being exchanged, another letter arrived from Julianne R. Davis, counsel to the NEA, asking for more application information on artists selected to exhibit and perform in Franklin Furnace's 1990–91 season. This I did provide, after sanitizing descriptions a bit: for example, as Harry Kipper usually performs in a G-string and proposed to tell Bible stories with dolls, I wrote that he would tell stories using dolls to enhance his message. This was not a lie; and besides, I had the feeling the NEA's counsel was just looking for certain names—Annie Sprinkle, Karen Finley—the "short list" of "obscene" artists already identified. Ultimately Franklin Furnace was awarded NEA funds, albeit late in the grant period and in our season.

At this moment, there was another deep divide among small arts organizations. Language had been attached to NEA grants by Jesse Helms that provided the money could not be used to create works which depicted homoerotic acts or were obscene or pornographic. Cee Brown, Director of Creative Time, refused to sign the grant contract, feeling the Helms language equated homosexuality with obscenity. I felt it was fine to sign for NEA money, because "obscene art" is an oxymoron. Sure, art often depicts sexuality, poverty, racism, violence, as it has done for 30,000 years. This discussion became a moot point when the Helms language was removed in 1991 in favor of "local standards of decency" language that put more authority into the hands of the recipients, but it is problematic from the point of view of "prior restraint." Who can judge in the present what will be considered obscene in the future?

In the summer of 1990, Franklin Furnace felt the fourth shock wave from Karen Finley's exhibition: The New York State Comptroller selected

five NYSCA-funded organizations to audit from among hundreds across the state—including both Franklin Furnace and the Kitchen. Mr. King was perfectly blunt when called by Stephen Salisbury of the *Philadelphia Inquirer*—he said he selected Franklin Furnace and the Kitchen because of all the publicity about obscene art he had been reading. But, by this time, Franklin Furnace had had so much NEA scrutiny of its books that the State Comptroller's audit was completed in two days.

1992–93 Visual Artists Organizations Grant

Franklin Furnace has received its largest and most constant federal support from Visual Arts Programs for its role in launching the careers of "emerging" artists. In June, we apply to the NEA Visual Artists Organizations annual deadline, using the just-completed season's visual material to support the following season's application. In June of 1991, Franklin Furnace filed an application with slides, as usual, and two videotapes of performance art presentations which were allowed for the first time in 1991. Thinking back, I honestly can't remember much about the decision to include the tapes except that first, we had them (Franklin Furnace does not have enough money to videotape everything so we request copies at our expense if an artist makes a tape), and second, the light was good (a ton of performances happen in the dark). Third, Eileen Myles and Scarlet O represented very different approaches to performance art. Eileen took the "minimalist" position in "Life" that the difference between calling herself a performance artist or a poet was whether she looked at her audience or down at her text; Scarlet's performance, "Appearances May Be Deceiving," was concerned with the performance of power in sexual relationships, and moved from Scarlet in a man's suit to slides to "slut" persona. I figured these tapes taken together would show a range of work to the VAO panelists.

What I did not know was that the peer panel would not be the only eyes that would see Franklin Furnace's support material. The VAO peer panel met in November 1991 and recommended $25,000. Then the Post Panel Review Committee, comprised of Bush-appointed National Council and NEA staff members, met behind closed doors on Thursday, January 30, 1992, I believe to find "obscene" groups, perhaps using an already compiled blacklist of likely candidates. (If you've read this far, perhaps you will agree with me that it is not entirely paranoid to think that blacklisting was going on in the NEA.) Out of 128 applications received from around the United States, Franklin Furnace's and Highways' applications were

identified as "in your face" provocations by Chairman John Frohnmayer and the National Council because of the sexually explicit content of the visual support material submitted. The National Council's viewing of a few minutes of Scarlet O's tape (which it turned out, was not considered by the peer panel) was unprecedented.

Franklin Furnace's board of directors wrote a strong letter of protest, with the assistance of arts attorney Barbara Hoffman, that pointed to the impermissible political grounds on which Franklin Furnace's grant had been overturned. There is, however, no appeal process once the National Council casts its vote. When acting chairwoman Anne-Imelda Radice overturned grants for two exhibitions on the body to university-affiliated galleries over the stormy protest of her own National Council, it became clear how politicized the process had become. And to my mind it is clear that the big institutions, which in the late '80s declared there were only a few "rotten apples" in the NEA barrel, could now, with the small ones, watch with trepidation as the basis for judging grants became political.

What is the Crime Here?

After "Carnival Knowledge," Franklin Furnace mounted "Public Relations AKA Propaganda"—a show organized by Lucy Lippard about the information war being waged by the U.S. in El Salvador and elsewhere in Central America. We did not get in trouble for this, nor has any one of Franklin Furnace's exhibitions of politically charged art caused a stir.[1] The crime in America, the country founded by the Puritans, is sex. And as the new Puritans were emboldened during the Reagan era, they intelligently commenced their attack on a dead man, Robert Mapplethorpe; then pursued individual photographers, Jock Sturges and Andres Serrano; then individual performance artists, Karen Finley, Holly Hughes, John Fleck, and Tim Miller; small groups like Franklin Furnace, Creative Time, Highways, the Kitchen, Movement Research, the Portable Lower East Side; and at the time of this writing, university-affiliated galleries. It's not hard to see that on the flash point of sex—about which most people have irrational feelings—and through the "unproved" new forms of art—photography and performance art—real headway is being made on placing limits on freedom of expression.

Rust v. *Sullivan*, the "gag rule" on doctors of federally-funded abortion clinics, was not used as a legal means of limiting artists' expression, although John Sununu was pressing John Frohnmayer to give it a whirl. The conservatives are claiming "the people" demand their tax dollars not fund

"obscene or pornographic" art, and sure enough, a lot of people have written cards and letters to their legislators at Rev. Donald Wildmon's behest. Artists, for all their political correctness, are not politically engaged enough to write letters. And furthermore, in artists' defense, their images and texts are complex—this is the difference between art and propaganda or pornography. So, I'm not sure the cause of freedom of expression at the end of the millennium will prevail and I predict dark days ahead for tolerance of ethnic, sexual, and social differences. But on a bright note, Franklin Furnace will go down in flames before limiting artists' expression, and as in the former Soviet Union, artists will go underground before they stop producing their works.

Notes

1. Well, that's not entirely true: when Franklin Furnace was selected in 1979 by the United States Information Agency to send artists' books to the Sao Paolo Biennale, Jenny Holzer's and Denise Green's works were considered "political" and therefore inappropriate to represent the U.S. Franklin Furnace withdrew the exhibition rather than remove works from the show.

3

"The Taxpayers' Money": Why Government Funding of the Arts Doesn't Mean Government Control[1]

by Marjorie Heins

Heins is director of the American Civil Liberties Union's Arts Censorship Project.

In 1965, when the United States Congress created the National Endowment for the Arts, the idea was to advance artistic freedom and creativity, not government-approved, officially "acceptable" art. To make its desires perfectly clear, Congress wrote into the NEA law: "It is necessary and appropriate for the Federal Government to help create and sustain not only a climate encouraging freedom of thought, imagination, and inquiry, but also the material conditions facilitating this release of creative talent."[2]

The dilemma was to create an agency insulated enough from political pressures to be able to support innovative, radical, even confrontational, work, in addition to funding the already established art that is usually presented by museums, concert halls, and repertory theater companies.

Congress needed to find a way to prevent the kind of interference and demagoguery that could easily destroy the integrity of arts funding. It needed to prevent situations where pressure groups intent on milking hot-button issues like sex and cultural elitism, subversion of traditional values, or perceived insults to organized religion, could take particular works out of context, publicize, distort, and oversimplify them, and earn political capital by complaining that these artists or grants offended the American public's moral, political, or religious beliefs.

The result was that Congress gave the NEA an elaborate "peer panel" structure to insulate Endowment decision making from partisan pressures.

The peer panels were to review grant applications and make recommenda-
tions to the presidentially-appointed National Council on the Arts, and the
Chair of the Endowment, who had the final word on grants. These politi-
cal appointees, more vulnerable to instructions from the White House or
other outside pressures, would rely on the recommendations of the ex-
perts. The system worked pretty well—at least for the first twenty-four
years.

There were, of course, occasional questions raised about particular
works during this relatively halcyon time. In 1972, Erica Jong's raunchy
bestselling novel, *Fear of Flying,* acknowledged in its flyleaf that an NEA
grant had made the writing possible. *Fear of Flying* was shocking to some
because it told of sexual adventure from a liberated woman's viewpoint.
One congressman complained that taxpayer money was "now supporting
the scurrilous and the pornographic, and further, that since ladies were
present, a reading of the text would be inappropriate." (The irony of this
remark, given that a "lady" had written the book, was evidently unin-
tended).[3]

Then in 1989, somehow the system went awry. As Donald Wildmon,
head of the Tupelo, Mississippi-based American Family Association tells
the story, it all started with a postcard from a constituent notifying him that
an artwork called "Piss Christ" was hanging in a museum in North Car-
olina. The work in question was a large, luminous photograph of a cruci-
fix immersed in a shimmering reddish-gold liquid. Only the work's title
suggested that the artist might have an ambivalent attitude toward the pow-
erful Christian symbol at the center of the work.

"Piss Christ" was the creation of Andres Serrano, a New York artist who
had for years been exploring the use of sacred symbols. Serrano, a
Catholic, was interested in the way these powerful symbols were cheap-
ened and commercialized. He was also interested in the sacred and profane
meanings of bodily fluids. In his art, he often incorporated these essential
fluids—blood, semen, and milk, in addition to urine. Previous experiments
with body fluids had produced "gorgeous sunsetlike veils," "apocalyptic
'landscapes'" and "shadowy figures," sometimes "blend[ing] ideas of
nourishment and pain in a single image."[4]

But Serrano's ambivalence, and his artistic intentions, got badly lost in
the row that followed. Critics said he *must* have known his title would of-
fend devout Christians. Wildmon, Senator Jesse Helms, and others lost no
time in beating up a froth of righteous indignation over the "taxpayers"
being "forced" to fund such insults to Christianity.

Soon enough, another example of supposed NEA malfeasance was un-

earthed. The agency had helped fund a traveling retrospective exhibition of the works of the recently deceased, much celebrated, but unquestionably controversial American photographer, Robert Mapplethorpe. The subjects of Mapplethorpe's stunning photographs—as probably few Americans need to be told—include not only gorgeous flowers and nudes but large, lovingly photographed penises, and unusual sexual practices like "fisting" or urinating into another person's mouth.

Obviously, Mapplethorpe's purpose was to confront—and force viewers to confront—the reality of some unusual sexual practices. These photos from Mapplethorpe's so-called "X" portfolio were a small part of the traveling exhibit, but they were pure gold for those who wanted to whip up indignation over "misuse of taxpayers' dollars."

There had always been a substantial body of opinion, mostly on the right end of the political spectrum, that government had no business funding art. President Ronald Reagan in his first term had tried mightily to get rid of the NEA. Mapplethorpe and Serrano presented an ideal opportunity to advance this agenda.

"The taxpayers' money" was a perfect if misleading slogan for this crusade. The NEA's critics claimed that their complaints about some of the art that was funded, their insistence that tax monies not be spent on projects that were sexually explicit, homoerotic, unpatriotic, or insulting to organized religion, did not amount to censorship. It was only that the government shouldn't *sponsor* such offensive works. Controversial artists could create controversial art on their own time, and "with their own dime."

"Sponsorship, not censorship" became the popular tune whistled on innumerable talk shows, and in countless newspaper columns. As one wag quipped, these may be "cutting edge" artists, but they shouldn't expect the government to buy the scissors.

It's true that if taxpayers don't like something, they can protest, and maybe even get the government's priorities changed. But the stakes are different when it comes to government funding in the sensitive area of free expression. When a city, state, or federal government establishes and supports a public university, it's financing a "marketplace of ideas" (to use a tired but still potent metaphor). It shouldn't expect that only courses, books, and speeches favorable to the government, or inoffensive to organized religion, the majority of Americans, or the majority of Christians, will be permitted.

The same is true when "the taxpayers" fund parks, sidewalks, or other public spaces given over to free speech activities. A city government isn't

thought to sponsor every speaker, no matter how kooky, who makes use of public land. The "taxpayers" who fund these open forums are not buying particular ideas that they like; they are buying one bigger idea—freedom. *All* the taxpayers, through their government, help support a marketplace of ideas even though some of the particular ideas peddled at that market will not be to everyone's liking.

This is a covenant that citizens share. We pool our tax money to support free speech, on the theory that we're a diverse society, likcly to be contentious and disagree. But free speech in public spaces and programs is a lot better than letting the government decide what speech is "inoffensive" enough to be allowed.

Because the government owns so much property and supports so much educational and cultural activity, allowing content restrictions on creative expression that somehow benefits from government largesse would be particularly dangerous. For example, the government funds Fulbright scholarships for study abroad. Is every scholar so honored to produce only work approved by the government censors? The government funds science research grants. Are scientists to clear their conclusions with the government just because their work is supported by "taxpayers' money"? The postal service gives special rates, and the Internal Revenue Service gives tax exemptions, to nonprofit educational and charitable organizations. Are these diverse groups, espousing so many different causes, to receive these subsidies or benefits only if their books, ads, leaflets, and letters comply with government rules against "indecency" or "blasphemy"?

* * *

It was in the midst of the ongoing battle fueled by critics of Mapplethorpe and Serrano that Congress, in two years' time, imposed two unprecedented ideological restrictions on federal arts funding. The first, enacted in 1989, barred the NEA from supporting any art that the agency "may consider obscene," including "depictions of sadomasochism, homoeroticism, the sexual exploitation of children, or individuals engaged in sex acts and which, taken as a whole, do not have serious literary, artistic, political or scientific value." (Senator Helms had tried but failed to include insults to religious beliefs on this list.) In 1990 a federal court invalidated this law, saying that it was unconstitutionally vague, and chilled the exercise of First Amendment rights.

Earlier that year, some newspapers began to publish distorted and sensationalized accounts of the work of four artists that the NEA's Solo Per-

formance Artist peer panel had recommended for grants. Among them were three—Holly Hughes, Tim Miller, and John Fleck—who were homosexual and used themes of gay experience and homophobic bigotry extensively in their work. The fourth artist whose work was sensationalized and taken out of context was Karen Finley. Probably the best known of the four, Finley is a powerful performer who sometimes removes her clothes and often places, dabs, smears, pours, and sprinkles food on her body to symbolize the violation of the female characters whose tales she shrieks and whines on stage. "It's not her sexuality but her emotional intensity that engages her audiences. . . . Her most recurrent themes are incest, rape, violence, alcoholism, suicide, poverty, homelessness, and discrimination. . . . Her work is nearly always shocking and invariably—some would say relentlessly—political."[5]

Shortly after the news stories on Finley, Fleck, Miller, and Hughes were published, then-NEA chair John Frohnmayer overruled the peer panel recommendations and denied the four grants. The artists sued, and shortly after they sued, Congress passed its second restriction on NEA funding. This time, the NEA chair was instructed to make sure that all grants took into account "general standards of decency and respect for the diverse beliefs and values of the American public." The *Finley* v. *NEA* lawsuit was soon amended to challenge the constitutionality of this "decency" requirement.

In June 1992 a federal court in the *Finley* case ruled that this "decency" requirement, like the "may be obscene" requirement before it, was unconstitutionally vague and chilled free expression. That's because, even when the government is doing the funding, it can't wield its formidable power to impose ideological restrictions. As Judge Wallace Tashima wrote:

> The fact that the exercise of professional judgment is inescapable in arts funding does not mean that the government has free rein to impose whatever content restrictions it chooses, just as the fact that academic judgment is inescapable in the university does not free public universities from First Amendment scrutiny. The right of artists to challenge conventional wisdom and values is a cornerstone of artistic and academic freedom.

About a year after Tashima's ruling, the government settled the four artists' claims and reinstated their grants. Judge Tashima's ruling striking down the "decency and respect" law came at a political moment when the NEA was more seriously compromised than ever. In February 1992, Republican presidential candidate Pat Buchanan ran campaign ads that ac-

cused George Bush of funding "pornographic" and "blasphemous" art "too shocking to show." In response, Bush summarily fired the then-chair of the agency, John Frohnmayer. Frohnmayer's departure took effect May 1, and within days his successor, acting chair Anne-Imelda Radice, was testifying before Congress that she would veto grants for any "sexually explicit" art or other projects that dealt with "difficult subject matter" or did not "appeal to the widest audience."

Radice promptly fulfilled her promise to Congress by vetoing grants for two art exhibits that had been recommended by a peer panel and approved by the National Council. The grants would have supported a show entitled "Corporal Politics" at MIT's List Gallery, and another at Virginia Commonwealth University. Both included imagery of human body parts— hardly rare subject matter in the visual arts.

A few days after the 1992 presidential election, Anne-Imelda Radice announced her resignation, opening the way for the new administration to begin repairing some of the damage that had befallen the NEA. This damage resulted from the fearful, censorious approach to arts funding that the agency had adopted in response to political pressures over the preceding three years. What the NEA and other government agencies created to advance free expression need is strong, principled, articulate, committed leadership that can knowledgeably defend even controversial art, and that can explode the right wing's seductive but pernicious "not with my tax money" rhetoric.

Notes

1. This chapter is adapted from a longer chapter of the author's book, *Sex, Sin, and Blasphemy—A Guide to America's Censorship Wars* (New Press, 1993). Copyright Marjorie Heins, all rights reserved. Reprinted with permission.

2. Preamble to the National Endowment for the Arts and Humanities Act, 20 U.S.C. 951(5).

3. The incident is recalled in Livingston Biddle's book, *Our Government and the Arts* (American Council for the Arts, 1988), p. 316.

4. Lucy Lippard, "Andres Serrano: The Spirit and the Letter," *Art in America*, April 1990.

5. Marcelle Clements, "Karen Finley's Rage, Love, Hate, and Hope," *New York Times*, July 22, 1990

4

Cultural Arson

by Jock Reynolds

*Reynolds is a visual artist who directs the Addison Gallery of
American Art at Phillips Academy in Andover, MA. His work
has had many supporters, including the National Endow-
ment for the Arts. From 1983–1989, Reynolds was the ex-
ecutive director of the Washington Project for the Arts in
Washington, D.C.*

Five years have passed since 49,000 people turned out to see Robert Map-
plethorpe's photographic retrospective at the Washington Project for the
Arts. Senator Jesse Helms, Congressman Richard Armey, and more than a
hundred other members of Congress had skillfully encouraged a flustered
Corcoran Gallery of Art into canceling its scheduled presentation of Map-
plethorpe's photographs during the summer of 1989, but the show did go
on at an alternative venue in the nation's capital.[1] Like those who had ear-
lier viewed the Mapplethorpe show in Philadelphia and Chicago, people
who came to the WPA galleries to see the artist's work reacted calmly to
the content of his images. Rather than being alarmed by Mapplethorpe's
photographs, the viewers were enthralled by his floral still-lifes and nudes,
intrigued with his stylish portraits, and often amused by the artist's self-
portrayals. The visitors, many of whom took the time to quietly watch a
BBC documentary on Mapplethorpe's life, registered neither outrage nor
contempt for the proportionally small number of sexually explicit images
that were presented within the entire retrospective. This is not to say that
the visitors did not scrutinize and discuss the provocative pictures con-
tained in the notorious X Portfolios, for they did. But the predominant
public comment heard again and again was, "What's all the fuss about?"
Years later, that question has still not been adequately answered.

Asked to contribute something to this anthology, I find myself pausing
to reconsider the Mapplethorpe uproar, the simultaneous Serrano dust-up,
and the ensuing controversies that have enveloped Wojnarowicz, Finley,
Fleck, Hughes, Miller, and many other American artists and cultural insti-

tutions who received public support for their work through the grants programs administered by the National Endowment for the Arts. My reflection brings forth feelings of both anger and fatigue, for I believe that the relentless attacks launched on our federal arts agency, and our creative cultural community at large, have unfairly taken their toll. It seems important to publicly acknowledge that a concerted political effort continues to scorch the reputation of the NEA and burn away public support for federal funding of the arts in our country. I have come to view the ongoing series of orchestrated political and media brush fires as a form of cultural arson. Trapped in the midst of this blaze is the NEA.

This image is a tragic one. I say this, for the NEA has been a constructive, lean, and productive agency over the last thirty years. Until its recent politicization, it enjoyed strong bipartisan support in Washington and provided our country with an exemplary track record of arts programming, both traditional and experimental in form across all the creative media. The agency has been well-administered, run by a knowledgeable and principled staff, which, in turn, has been thoughtfully served by a legion of constantly rotating peer panelist reviewers—arts professionals from all over the country who donate their time and expertise to recommend grants on the nation's cultural behalf. But recently, seemingly overnight in historical time, the NEA has been branded by its attackers as highly suspect, out of control, and irresponsible in its conduct.[2] It has also become clear during the last five years that those who have attempted to bolster the NEA cannot adequately compete with those opportunists roaming our cultural landscape with a full-time interest in creating political and cultural havoc. It seems that it is now easier to inflame public controversy in America, and easier to destroy a cultural agency built with constant care, than it is to create and sustain something of constructive cultural purpose.

At the beginning of 1994 it seemed that the incendiary attacks on the NEA and America's contemporary artists were finally lessening. Actress Jane Alexander, the first artist ever appointed to lead the federal agency, had begun her tenure in Washington with grace and eloquence. She seemed to be restoring reason to the situation at hand. But then a spurious story was written in Minneapolis by Mary Abbe, a newspaper art reviewer. She mistakenly claimed that a performance artist, Robert Athey, had spilled AIDS-infected blood onto audience members attending a Walker Art Center presentation. Because the Walker had spent $150 of NEA funds to sponsor Athey's work within a city festival of gay and lesbian art, flames of controversy again engulfed the Endowment as the story hit the wire services and made its way straight to the corridors of power in Washington.

Some politicians seized the misinformation as another opportunity to rant in the press and pressure their colleagues to do away with the NEA. The full resources of the Walker's staff and trustees had to be mustered to clarify the true facts of the situation and publicly explain a cabaret performance that only a handful of people had seen. The people at the Walker spent countless hours refuting the erroneous charges that were hurled their way, as did the NEA's staff and Ms. Alexander. Nonetheless, the NEA's entire budget was soon cut by 2 percent. The message from Congress has now been forcefully sent to the NEA and the American cultural community: You will be economically punished if art funded with public tax dollars becomes a subject of controversy. It doesn't seem to matter to some members of Congress that they are ill-equipped to define what "controversial art" really is, nor why controversy within cultural expression should be discouraged for the good of the nation. After all, when some people praise art which others have castigated, how can anyone define which art is worthy or unworthy of public support?

With the heat rising around them again in the summer of 1994, the NEA's leadership staff and its National Council began circling their wagons in a defensive posture, apparently unaware that a prairie fire cannot be avoided by such maneuvering. At the National Council's August meeting, an annual gathering at which many of the agency's program grants are reviewed and approved, the new "working group" of the National Council saw fit to "red flag" and then deny three photography fellowship applications that been recommended for funding by the peer panel serving the NEA's visual arts program. The photographers quashed by this un precedented action—Merry Alpern, Barbara DeGenevieve, and Andres Serrano—were three of some thirty artists chosen from a pool of 1,700 applicants. Their work had been recommended for funding only after surviving rigorous scrutiny by a diligent and knowledgeable panel of photography professionals. The panel's chairman was Andy Grundberg, director of San Francisco's Friends of Photography and former photography critic for the *New York Times*. Nonetheless, the National Council voted down the three artists' fellowships on the basis that they lacked "artistic merit." Never mind that none of the National Council members voting on this decision possessed expertise in the medium of photography. Note, too, that Grundberg was not invited to the National Council meeting to give supportive testimony on his panel's deliberations, as used to be done at the NEA before Congress demanded that the grant-making process be made "more accountable and fair." Sadly, I think, the recent deliberations and actions taken by the NEA were just what the American Congress sought to

avoid when it created the fledgling agency back in 1964. The original congressional debates and enabling legislation that authorized the NEA clearly sought to hold political considerations and individual personal taste at arm's length from public support of art and artists. Now these criteria have dramatically entered the deliberative process at the Endowment and will help determine who and what gets funded from the agency's grant programs.

People who advocate the continued public funding of the arts in America must now face the hard facts: the NEA's leadership staff and National Council don't seem willing to take the heat any more for art and artists that may prove difficult or controversial. Deliberate and informed peer panel recommendations will now be overridden by the National Council when the going gets rough. And so, the cultural self-censorship, which many had feared would raise its head in 1989, has finally arrived in earnest. As is often the case, it has been ushered into place by well-meaning people who will calmly tell you that they are trying to save the Endowment and public funding of the arts in America. I would counter this rationale by saying it's not healthy to create a new federal arts funding field, one that is no longer level and fair. To do so will profoundly affect the ways artists, cultural organizations, and related national, state, and community funders regard and respect the NEA in the future. If the current policies are extrapolated in their present trajectories, it's likely that fewer members of America's creative community—artists, presenters, and funders alike—will continue to look to the NEA as a source of support for the research and development of new work and cultural experimentation—a function the NEA seeded for so long. After an enlightened thirty-year partnership of public and private support of the arts, the NEA is at a crossroads and is becoming timid. And since timidity has never been a force to catalyze creativity or democracy, one wonders what will become of this diminished federal agency and our national nonprofit cultural development and infrastructure.

In considering how all this has come to pass, I have paused to recall that none of the elected officials who attacked the Robert Mapplethorpe retrospective and the NEA in 1989—senators Jesse Helms and Alphonse D'Amato, congressman Richard Armey, Dana Rohrbacher, Philip Crane, and others—ever attended the Mapplethorpe exhibition in person. They never even made the effort to see the artist's original work when it was within easy walking distances of their offices.[3] I ask again now, as I did in the summer of 1989, is it unreasonable to suggest that these "leaders" should have felt some real responsibility to personally witness Map-

plethorpe's artwork before they rushed to their chambers and the media to trumpet, with great moral certainty, that public funds were being squandered on "pornography"?

I don't think that it is unreasonable to suggest that an exhibition of visual art deserves to be seen before it can be seriously discussed and judged. But living as we do, in a mass media environment which constantly decontextualizes and fragments representations of almost all firsthand human experience, perhaps some people actually believe that artwork and exhibitions don't need to be seen in person any longer in order to be understood. Nonetheless, it is important to remember that most visual artworks remain discreet objects. They have material form, meaning, and character that can only be fully appreciated in a one-to-one relationship with their viewer. If we cannot collectively agree on at least this, maybe we should close up all the country's museums and galleries and just send out videotapes, press releases, and Xeroxes describing the artworks in our care. Maybe we should also simply describe the experiences and reactions people might have if they encountered art for themselves.

As I think back to the summer of 1989, the very purpose of a retrospective exhibition bears mentioning again. A retrospective, by definition, is a form of cultural dialogue that cannot be edited at will to suit politicians or curatorially refitted to avoid potential public controversies. A retrospective exhibition will always be an attempt to look back in time and offer a thorough and representative summation of an artist's work. Given that fact, could any professional curator or institution have been expected to organize a comprehensive public survey of Mapplethorpe's work and eliminate a major aspect of his creative work because it might offend some people? Or because U.S. tax dollars were helping support the catalogue for the exhibition? If Mapplethorpe's photographs depicting homosexual, erotic acts, and sadomasochistic practices had been eliminated from his retrospective to satisfy the outraged attackers of the artists and the NEA, would a full and accurate portrait of the artist's work have remained intact to be seen and judged? I think all fair-minded people can agree that the full scope of Robert Mapplethorpe's photographic expression had to be included in this touring retrospective or else Mapplethorpe's own history, and art history at large, would have been falsified. And for what real purpose? I'm certain that every cultural organization that agreed to show Janet Kardon's carefully curated Mapplethorpe show understood and knew what they would be exhibiting as they contracted themselves as hosting venues for the University of Pennsylvania's touring retrospective. Surely the Cor-

coran Gallery of Art's curators, normally precise and conscientious in their work, knew this—even as the Corcoran's director and trustees back-pedaled in intimidated disgrace in the summer of 1989.

But let's move on to the crux of the issue, the calculated politicization of publicly-funded arts for agendas which have little or nothing to do with art. It strikes me that there is a great irony afoot in the recent attacks on artists and the NEA. We've seen a wave of political actions taken, all wrapped in the guise of sound moral principles and values, when what has really been provoked in the last five years is a fabricated wave of intoler-ance and prejudice. I say this with some confidence, for I have personally taken the time to see a great deal of the supposed controversial art sup-ported by the NEA, and have yet to feel that anything I have viewed was unworthy of the public support it received. I readily admit that some of this art has been outrageous, some of it fraught with great pain, anger, and sor-row, while still other works flaunt individual life-styles and values that dif-fer greatly from mine. Nonetheless, I can still recognize the worth of voices, ideas, images, performances, and craft that offer me something dif-ferent from my work and ideas as an artist. And thank God for this. How dull and alarming it would be if all the NEA grants were to start encour-aging a more narrow and prescribed form of American cultural expression, one where everyone's work started to look more alike, homogenized in some way to avoid any necessary offense to whomever. And although I certainly don't foresee our country sliding toward some totalitarian dark-ness, haven't we already seen how ill-advised the Soviet Union's efforts were in this century when its government greatly restricted funding and work opportunities for living artists? What were the real individual and/or societal rewards of funding artists only when they "created" within an "of-ficial style," an ultimately very dreary form of social realism?

Amidst my current distress at what I see happening to the NEA, I re-main confident that as time goes on, reasonable people will gain the dis-passionate distance to reconsider the political and media tactics some elected officials and the far Christian right have employed to discredit our national arts agency. Maybe because the agenda of these people has ulti-mately so little to do with art (remember that most of these indignant pro-testors don't ever bother to see the art or exhibitions they claim offends them), they'll soon find more desirable targets for their political mischief, direct-mail fundraising, and fifteen minutes of media fame. But maybe they won't. So it might be more important to keep examining the attempts afoot to define and control "American values," a trick which is being per-formed right before our eyes? After all what's the real agenda behind the

flashing silk scarves figuratively employed by these partisan politician magicians? And how do they play their trick with such deft sleight of hand? Hasn't its success really turned not on art but on directing our eyes to a range of malignable minorities in our country: not just artists in general, but gay and lesbian artists, artists with AIDS, artists of color, artists addressing tough social issues in their work? The list goes on and on. But now watch as the swirling scarves make a big issue and flourish over these people's life-styles and sexual habits, casting them together as stereotyped minorities, sustainable as creators only when they're dipping into the NEA's federal trough to support their "perverted" cultural expressions. To follow the trick further, you'll need to forget that these people—artists and others—pay taxes, too, and are as individual and diverse in their expressions, values, and actions as any of the rest of the American citizenry. Keep watching now as the scarves flick again to make great cover for intolerance with a flourish—some new instance discrediting an art project sponsored by tax dollars. Wow! It's amazing! Magically, real bedrock "American values" now belong to the far Christian right and their political supporters and not you and me. They are defining what we should fund and how we should see without even seeing themselves. It really is a fantastic trick being played out before our eyes.

I'm betting that I'm not alone in feeling offended by the "value grab" being performed in our cultural arena. I happen to be a person who is neither radical in my politics nor personal behavior. I was raised to embrace strong Christian tenets, ethical behavior, and family values and yet my values aren't in synch with the sound bites of Senator Helms and his ilk, nor the unctuous televised sermons uttered by Pat Robertson, Jerry Falwell, and others. I have no desire to silence these men or de-fund their voices, even if I find them very distasteful. I do not think there is anything wrong with a healthy controversy or an ongoing competition for values in our society. But that is neither the method nor the intent of the far Christian right and its political representatives. Hearing them and watching them as closely as I do, I think these folks really believe that they own the deeds to virtue, family, religion, culture, and proper personal conduct. They lay claim to all of our fundamental American institutions and values with complete self-righteousness, and then trade our shared societal principles as so much cheap political capital to achieve their own dubious climate of intolerance. And for what ends?

Not too many years ago, in Washington, D.C., a lawyer uttered a memorable phrase during a tense congressional hearing: "Senator, have you no sense of decency?"[4] The emphatic question was perfectly timed and

helped end an ugly and demagogic chapter in American history. Maybe it's time to dust off the phrase again. The problem with decency in America is not with the Arts right now.

The author would like to thank Ms. Marion Stroud for the Mt. Desert Island artist's residency which supported time for reading, reflection, and writing on this subject.

Notes

1. On June 8, 1989, Congressman Richard Armey (R-Tex.) was joined by more than one hundred members of Congress in sending a letter to the NEA criticizing the Endowment's support of an exhibition entitled "Robert Mapplethorpe: The Perfect Moment." For further details, quotes, correspondence, events, press articles, and editorials surrounding the Mapplethorpe/NEA controversy, please consult *Culture Wars: Documents from the Recent Controversies in the Arts.* Edited by Richard Bolton, published by The New Press, New York, NY, 1992.

2. Beginning in 1985, Richard Armey (R-Tex.), Tom Delay (R-Tex.), and a few other members of Congress vigorously attacked the NEA during its normal five year reauthorization hearings. They went after the Endowment through its Literature Program, saying public funds had been misspent supporting poets who employed "pornographic and homosexual" language in their writings. Then-NEA Chairman Frank Hodsoll mounted a strong defense of free speech and the NEA at the time, but his resolve to conscientiously approve and support NEA peer panel grant recommendations thereafter began to weaken. Soon after the NEA survived its reauthorization hearings, battered but intact, an NEA Inter-Arts Program Public Art grant pending to the Washington Project for the Arts, for a project supporting Jenny Holzer's "Sign on a Truck" (a truck-borne video work which dealt with an individual citizen's right to freedom of speech before the three branches of our federal government), was quietly quashed within the Endowment. The grant to WPA, which was recommended for funding by an Inter-Arts Program peer review panel, was tabled by Chairman Hodsoll. He personally reviewed the project with the NEA's National Council and then rejected it for funding due to a "lack of artistic merit." The ridiculous artistic knock of Holzer's work (who was a year later to represent the United States as the sole American exhibited in the Venice Biennial) was laughable within artists' circles, but continued further when then-acting NEA Chairman Hugh Southern and the NEA's National Council (the presidentially appointed board that advises the Endowment's chairman and votes its approval of all grants) laid back on the ropes in 1989, refusing to take any strong collective action to defend the NEA's funding of Robert Mapplethorpe's photographic retrospective exhibition or Andres Serrano's photographic award and show sponsored by

the Southeast Center for Contemporary Art, with grant support from the NEA's Visual Arts Program. And from that point on, as John Frohnmayer assumed the NEA's chairmanship, replacing a dispirited Southern as the agency's leader, the situation deteriorated further in rapid succession to the political morass we ponder today.

3. During the time the WPA exhibited "Robert Mapplethorpe: The Perfect Moment" in Washington, D.C., the organization was visited by only a few members of Congress. Congressman Pat Williams (D Mont.), who chaired the congressional committee with oversight responsibilities for the NEA, took a thorough look through the exhibition, asked many questions, and emerged satisfied that public funds had not been misspent. Williams's opponent in the next election dubbed him "Porno Pat" for the reasonable and courageous stand he consistently took in defending the NEA. A few other congressmen attended the show at the WPA in support of a benefit evening hosted for the American Foundation for AIDS Relief. Noticeable that evening were congressmen Barney Frank (D-Mass.), Jerry Studds (D-Mass.), and John Lewis (D-Georgia). The WPA's staff, which carefully monitored the press crews and visitors attending Mapplethorpe's exhibition, never once observed any of the "outraged" members of Congress in the galleries. None of them showed up to view the show they were so vigorously protesting.

4. During the 1954 Senate U.S. Army hearings investigating possible communist infiltration of the Armed Forces, Army Special Counsel Joseph Welch finally helped bring Senator Joseph McCarthy's rampaging demagoguery to a halt before a nationally televised audience. Welch's calm and reasoned response to McCarthy's continual bullying of government witnesses signaled a healthy turn of public opinion, which in turn helped end a particularly "intolerant" spasm of American history.

5

Confessions of a Literary Arts Administrator

by Liam Rector

Rector is presently the director of the Bennington Writing Seminars at Bennington College and has worked administering literary programs at Associated Writing Programs, the National Endowment for the Arts, the Folger Shakespeare Library, and the Academy of American Poets.

It is 1983 and I am sitting in Washington in a cubicle of the Literature Program of the National Endowment for the Arts. I am a "program specialist" in charge of administering grants to American poets. Federal lore has it that these cubicles were designed by a man who later renounced the social effects of his invention, a design which was meant to create maximum public space and minimum individual privacy for those who inhabited and moved through these cubicles. Lore has it further that the man went on to commit suicide. Are these received factoids, these rumors, true? As federal workers come to say, it doesn't matter; rumors beget perceptions and appearances, both of which pass daily and easily for reality in Washington. We who work here live in a public world, a veritable aquarium of appearances which float and travel as reality. As it happens, given the rules of the game, the veil of Maya is most often reality; you have to go with the odds. There aren't many of Alfred Jarry's pataphysicians in Washington, those who practice the science of exceptions, but the science of exceptions is what the NEA fellowships to poets are all about.

I am going through the pile of 1,200 manuscripts of poetry we the people receive as applications for U.S. fellowships to poets each year, fellowships of $20,000 which go out annually to some fifty poets. Processing these applications is physically and logistically an action remarkably akin to cleaning fish. I try to remember there may be a section of "Four Quartets" somewhere in the pile; there may be a "Howl" in there somewhere. I try and treat each application as if there were an aesthetic, perhaps a style,

at most an achieved art and soul alive in each sheaf of poems. Here in the
Literature Program is where literature, if ever, gets turned into mere paper.
But we who work here do so to honor literature and writers, all of which
represents nothing if not the individual and the individual calling, the indi-
viduated enterprise seeking communion.

It is 1985. Today is when Dick Armey, a Republican congressperson
from Texas, is rumored to be sending in some of his staffers to go through
the application manuscripts for potential fellowships to poets. These ap-
plications, he has heard, are rumored to contain obscenities. The clean-cut,
fresh-faced twenty-something staffers arrive and the director of the Liter-
ature Program, Frank Conroy, takes them aside for a moment: What are
they looking for? What are their constructions? What is "the criteria"? And
he is told they have come with instructions to ferret out "Dirty words. Sex
words, and like that."

I am outraged; the entire staff is outraged. But there is nothing, for the
moment, we can do about it. It is the prerogative of any U.S. congressper-
son to go through such files if they want, any time they want. And it is even
the prerogative of any U.S. citizen, through the Freedom of Information
Act, to likewise have access to these files. The staff agrees with all of this
in principle, and we labor long to do most of what we do "in the sunshine,"
in keeping with the fact that we are spending public money and must do so
visibly, judiciously, responsibly, and accountably to the taxpayer. Very lit-
tle except panel meetings—to allow for the greatest candor and therein the
greatest education of each other among those assembled—is conducted
behind closed doors, "in camera," at the Endowment, and even at the panel
meetings there is always a discussion at the end which is open to the
public.

But in practice we know today that we and our work, these poems and
their poets, are being subjected to a political agenda which is meant to dis-
credit the Endowment for funding "smut"; we know this trolling for sex
and cuss words is meant to undo what we do. By the end of the decade, un-
known to us today, there will be beat reporters from at least five major met-
ropolitan newspapers covering this issue. It will have been on the cover of
Time and *Newsweek. McNeil/Lehrer* will have chewed on it a time or two,
and it will be reported narratively on the network nightly news. People will
be calling it "the cultural wars."

In 1985 I consider, somehow, reporting this intrusion of the Armeys of
the night. I consider "whistleblowing," but the question is where to whis-
tle. The federal bureaucracy has already given its permission, if not its
blessing, to the inquisition of Armey. Who is there to complain to? At this

point I don't know much about the First Amendment and the protection it affords to speech and expression (I don't know much beyond the usual rumors), I don't know anything about how to go to the press (such as picking up the phone), and I have recently found my own ticket out of the bureaucracy by having received a fellowship in poetry from the Guggenheim Foundation, a private foundation not quite subject to the searches and seizures found in public philanthropy. So I am soon to head for the hills, flee on my donkey, and I keep my own counsel. I am going home and will soon have the time to do nothing but write poems. The fish I will be cleaning will be my own fish, and let each writer fish for him or herself.

1986 is mostly spent at home except for a brief foray to Europe, where I learn that censorship issues among writers in England, especially at the B.B.C., have begun to crop up with renewed rapacity under the Thatcher government. In the U.S., talking to fellow writers about the staffers and their obscenity troll at the Endowment, everyone seems to think it was but a blip on the screen: they were fundamentalist cuckoos out on a momentary rampage; they were bluenoses up to their usual vote-getting, fire, brimstone, and fundraising; they are Philistine distractions.

Five years later, after a stint as a director of a service organization for writers, I will be at Harvard, taking myself to school on the First Amendment, learning all I can learn also about advocacy, cultural policy, and the press, poring over books such as *Liberty Denied: The Rise of Censorship in America, Minnesota Rag: The Dramatic Story of the Landmark Supreme Court Case That Gave New Meaning to Freedom of the Press, 50 Ways to Stop Censorship and Important Facts to Know About the Censors*, and other such books. I will be turning the pages of case studies that follow in the wake of position pieces written by Kathleen Sullivan, a professor at Harvard Law. I will be studying "press politics" at the Kennedy School of Government with Marvin Kalb, a former cold warrior I grew up listening to and staring at on television, a kind of Uncle Marvin, a man who now has his own past to ponder as the Cold War likewise came to a head at the end of the '80s, as the long shadow of Vietnam continued to haunt us all still. Oliver Stone's film, *JFK*, will be released, and we will again ponder access to government information.

I will be studying (the dearth of) women as political leaders and how alleged sexual harasser and Supreme Court Justice Clarence Thomas floated to the top; I will be studying the nimble arts of negotiation game-theory (getting to yes; letting them have your way). With First Amendment scholar Frederick Schauer, I will be discussing how the scope of our freedoms of speech, alone in the world in their breadth, may be intruding into

the establishing of arguably necessary social policy (laws) regarding pornography, racism, and such. I will be pondering the alliance of feminist groups with far-right Christian fundamentalist groups over the issue of pornography in Minnesota, and how poets such as Adrienne Rich, Audre Lorde, and other artists rose up against this and the restrictions it might impose upon artistic freedom and depictions of eros. I will be attending a guest lecture at Harvard Law in which former Attorney General Ed Meese, who instituted a report on pornography which still has repercussions on policy, procedure, and enforcement within the Justice Department (with a recent defense of entrapment to be heard by the Supreme Court), calls from the podium for the abolition of the National Endowment for the Arts.

Many notions now float about concerning why Senator Helms, the American Family Association, "The 700 Club," and so many others are so interested in the NEA, and one posits that it was with the collapse of the Cold War that some of our politicians moved to define and evoke a new shadow, a new bugaboo, a new enemy. Our enemies clarify us, they give us energy, they are useful in the rationalization rites of making excuses and assigning blame. Personal responsibility and any notions of leadership have all but imploded on the left, and after capturing the financial and political life of the nation, the Republicans are now launching upon a domestic agenda to dominate the last three preserves of progressive politics: the arts, the universities, and the media.

In order to make ends meet and put a dent in the $30,000 I have by then borrowed in order to come to Harvard, I'm now teaching a graduate course, "Special Topics: Censorship," at Emerson College in Boston. In the course, subtitled "The Cultural Wars," we are studying public funding of the arts and content restrictions on that funding. We are studying "hate speech" strictures at universities throughout America, "political correctness" (the Stalinist "sensitivity police" of the left and their multicultural-hating counterparts on the right), film ratings, record labelings, definitions of "indecency" at the Federal Communications Commission (where broadcast of Ginsberg's "Howl" on the radio is again receiving its share of shit), attacks on the Corporation for Public Broadcasting, books being pulled from the shelves of public schools and libraries, and we are studying the Supreme Court decision on nude dancing in Indiana and the "gag rule" on federally-funded abortion clinics. We are looking at specific pieces of literature and pondering the legal definitions of obscenity, libel, and blasphemy. We are trying to figure out who the players are. We are looking into far-right fundamentalist Christian organizations, their agenda for America (particularly their appropriation of the phrase "family val-

ues"), and we are hearing from speakers on all these issues—the Boston Coalition for Freedom of Expression, Morality in Media, and such—as we use a text I put together from two years of documents and press clippings from the trenches of this debate. No full book on all this, particularly as it hits the arts, has yet been published.

My discussion of these matters is now far from academic. I am no longer solely writing poems and essays on literature, and the essays I do write now take on a decidedly more political dimension and sense of intervention. Things have heated up, and by now I have spent most of the last years of my professional life immersed in the cultural wars (the cultural ward?) day and night. In the past I have by turns taught in universities as a practitioner of writing. Now I am teaching as a different kind of practitioner.

In 1989, as director of Associated Writing Programs, I moved to co-found—along with PEN, Poets & Writers, the Council of Literary Magazines and Presses, and other such organizations—the Coalition of Writers' Organizations. Directors of literary centers such as the Loft flew into Washington from Minneapolis; organizations the likes of the Academy of American Poets and Before Columbus showed up. Directors from literary presses such as Copper Canyon and Calyx flew in from Port Townsend and Eugene. We were joined by other organizations, presses, and magazines and soon formed an *ad hoc* coalition more than 70-strong. Such a coalition had never, to my knowledge, existed before in America. Gara LaMarche, then-chair of the Freedom to Write Committee at PEN and now director of the Fund for Free Expression; Richard Bray, director of PEN West; Helen Stephenson of the Authors Guild—all of these people and their organizations threw themselves into the fray with an especial intelligence and nerve. Larry McMurtry, Garrison Keillor, Donald Hall, Arthur Miller, and hundreds of other writers contributed through various forms of writing—op-ed pieces, letters to the editor, speeches, testimony, and other forms which many of us never knew we had in us. We brought writers to the negotiating table, and found at that table much kinship from other art forms and organizations which had publicly been at that table for some time. Compared to dance, music, theater, film, and such, writers had been ill-organized and not much at the table before. Although the Literature Program at the Endowment receives only roughly 3 percent of the funding for the arts at the NEA, it had long taken about 30 percent of the heat regarding so-called obscenities. Whatever the increasing illiteracy of our culture, writers bring with them the authority of the word—the commitment, on-the-record, and even contractual verity of the printed word—and in Wash-

ington, a city of lawyers and legislation made of words, that counts for something. People For the American Way, Norman Lear's group, and the American Civil Liberties Union were also heroic in rising to the defense of artists and of freedom of expression. Actors and actresses were crawling all over Capitol Hill: Paul Newman, Hume Cronyn, Jessica Tandy, Morgan Freeman, Kathleen Turner, Susan Sarandon, Ron Silver, much of the cast of *L.A. Law*, and many others. Shakespeare weighed in heavily, including the Folger Shakespeare Library in Washington and summer Shakespeare festivals throughout the United States, and Joseph Papp was to spend much of the last years of his life directly confronting the issue with characteristic elan.

Many during that year abandoned the schoolboy and schoolgirl naivete and entitled petulance that had made many in the arts seem like spoiled brats and sour grapers, and many kneejerk righteous indignators turned into practicing and practiced warriors of a different ilk.

I was never a cold warrior. On one of the other sides of that divide, I practiced disaffiliation, organized draft resistance to the Vietnam War, and a disavowing of what I took to be The Red Scare. But by now I have consciously come to think of myself as a cultural warrior. I think sometimes that I have become the equivalent of an ambulance chaser in terms of censorship, but I see First Amendment issues wafting through many of the headlines and leads of the day. I feel I can close my eyes and braille the culture for what a crisis our freedoms of speech are experiencing just now. In teaching the class at Emerson (one sponsored through the writing program there, with young writers and editors as students), we broke through the long shadow of the New Criticism and we studied things far "outside the text." We studied history, biography, the daily newspaper; we studied the culture. In class I strove to be fair; I strove to give voice to all sides (since there are more sides to this than merely "both sides" would bespeak), but all the students knew that I had by then become a near-absolutist about the First Amendment. And we tried to keep our sense of humor. There is political correctness about this on almost all sides, and it is presumptuous, humorless, and boring. The First Amendment itself is not an ideology nor should it attempt to function as one; it is rather a venue for ideologies and for other currents.

And by now I had many war stories to tell the students, having met with people in Congress, attended an "arts summit" sponsored by a member of Congress (Pat Williams from Montana), having testified in Congress. With the press I had been on deep background, on background, and had been an unnamed and quoted source in the *Washington Post*, the *New York Times*,

the *Boston Globe*, *USA Today*, the Associated Press, and other such out-
lets. Even in my former local paper in Norfolk, Virginia, there had been the
great fun of debating Ralph Reed, director of the Christian Coalition, a Pat
Robertson offshoot that was fond of incessantly invoking Mapplethorpe's
photograph of "one man urinating into another man's mouth." I had writ-
ten about the cultural wars in newsletters and in pointy-headed quarterly
rags which go out to lawyers, public policymakers, and arts administra-
tors. I had by then also made the acquaintance of many journalists, those
"hanging on the skirts of literature," as Kalb was fond of quoting, and I had
lost the snobbery toward journalists bred by years as an "English major."
(We English Majors supposedly were studying and making Literature,
"the news," as Ezra Pound said, "that stays news.") Journalists, by and
large, love the First Amendment, are very canny about it, are very eager to
make common cause with other writers, and I came to love them for that.

Most notably I made the acquaintance of a generational cohort who had
himself received an M.F.A. in poetry from Columbia, as I had done grad-
uate work years earlier at Johns Hopkins. Stephen Salisbury of the
Philadelphia Inquirer is the son of Harrison Salisbury, one of the most im-
portant reporters for the *New York Times* on Vietnam. The father covered
one war and the son was now covering another. Stephen and I were both
wearing suits to Senate hearings now. Neither of us could believe what was
happening to freedom of speech in our country, and both of us wrapped
ourselves in the protective gauze of cynicism as we attempted to come to
terms with it. In addition to Salisbury, other reporters gave literate and im-
passioned coverage to the issues: Allan Parachini of the *Los Angeles
Times*, Kim Masters of the *Washington Post*, and Patti Hartigan of the
Boston Globe. The good, gray *New York Times*, usually exemplary in cov-
ering censorship issues pertinent to literature, acted as an uninspired if
utility player on the echoing green.

Susan Wyatt, then-director of Artists Space in New York—the gallery
which had its funding rescinded by the NEA and then given back—func-
tioned also as a kind of Joan of Art, negotiating the terrain between vari-
ous art forms, including literature, and the worlds of press relations, the
NEA, the prospects for support for unfettered funding among members of
Congress, and the artists and administrators working in her own James
Wright, blazing, cowchip-strewn field.

In the so-called compromise which was eventually reached—the stric-
ture about "general standards of decency" for NEA-supported art—no one
I know of in the arts community came away happy. The work of freedom,
the work of not only having but enforcing the U.S. Constitution, remains

to be done. The fact that poets such as Donald Hall now sit on the National Council on the Arts, the oversight body for the NEA, is a step, in my view, in the right direction.

In Neil Sheehan's brilliant book about Vietnam, *A Bright Shining Lie*, it's made abundantly clear how the press acts as a watchdog for an inherently vulnerable yet problematically insular federal bureaucracy. The Pentagon Papers were a milestone in the First Amendment crossfire between freedom of the press and national security interests, between the government's need for secrecy and the public's need and legal right to know. Vietnam and Watergate changed America and changed press relations forever, and in our government and the democracy it supposedly looks to enact there is a vast interrelationship with the press which is animated by whistleblowing, leaking, and other formal and informal forms of gossip that constitute a form of oversight which is now integrally part of our system of checks and balances. "Govern or be governed," said Jefferson, and the press is now that estate which translates between the governors and the governed. The ideal is that we, through our representatives, govern ourselves; the reality is that incumbents rule the roost and the press negotiates the tension, acts as a conduit for the gossip between the governors and the governed.

Many in the arts community felt it was best to keep news of the NEA, the cultural wars, and the like out of the press. Where the NEA was concerned many arts advocates, particularly inside Washington, felt the matter could be best dealt with by keeping it out of the headlines and keeping it in the back rooms where it could be settled by the usual suspects, largely patrician allies who found, in 1989, that some 40,000 letters had descended upon Congress protesting NEA-funded "smut." AIDS in particular and sex in general are making many in neo- or paleo-Puritan America a bit crazy these days, and the majority of politicians feel they can't get publicly near any of it. They do not, as they say, want to "walk the plank" or "fall on their swords."

My sense of it now is that the genie is out of the bottle; the time for relatively unfettered public funding for the arts, occurring outside a larger debate about values, has passed. I think that the time for settling these issues, no matter how conservative the climate—for, in effect, establishing a national arts policy in line with the Constitution—is now, and has come as an event which will have to be settled in public and in some important sense by the public. The NEA is, if you will, but a metaphor for the entire vortex. Those in the arts whose only interest is to belly up to the trough of public funding with no concern for the First Amendment or freedom of ex-

pression will continue to be seen, by right and left alike, as the network shills they in fact are.

Another sense I have is that freedom is one of the few things the right and the left can agree upon, and there is something in the fabric of the American Character to be trusted here. Where there are gray areas that no legal definitions or legislated public policies can reach—and First Amendment cases, particularly those involving obscenity and blasphemy, are full of concrete examples—I think there is a broad consensus that if we are to err we must err on the side of freedom as we take things, take ourselves, case by case. The subtext of much of this debate is twofold: homosexuality and how it is to be regarded, and how to cope with the explosion in electronic imagery—through cable, computer, videocassette, and other venues—coming right at us, public in our homes. Censorship thrives in private; once light is shown on it, it most often goes away; and if it does not, even more reason for the light.

My heroes now are as much former Supreme Court Justice Oliver Wendell Holmes and his sort as they are T. S. Eliot and the modernist mottle. As Holmes in his later life never tired of pointing out, freedom of speech exists specifically for the speech we hate. The sweetness and light in ourselves tend to take care of themselves, and contracts—such as the social contract represented in our Bill of Rights—are made for the settling of disputes. There is no more important linchpin in the circulatory system of our democracy, or for our hope to govern ourselves, than the First Amendment. We now have a Supreme Court which has moved and will in all likelihood continue to move against freedom of speech and if writers and the arts community are not prepared to sustain an ongoing effort on behalf of the First Amendment, we will get what we deserve.

Whatever its sensationalism and yellow yelp, the press strikes me also as one of our only hopes here. Where freedom of speech is concerned the press is, on the main, an ally of artists everywhere. We have but to ply our trade in letters to the editor and op-ed pieces, and reporting an incident of censorship often involves nothing more difficult than picking up the phone and calling an assignment editor.

The American Library Association, PEN, People For the American Way, the American Civil Liberties Union, the Fund for Free Expression, and nearly every other organization that keeps track of such things point to an alarming rise of censorship in America. Knee-deep in recession (if not The Coming Crash), we can expect that censorship and matters of related hatred and suppression will get worse before they get better. ("Hussein still has his job; do you still have yours?" was one of the on-the-money and

mordant bumper stickers gracing many cars in New Hampshire during the 1992 primary.) I've come to think that hate is the flip side of love in most of this; at least hate is moving and capable of catharsis, redemption: Lord save us from our indifference. . . .

On February 21, 1992, John Frohnmayer called a meeting of his program directors at the NEA. Frohnmayer announced that he was resigning from the NEA, retiring from public life; he sang the Shaker song, "'Tis a Gift to Be Simple," and he recited a poem by William Stafford. Only three weeks before, two grants had been killed at a review of grants before the National Council on the Arts, the presidentially-appointed group that oversees the NEA and now has the authority to veto prospective grants. In the 17 to 1 vote in favor of killing the grant to one organization from New York, Franklin Furnace, poet Donald Hall provided the lone dissenting voice and vote. Supposedly lack of artistic merit was the rationale for denying the grant which had been recommended for funding by peer citizen review panels from the field, but reports about what went on around the table and in the corridors, according to an informed source, proved otherwise. The talk was of fear and the wrath of Congress if the NEA was seen to be funding sexually explicit work. Many are buying into the brinkmanship ante that the game is to play ball or lose the Endowment altogether. The name of that game is fear; the strategy for feeding that fear is appeasement, and appeasement of that stripe is only viewed as weakness by those who oppose the Endowment. Few are willing to split the hair between paranoia and reasonable fear, and appeasement remains the mode of the day.

I for one think excellence and merit are not necessarily code words for racism, "elitism," and other shibboleths by which the left attempts to demonize or dismiss the right and its constant whacking away at what the right perceives to be "the lowering of standards" inherent in "multiculturalism." I think the arts community is generally united, cross-culturally, in wanting to see artists and projects awarded according to their excellence and artistic merit—given the fact that many aesthetics and cultures are brought into play in making those judgments—augmented by the development of audiences for the arts and educational efforts which provide access to excellence, at least in theory, for everyone. But excellence and merit are not, I fear, calling the shots at the NEA of 1992. Instead, the Rev. Wildmons and Pat Robertsons of the world have—in classic textbook "chilling effect" style—now been internalized by the agency itself. Whether the agency will ever regain the trust of artists and voters, or

whether it will become the "politically correct" tool of a sex-panicked agenda, or whether it will go down in flames—all that remains to be seen.

Whatever the case on that front, Pat Buchanan's near 40 percent showing in the New Hampshire primary and his promise to go on to Super Tuesday in the south with the same tirades against the NEA that he had delivered from literal pulpits in New Hampshire—all this provided the background for Frohnmayer's "resignation under pressure." Buchanan calls the NEA "the upholstered playpen of the arts and crafts auxiliary of the Eastern liberal establishment," and this former speechwriter for Spiro Agnew, the barking bard responsible for Agnew's "nattering nabobs of negativity," raised a large voice in the Republican choir in the 1992 election. I think those who love the arts vastly underestimate Mr. Buchanan's appeal and ability. To dismiss his constituency as a "protest vote" is too much akin to Nixon's mistaken dismissal of anti-Vietnam War sentiment as a mere "protest movement" far from the values of the then supposedly "silent" and soon thereafter "moral" majority. Many American intellectuals on the left in the '80s tried to build their sequestered utopia in academia with committee battle cries such as "Hiring Is Curricula," and in sequestering themselves thus they may have, as Berkeley professor Todd Gitlin recently opined, in effect demobilized themselves, taken themselves out of the larger sphere of action.

Thinking of harnessing all of our anger and violent disappointment into a third party might be more to the point, for those disillusioned on the left as well as those on the right. "The new left" began with the free speech movement in Berkeley, and common cause might now be made with those who still uphold freedom of speech as a central and circulatory value with our culture, our cultures.

As Donald Hall said before the Council in that meeting, "On my memory of judging over the many years contemporary art, especially art that is by young people, or new, I think evenness is the last thing I want to see. . . . I think that some terrible failures, as long as they are accompanied by exciting successes, are more promising for the future." So any decision we make even about artistic excellence must be modulated within time, within context, within the knowledge and even the faith we bring to our judgments about artistic history, achievement, processes, and possibilities. The 17 to 1 decision wherein Hall was the lone voice would have gone in exactly the opposite direction only eight years ago, I think. That much erosion has taken place.

And are we then to put all this on presidentially-appointed John Frohn-

mayer's shoulders? In my view he was a relatively good and decent man, a moderate Republican who did have a sense of what was at stake and at times, if fitfully, tried to hold the line against content restrictions of publicly-funded art. In Washington, perhaps as in no other place in the nation, one has to have not only goodness and decency but also the ability to make one's goodness and decency stick, and this administrative acumen Frohnmayer, thrust into an admittedly almost impossible situation, sadly lacked. As Allan Parachini, former *L.A. Times* reporter and currently director of research for the ACLU of Southern California, said about Frohnmayer's departure, "He sent conflicting and mixed messages. There is no middle ground when it comes to artistic freedom of expression. John Frohnmayer tried to compromise, but you can't compromise on that issue." In trying to find and walk a middle ground, trying to please everyone, Frohnmayer pleased no one. He has gone back to what in Washington is called "private life," and all the current signs at the NEA point to the fact that, as Helms said a few years ago, we ain't seen nothing yet.

How will the art community respond to this? Will artists internalize the hysterical cop? Will they omit pieces which include explicit sex in their applications to the NEA and then look over their shoulders when they print sexually explicit work of merit which they know will bring down upon them NEA and/or congressional wrath? What are the prospects of federally-funded art? Have they succumbed to the contradictions and blandishments the detractors and skeptics attempted to foretell when the Endowment was formed in the sixties? In a time of so many pigs and so few troughs, how will funding for the arts fare amidst other priorities within the post-Gilded Age deficits of the nineties? What effect will money being siphoned off to state arts councils have, in the midst of an ongoing and rapacious decentralization and privatization in which the federal government, having lost much of its legitimacy and authority in almost all quarters, is seen to have no basic role to play? How will the debate continue to be framed, and who will frame it? In my view, the argument about whether we should or should not publicly fund the arts is an honorable one, akin to the fact that honorable people can, say, disagree about abortion. But to fund the arts and then subject them to content restrictions, from whatever point of view, has no honor at all.

What I've learned from this war—with its Bible Belt and its Harvard, its "Piss Christ" and its Holy Rollers, its poets and journalists, its hysteria and its law, its coalitions and betrayals, is that things are—especially in the dark night I take our present Puritan moment to be—best aired in the sunshine and fought across the board where the wide spectrum of our free-

doms and our democracies collide, which I think will stay firmly in the headlines for the decade to come.

Artists and the public now face the necessity, I submit, of joining with other writers internationally in an effort to actively, aggressively, and incessantly fight to preserve our freedoms of speech and expression. Salmun Rushdie remains in hiding. Who will speak for him, if not us? Issues of freedom of expression and censorship have and may always be with us (wars and rumors of wars), but the battle tends to be a zero-sum game, with the triumphs of one side turning into the defeats of another. Where writers and their literature are known as truth tellers, as was recently the case with Havel's presidency, we might even act to fill the vacuum of leadership and authority which we cynically live with and within today? I do not myself "buy" the contention that artists are inherently solitary creatures, somehow above, below, or to the side of issues of community, communion—connections with the people, places, and things which compose our social and economic—our political—lives. In any case, we have some housekeeping to do, through and alongside our lives as artists. And our house—cocoon as we might, protect our privacy as we must—also exists among other houses, within the communion between art and audience, which the arts as a whole enact as does nothing else in telling the tribe that we do not live apart nor live by bread alone.

6

Setting the Record Straight: Diary of a Controversy

by Susan Wyatt

Wyatt is an independent arts consultant and arts advocate who is a member of the Arts Action Coalition. During 1990–91 she visited some 100 congressional offices in support of the arts and the NEA. She testified at a congressional hearing on the impact of the 1990 NEA Re-authorization. Wyatt is the former executive director of Artists Space, an artists organization which provides exhibition opportunities, financial assistance, and professional services to emerging artists. In November of 1989 she led Artists Space through a crisis involving the withdrawal of an NEA grant. Two weeks after the grant was withdrawn, it was restored by the NEA after a public outcry which included Leonard Bernstein's refusal of the National Medal of Arts.

In 1989, Artists Space applied to the National Endowment for the Arts for a $10,000 grant under the Museum Program's Special Exhibitions category. We were seeking funding for a show dealing with the topic of AIDS which we had scheduled for a November opening. We often use artist-curators at Artists Space and we hadn't had a photography exhibition for a while, so we asked Nan Goldin—a well-known photographer—if she would be interested in organizing a show. She immediately suggested the topic of AIDS and we agreed.

At that time, I had just become a member of a group called Visual Aids which was planning the first "Day Without Art," which was intended to memorialize those who had died of AIDS and the art they might have created had they lived. For that reason, we scheduled the show so it would coincide with "Day Without Art." In the fall of 1989, Nan chose the title "Witnesses: Against Our Vanishing" for the show.

In preparing for the show, the summer of 1989 happened. Because the

Serrano and Mapplethorpe exhibitions were so controversial and their works were photographic and—at least in Mapplethorpe's case—dealt with sexuality, it certainly crossed my mind that "Witnesses: Against Our Vanishing" had the potential to be controversial.

We received NEA funding for the show sometime that summer. In October, we were working on putting the show and the catalogue text together. Nan had asked several people to write essays, including photographer David Wojnarowicz, whose work was in the show. David's text was a first-person narrative about what it feels like to have AIDS. It was a very powerful, very moving piece. But it used words like "shit" and "fuck" and had specific characterizations of several public figures. The narrator fantasized about throwing Congressman William Dannemayer off the top of the Empire State Building. Dannemayer was well known for his condemnation of homosexuality. Other public figures were also named in the text. For example, it likened Cardinal O'Connor to a Nazi and suggested that fantasizing about setting Senator Jesse Helms on fire gave the narrator relief from his pain and rage.

We had never published a catalogue text which had these kinds of four-letter words in it. I'm not a lawyer, and I didn't know very much about libel laws and was concerned. Because I worked closely with a board of directors which includes a lawyer, it was my practice and policy to bring controversial issues to their attention so that we could work together and so that people wouldn't be blindsided if a controversy occurred.

Because this catalogue text specifically mentioned public figures and because it could be construed as combining the issues of homosexuality and blasphemy in the context of a show about AIDS, the board and I decided it would make sense for us to use private funds to publish the catalogue and to use our grant to partially finance the show. We had estimated the catalogue would cost $7,000 and the show $30,000 and we figured we could allocate our $10,000 NEA grant toward the exhibition and find private funding for the catalogue. Meanwhile we had applied to the Robert Mapplethorpe Foundation and received a $5,000 grant which could be allocated toward the catalogue in place of NEA funds.

So I called David Bancroft, the Special Exhibitions specialist at the NEA. I have been accused of calling NEA Chairman John Frohnmayer, but that was not the case. Bancroft was the specialist who dealt with this particular category of the NEA's Museum Program and I explained the nature of the show—which hadn't changed—and asked him about allocating the $10,000 solely to the exhibition. Bancroft told me it was a very

simple matter, that all I had to do was write a letter, and he suggested some phrasing. He also suggested we send in a revised budget. It seemed very straightforward.

Because the agency had been through a horrible summer with the Helms Amendment, I also asked Bancroft whether we should credit the NEA in the catalogue. We had, for instance, received an anonymous contribution for the show from a corporation which had specifically asked not to be credited. In response, Bancroft basically said he didn't know how to advise me and suggested I speak to Ana Steele who at that time worked in the chairman's office. When I did so, Steele said she couldn't advise me.

What I wanted to do was to set up a scenario which the board and I had determined was the wisest and which I had discussed with Bancroft. We wanted to be able to prove, via the grant documents, that the catalogue was privately funded. Part of the rationale was to counter vocal NEA critics such as Congressman Dick Armey whose constant refrain was "You can do anything you want on your own time and with your own dime." We knew it was very likely that the catalogue text would be picked on because it would exist after the show closed, and because I knew Senator Helms—who was specifically mentioned in the text—was looking for material in his effort to restrict the agency. It was very likely the catalogue would come to his attention.

We had been through some controversies in the past at Artists Space and I had seen their effect on artists. My intention was to protect the artists in our show from the kind of stereotypical ridicule frequently heaped on artists, a recent example being Morley Safer's report on *60 Minutes*. I didn't want to see their work held up for abuse like Serrano's and Mapplethorpe's. I knew Robert Mapplethorpe—he organized a show for us at Artists Space—and I had also gotten to know Andres Serrano and saw how difficult that whole time was for him. Artists Space was created to promote the work of young and unknown artists—not to put them in a situation which would be self-defeating or hostile. That's what I was thinking about.

When I went through the grant file to revise the budget, I discovered the original grant award letter which was signed by Hugh Southern—the then-acting chairman of the NEA—specifically mentioned "exhibition and accompanying catalogue." So to make a change in the budget would not deal with the fact that there was a letter saying that the catalogue was funded by the NEA. Once I realized that, I called David Bancroft back and asked if there was a way to change this letter. He said he didn't know and explained they always phrase the letters that way whether there's a catalogue or not

because if there is a catalogue they want to be able to say they had funded it. He said he would have to get back to me about whether or not they could make the change in the letter.

By that point I had already decided, based on my conversation with Ana Steele, that I would credit the NEA in the announcement card. But I made it clear it was the exhibition that was funded. I said nothing about the catalogue. It would not have been usual to put that on the exhibition announcement anyway.

After a while, when I had not heard back from Bancroft, I called him again. When I finally got in touch with him, he told me he had ascertained it was possible to get a new grant letter. He said I should send a letter requesting a change along with the revised budget and that's what I agreed to do. When I asked him whether I should tell Ana Steele that I had credited the NEA for the exhibition on the announcement and press release, he said that would be a good idea.

At the time all of this was happening, I was also a board member of the National Association of Artists Organizations. John Frohnmayer had just become chairman of the NEA in early October 1989, and when NAAO had its national conference in Minneapolis, we had asked Mr. Frohnmayer to attend. We wanted to introduce him to NAAO and the artists' organization field. Because he had just started, he could not attend, so Charlotte Murphy, who was then the NAAO executive director, put together a small group to meet with him in Washington. Because I'd been very active on the advocacy issue, one of our primary concerns, Charlotte asked me to attend the meeting.

Charlotte and I went with Inverna Lockpez, who was then-president of NAAO and also worked out of New York. We met with Rep. Sidney Yates that morning and we had several other meetings on Capitol Hill. I had spoken to David Bancroft at the end of the previous day, but I hadn't had time to reach Ana Steele. When we went to Mr. Frohnmayer's office, they said he was delayed. Because I was in the NEA building and I had 15 minutes to kill, it seemed a good time to call Ana and tell her we were crediting the NEA in the announcement in our press release. When I did, she told me they had briefed the chairman about the Artists Space show and that he would probably raise the topic with me at the NAAO meeting.

Charlotte, Inverna, and I had chosen very carefully the issues we wanted to bring up on behalf of NAAO. We knew we didn't have much time with Frohnmayer and we had very specific goals. I told Ana this was a NAAO meeting, not a meeting about Artists Space and that I really didn't know if it was an appropriate forum in which to discuss the grant. I'd be happy to

talk to him, I said, but I'm really here for NAAO, to talk about NAAO business. Ana said she would try to convey that message to him but that she couldn't promise anything.

Mr. Frohnmayer finally arrived and we had a productive meeting with him. We had covered all the topics we were interested in and as we were getting up to leave, Mr. Frohnmayer asked to speak to me privately. When the others had left, he raised the issue of the Artists Space show. I told him of my conversations with Bancroft and Steele and of Artists Space's intention to separate the catalogue from the scope of the NEA grant. He was aware that I had credited the NEA on the exhibition announcement. He asked me if it would be possible to take the NEA credit off the catalogue entirely and I told him that, because the catalogue hadn't gone to press, that it was feasible. Mr. Frohnmayer then asked if it would be possible for the NEA to put a disclaimer in the catalogue. The board and I had decided to include a disclaimer on Artist Space's behalf. I had spent some time and effort to devise one we felt was appropriate. Since we had done one for ourselves, I did not think I should automatically discard the possibility of a disclaimer for the NEA, however I told Mr. Frohnmayer that I would need some guidance as to what it might say. Mr. Frohnmayer then asked if it would work if they supplied us with the language. I said that would be fine. He then asked me if I would be willing to have Drew Oliver, who was head of the Museum Program, come to Artists Space and look at the work in the show. Drew would be coming to New York in a matter of days.

I explained to him the show was scheduled to open the 16th of November. At the time I was speaking to him it was October 25. I said we would do the best we could to show him what we had. We definitely had the catalogue text. We had slides and I told him I would try to bring together some of the work, although many of the photographs were still at the framer and some were still to be collected. Mr. Frohnmayer said that would be fine. He wanted Drew to see whatever we had of the work and to read the catalogue texts. He told me to contact Drew directly, which I did.

And that was the end of that discussion and my first encounter with Mr. Frohnmayer. I never called him about the show. As far as I'm concerned, he raised the issue with me. I really had no reason to raise it with him after my conversations with David Bancroft and Ana Steele. The matter was essentially resolved. The only thing I had to do at that point was write an official letter requesting the change and to send a revised budget, which Celeste Dado (the assistant director) and I did and sent out as soon as I got back to New York.

Drew Oliver soon visited. We had made an effort to collect what we

could and we showed him that as well as a copy of the galleys for the catalogue, which included David Wojnarowicz's text. What I was waiting for was an indication as to whether the NEA wanted to be credited in the catalogue. My original idea had been to acknowledge the NEA's support of the exhibition in the catalogue but make it clear that the catalogue itself was privately funded. It was my understanding from my conversation with Mr. Frohnmayer, however, that he wasn't even sure that they wished to have an acknowledgement of their support of the exhibition. I needed to know his preference as well as to get his guidance on the language for the NEA disclaimer. I explained to Drew that we were on a tight deadline and that we needed to know as soon as possible. He said he would read the catalogue text and report back to the chairman and then report back to us.

* * *

By way of digressing, I want to make it clear that it's not an ordinary thing for me to have contact with the NEA chairman. Previously, I had met only one chairman, Frank Hodsoll, who visited Artists Space when he first took the post and was seriously investigating a lot of the more experimental organizations. He made an inspection tour in New York. I thought it was an honor to be asked by NAAO to meet Mr. Frohnmayer. It was not an ordinary event, and he was certainly not someone I would consider getting into an argument with. NEA support was very important to Artists Space. It was a small, but influential, part of our budget. We had received maximum funding for many years in the Visual Arts program and that was very important to me. I certainly didn't want to jeopardize our relationship or any future funding for Artists Space. I also wanted to be as supportive as I could to the NEA which I considered was getting a very bad and unfair drubbing in Congress. I was very cheered by Frohnmayer's attitudes at his recent confirmation hearing, and his call for more funding. I wanted to support him in that endeavor.

* * *

We had set up a situation which had the potential to backfire. Part of the idea of contacting the NEA had been to give them a heads-up signal about the show. The show's goal was made clear in the application. I had been concerned that the NEA had not been supportive of either Serrano or Mapplethorpe. I had been, in fact, really quite horrified that Hugh Southern had

written a letter to members of Congress saying that he was personally offended by Serrano's work. I didn't want the NEA to have that kind of relationship with the work in our show. In essence, part of what I was trying to do in contacting the NEA—besides removing the catalogue and the other issues I've already mentioned—was to offer the agency the opportunity to be supportive and to be able to say, "Yes, we didn't fund this catalogue that everyone's so upset about but we did fund this exhibition which contains a lot of very valid work." The goal was to provide them with a possibility of being able to support it even when some of the work might not have been politically viable for them to support.

When Mr. Frohnmayer called me the afternoon after Drew Oliver had visited, I obviously wanted to be as professional and clear and accommodating as I possibly could while still protecting what Artists Space was about and what the artists were doing. He told me he did not want me to credit the NEA at all, for the catalogue or exhibition. He understood that we had already distributed press releases and asked if we would be distributing more. We were not preparing a separate mailing, but we generally have press releases available in the gallery and for handouts. He asked if it would be possible to remove the name of the NEA from any future press releases and from the announcement. Removing it from the press releases was possible, I said, but the announcements had already been printed and we couldn't reprint them. There was nothing we could do about them.

On the wall at the entrance to the gallery, we listed the title of the show, the curator, any kind of relevant credits, as well as who funded it. Mr. Frohnmayer asked if we could remove the NEA's name from that location as well. This confused me. I knew by that point that there was press interest in the show and in "Day Without Art." I knew the *Village Voice* in particular was very interested. They wanted to do a prereview and have something in the paper before the show opened. Given the nature of the show, I knew there would be questions about whether it was funded by the NEA or not and didn't know how to answer that question.

So I posed this problem to him. I was trying to understand what his strategy was. And he said I should have the press call him. In other words, when Elizabeth Hess—the art critic for the *Village Voice*—asked me, as executive director of Artists Space, whether the show was NEA funded or not, I was to tell her to call John Frohnmayer. It was ridiculous. She would have laughed in my face. It didn't make a grain of sense.

Further, he instructed me to include an oddly worded disclaimer, which said, "The opinions, findings and recommendations included herein do not

reflect the view of the National Endowment for the Arts." This disclaimer was to be on the press release, he instructed, and wherever there were official credits. I was to remove the name of the NEA but I was to place this disclaimer everywhere. At that point, it seemed to make the most sense to get off the phone as fast as possible to try to understand what he was asking me to do, and not to get into an argument with him.

Nothing he said made sense to me. It was reasonable to have a disclaimer if you had a credit for the NEA, but if we weren't crediting the NEA it was a little bit like saying the pope may not approve of this exhibition. Why would the pope care unless the pope had something to do with it?

I was really very perplexed by this. I tried calling the Museum Program at the NEA and I spoke to another member of their staff. The following morning, I spoke to Drew Oliver. I didn't like the language of the disclaimer; it was like a big red arrow. It seemed like everything had been made a lot more difficult than it needed to be. So I told Drew that I was considering calling the chairman back to propose rewording the disclaimer slightly so it was less legalistic and without the "opinions, findings and recommendations" wording. I proposed we include a slightly modified version of the disclaimer, but that if we were to do that, we had to make it clear that the NEA had funded the exhibition. It made no sense to have one without the other. Drew said that he did not want to discourage me from calling the chairman, but he did not think he would change his mind. He agreed that the situation with the *Village Voice* was difficult.

When I had worked out a phrasing with the lawyer on Artists Space's board, I called Mr. Frohnmayer back and made the counterproposal. It made more sense for us and didn't force me to be coy with the people in the press or anyone else about whether the show was funded by the NEA. Up until that point, there had been no discussion about taking the grant back. During my very short conversation with the chairman, however, he started to put the screws on me to voluntarily give the grant back. That was something I neither wanted nor was prepared to do. Our lawyer had warned me to be very careful not to say anything about that, and it certainly was nothing I was going to commit to over the phone without serious discussion with the board. So when he started doing that, I thought the best plan—again—was to get off the phone.

At the same time—again in my capacity as a NAAO member—I had been attending National Council meetings. I had been to the previous National Council meeting in August and I was planning to attend the early November National Council meeting. My third conversation with Mr.

Frohnmayer was the day before this council meeting, and he was aware I was coming to Washington. I hung up the phone and tried to recuperate. About five minutes later Artists Space's lawyer called me and said she was getting messages from legal counsel at the NEA and asked what was going on. I related to her my conversation with Mr. Frohnmayer, and she talked to the legal counsel at the NEA.

She soon called me back and told me the NEA was drafting a letter to me asking for the grant back. At this point I was trying to get my bag packed, get out, and catch the last shuttle to Washington. Art Warren, the NEA legal counsel, had faxed a draft of the letter to our lawyer, but I didn't manage to get a copy of it before I left. She told me, however, that the following morning in Washington at 9:00 A.M. I was to look for Warren at the council meeting and that he would have this letter waiting for me.

At the previous National Council meeting there had been discussion of a cut to the Visual Arts Program. The Senate Appropriations Committee, encouraged by Senator Byrd, had made a significant cut—$400,000—in the Visual Arts program appropriations. The money saved by this cut was split between the Folk Arts program and the Locals Program. I was very concerned about this issue and had managed to discuss it with a number of council members and also had met the reporter who was covering the NEA for the *L.A. Times*, Allan Parachini. I spoke to him a few times on the phone and he quoted me in a story he had done in early October about the outcome of the Helms Amendment vote. He had also quoted Charlotte Murphy, and the three of us—Charlotte, Allan, and I—had set a dinner date in Washington for the night before the November National Council meeting.

As I was preparing to leave for D.C., I called Charlotte and told her to cancel the dinner and to give Allan no reason. "Somehow find a way to get rid of him," I said. He was the last person I wanted to talk to. I was hoping to resolve this issue among ourselves and with the NEA and not have it became an issue in the press. I was very aware of what had happened at the Corcoran—how, when the decision was made to cancel the Mapplethorpe show, a number of members of the board had disagreed and spoken publicly against it. It seemed to me that having board members saying conflicting things would be very destructive. I also wanted us to have a very strong response, but I didn't know what Artists Space's board's response would be. I could gauge that some board members would feel very strongly that we shouldn't give back the grant, but I didn't know if all the board members would feel that way. The last thing I wanted would be to have the situation unfold in the press and tear the organization apart.

As I was on my way to Washington, my entire staff had a meeting and voted unanimously that Artists Space should not give back the grant voluntarily. I agreed. I really wanted to work with our board to have everyone come to that conclusion. I wanted to manage the situation internally before anything happened or was written externally.

So Charlotte canceled the dinner. When I got to the NEA the next morning at 9:00 A.M. for the National Council meeting, Allan Parachini was lying in wait for me. As I came in the door, before I had a chance to find Art Warren or to get the letter, Parachini came up to me and said he had heard I had a letter from the chairman asking for our grant back on our upcoming AIDS show. I was so stunned that he had that information, that I just asked, "Who told you that?" The NEA's public affairs person, he said. Now, I had not only not gotten any letter but I also wanted to try to convince the NEA not to give me the letter. So I told Parachini I hadn't received any letter. It was the truth, after all.

* * *

It is important to note that at the NAAO conference the previous month, I encouraged people to contact the NEA and indicate concern with the Helms Amendment—a very confusing piece of legislation which was later ruled unconstitutional. It seemed to me that at that time there was an attempt to demonize a couple of artists, a couple of exhibitions, and to set up a black list. For example, the organizations which had originally sponsored the Mapplethorpe and Serrano exhibitions were singled out for specific congressional scrutiny, if the NEA wanted to give them any funding. At the NAAO conference I spoke about the issues and about the black list and suggested that if these organizations were guilty of something, we were all guilty. I also suggested black lists were powerful if they were short and that if there were many organizations involved, the black list's power would be diluted. If a lot of organizations called and said they didn't understand the Helms Amendment and how it applied to them, the NEA would be empowered to say to Congress, "We're getting hundreds of calls from our grantees who don't understand this legislation." This proposed tactic was very controversial and a lot of people disagreed with me. Some thought an organization would be red flagging itself if it called and expressed concern. Others felt grantees should just do their projects with the money and not allow the NEA any possibility or option to try to redirect their grants.

Subsequently, some people accused me of causing the Artists Space controversy by red flagging our own show. Why hadn't we just gone ahead and done the show and waited to see if there was any controversy? Why had we called attention to it by removing the catalogue from the scope of our grant? I've already explained the answer to that question. I didn't want the artists to be dragged through the mud, I didn't want the work held up to ridicule, and I also was interested in protecting, to the extent that I could, the NEA. I felt it was a very important agency which did a lot of good work. It was very difficult for me to be in an adversarial position with the agency and Mr. Frohnmayer, because I had been advocating the NEA very strongly in the preceding months. I felt like I was being asked to choose. Was I willing to sacrifice my principles and Artists Space's principles in order to accommodate the NEA? Or was I going to stand up for my principles and those of Artists Space and sacrifice the agency I had worked so hard to try to support?

It was a horrible choice, although there wasn't much of a question in my mind as to what the outcome would be. When it came down to it, I was executive director of Artists Space. In a way, I was in a fortunate position. I had a board which was half artists. I had a very, very clear mission at Artists Space to support the work of artists, unlike the Corcoran which had a much broader kind of mission. Christina Orr-Cahall, faced with making a similar kind of decision as to whether she should have the Mapplethorpe show or not, didn't have that bedrock to fall back on as I did. Not that I want to defend her; I disagree with the choice she made. But for me there was never any question as to which way it had to be.

* * *

My first day in Washington I spent a lot of time trying to avoid Allan Parachini and attended several meetings with Art Warren and with Julie Davis, the chairman's special assistant. I did not, however, meet with Mr. Frohnmayer, but he did come up to me at a certain point in the day and basically told me he thought there was respect between us. I agreed. That was about the extent of our conversation. I did get his letter later that afternoon and spent several hours going over it with Art Warren in great detail, asking questions about everything it meant and the reasons we were being asked to give the grant back. Before I received it, I tried to explain to Warren that I did not need a letter, that an oral request from the NEA would have sufficed for me to convey their proposal to my board.

By that point we had already begun to set up an emergency board meeting which was to take place in the middle of the following week. I offered to stay over in Washington an extra day or two to meet with Mr. Frohnmayer. I tried to convince them not to give me the letter. They did give it to me, however, and told me it was completely confidential. I asked for this confidentiality to give Artists Space time to make a considered decision as to the course it would take. I was told by the NEA that I could release the letter to the press if I wanted, or it could remain secret. They told me they would not release it to the press, that no one knew about it except for them and me.

I had told them previously about Allan Parachini's question and had asked them to correct him, to tell him I hadn't gotten a letter, because at that point that was the case. It was my understanding that they had corrected him. When I was finally given Mr. Frohnmayer's letter, I told no one except for a couple of board members. I had no intention of releasing it to the press. I told that to Art Warren. I told him that if I were to release it to the press, I would let the NEA know in advance. We decided I would meet with Mr. Frohnmayer Monday morning, right after the National Council meeting had finished, and that I would go back to New York, hold the emergency board meeting, and that we would get back to the NEA with a response after the board had met.

I also agreed to be interviewed by Allan Parachini, because he said he was writing a story for the Monday *L.A. Times*, regardless of whether he spoke to me or not. Once he put it that way, I felt I had very little choice. I didn't want to tell him about the letter, but I did want to tell him certain things about the show. I also wanted to give him a general idea about Artists Space, its programs, and how it fits into the arts community. I wanted to make sure Artists Space was not marginalized and that Parachini understood that I was facing a situation which would soon affect many arts organizations, large and small, experimental and traditional, as a result of the recently passed 1990 Appropriations Act which included the so-called "Helms Amendment." I wanted to explain that the show was appearing in the context of "Day Without Art," which hundreds of organizations across the country were participating in. I basically wanted to indicate I had an ongoing dialogue with the NEA about the grant.

I explained to Parachini what the show was about, who had organized it, and how much it was going to cost. I didn't get into the nitty-gritty of explaining the catalogue text and separating it from the show, because I thought those were things that, from my understanding, were still under negotiation. I didn't want to preclude any possibility at that point. I asked

him if he would please fax me a copy of the story when it came out. He said he would. I advised Art Warren of my decision to be interviewed by Parachini in advance and reported to Warren my discussion with Parachini immediately afterwards.

That Monday morning I met with Mr. Frohnmayer—I spent maybe an hour with him, Julie Davis, and Art Warren—and we basically talked about the issues involved. I tried to understand his reasoning for withdrawing the grant. I argued with him about the advisability of that, coming up with as many reasons as I could to persuade him it wasn't a good idea. Basically, I wanted to get as much information as I could so I could report to my board about his rationale. I argued with him about official art and unofficial art and all of the related topics.

I was staying with my parents, who live in Washington, and returned there after the meeting. Very soon after I arrived, I received a call from Kinko's saying that a fax had come in for me. So I went rushing down there to get the *L.A. Times* piece. I don't know what I was expecting but I certainly hadn't expected what I got. The story said that I had a letter from the chairman, something which I had never confirmed—or at least I thought I hadn't. But then I started wondering if Parachini had found some clever way to make me admit I had the letter without my even realizing it.

I was very upset about that. I was trying to negotiate with the NEA in good faith. I had said I wouldn't tell the press about the letter. I kept the NEA informed continually as to what I was doing. The whole description of the show and my discussion with the NEA was portrayed as provoking the controversy. Artists Space was portrayed as a radical, activist organization, thereby marginalizing it. This was exactly the reverse of what I hoped to accomplish by talking with Parachini. The story suggested that I deliberately forced the issue to create a confrontation with Chairman Frohnmayer.

The article also mentioned a National Council member I knew. In talking to Parachini, I had made comparisons between organizations and one I mentioned was the Metropolitan Museum of Art. Wendy Luers was and still is on the National Council. I had set up a lunch for Wendy, Charlotte, and myself long before any of these events about our grant had happened because I wanted to introduce her to NAAO. Allan Parachini wrote we had lunch in a restaurant near the NEA, and he made it seem like there was a conspiracy of some kind among us about Artists Space's grant. He quoted my reference to the Metropolitan Museum and noted in the story that Wendy was the wife of William Luers, president of the Metropolitan Museum. It was a strange article. Allan's references to Wendy and the Met

made me upset because I like Wendy and didn't want to get her into an awkward position with the NEA. Bringing her into it didn't make sense. I was very angry.

As soon as I got the fax, I did two things. First, I called Allan Parachini and told him I was very angry about the article. The first question I asked him was whether I had told him I had a letter. He said, "No." I was concerned about breaking good faith with Mr. Frohnmayer, and I asked him if he would tell the chairman that. He said, "No." When I asked why, he said it would lead to a series of questions which he didn't want to answer—in other words, who his source was. The only way he could have gotten that information is from someone at the NEA, I realize now.

As soon as I hung up, I called Mr. Frohnmayer and spoke actually to Julie Davis who said they had just gotten a fax of the article and that she hadn't finished reading it and that she or Mr. Frohnmayer would call me back once they had. I tried to reach an Artists Space board member and I called Wendy Luers to tell her about the article. She was very nice and very calm about the whole thing.

Mr. Frohnmayer called me back sometime that afternoon and I told him about the exchange I'd had with Allan Parachini. I basically just wanted to tell him that I was very upset about the article, that I hadn't broken my word, and that we would be in touch as soon as we completed our board meeting.

By that time, I was beginning to get press calls. The *New York Times,* the *Washington Post*—everyone was calling. I went back to New York and got ready for the board meeting. The upshot was that our board voted unanimously not to return the grant. By that time I had also gone over the terms and conditions of the grant in some detail and had received all the legal information we needed. Our board lawyer had begun the process to get us legal representation.

Throwing a twist into the situation was the fact that we had not yet submitted a cash request for the grant. We had not yet physically received the funds. Usually when you have an NEA grant, you first receive a grant award letter. It's only when you incur costs that you put in a cash request to actually, physically receive the cash. You are allowed to have it thirty days in advance when you submit a substantiation of expenses. We had been fiscally prudent and were not yet using the money. The show had not opened, and we had not begun to incur costs. So we had not filed our cash request and had not physically received the money. I didn't even realize it until just before I went to Washington. Frohnmayer, however, was clearly aware that we had not received the $10,000.

The board meeting was a lengthy procedure because the board also thought it should make a unanimous statement. I had to track down four or five of the board members and explain the issues and make sure they understood and were agreeable. Ultimately, we came up with a unanimous decision not to relinquish the grant, a decision which made us all proud.

The day after the board meeting I was able to fax a very short letter (saying that we were not going to relinquish our grant) to Mr. Frohnmayer in response to his letter to me. At that point, I also faxed a cash request asking for the money.

Meanwhile all hell had broken loose at the gallery. The artists were very upset. There had been a story in the *New York Times* so there were a lot of people in New York who were very concerned about the precedent set by the NEA in response to our show. We were inundated with media requests and television cameras which appeared on our doorstep. In a small gallery like Artists Space (we have a full-time equivalent of nine on staff) we had no one to deal with the press. I was there from seven in the morning until midnight trying to respond, getting hoarse, having to have a glass of water next to the phone all the time. It was like being in a war zone. We have three incoming phone lines and they were all just permanently busy. I would get stacks of messages—four or five inches high—from the media. Finally, someone suggested we have one or two press conferences a day.

The fact that the grant had been withdrawn was on the front page of the *New York Times* the next day after the board meeting. That's how they phrased it: that it had been "withdrawn." And the *Times* article said something which had never been mentioned during my many discussions with people from the NEA: Mr. Frohnmayer said he had turned the matter over to the Justice Department. I didn't really know what that meant and still don't, and I never have been able to understand what exactly happened from a legal standpoint.

From our perspective, the NEA had voluntarily asked us to give our grant back and given as their only justification the political climate. Our rationale was that the political climate was not a valid enough reason for us to relinquish a legitimate grant. We thought the show was legitimate and contained legitimate art and for us to voluntarily give the grant back would have been some kind of acknowledgement that the art was somehow invalid.

* * *

What was ironic about the whole controversy was that by separating the catalogue from the exhibition, from David Wojnarowicz's point of view, it somehow invalidated the catalogue. Of course that was never my intention. He was very angry, at me in particular, that we had done that without consulting him. But, like it or not, it was Artists Space's grant; it was something we had applied for and something only we bore the responsibility to fulfill. I felt our mission was to present the work in a way that the artists wanted. It wasn't necessarily our responsibility to make sure that the artists were happy about where funding came from. We did once have an artist who objected to a certain corporation funding his project. That was something we dealt with. But I really didn't feel it was something artists could realistically expect to control. What they could have control over was their own work and how it was presented. But we were fiscally, legally, and in every way responsible for any grant given to Artists Space. Those were our decisions to make and I know our board—the body ultimately responsible for making decisions—felt the same way. The catalogue was privately funded, but we published David's text unedited, the way he wanted.

One of the first questions I had from the press was whether we were planning on canceling the show. I didn't understand why they were asking this. Of course we were not going to cancel the show; we were going to present it completely the way we had always intended to present it. The only thing I did—about which, again, David was very angry at me—was to make certain suggestions to him about a few minor text changes. The lawyer on our board had told me certain parts of the text could be considered libelous, had suggested modifications, and advised me to call David and discuss with him certain wordings and see if he would be flexible about changing them.

I was under a great deal of pressure at that point—we had an executive meeting in an hour—and I had to act on their advice and then get back to them. I called David and I did talk to him about the possibility of changing certain wordings in the text. He was very upset and very adamant about keeping it exactly as he had worded it. As soon as I had the conversation with him I understood how much the text meant to him and how purposeful he was about the wording. If I had never asked those questions, I don't think I would have understood. After that, I called our board lawyer back and said, "The text has to be the way it is; how do we protect ourselves?" That's when we came up with the disclaimer.

David was angry with me and claimed that I tried to censor him. I don't

know if that's what I did; I don't think so. I asked questions. I guess people disagree about whether I should have asked them. But I was head of an organization which had to take responsibility. And I will never regret asking them. David's answers to them taught me a great deal and the harsh reaction he had to my tentative suggestions gave me a clear sense of the power of his conviction and his vision. It gave me the ammunition and determination to defend that text, which I had to do over and over again as the situation unfolded. I would never have understood it as well if I hadn't asked. David was not the first nor the last artist of whom I had to ask those questions. It's not easy to ask those questions, but I've learned something I needed to know every time I have.

* * *

During this time, there was a hiatus when everyone was acting as if the grant had been withdrawn. But I had been studying the legal documents we had. In the terms and conditions there was a section which addresses grant termination. There were two kinds: "termination by convenience" and "termination by cause." This was one of the things I had spoken to Mr. Frohnmayer about when I met with him the Monday after the National Council meeting, and I had also raised the issue with Art Warren when we went over the letter. It was my understanding that what the letter was doing was essentially proposing termination by convenience, which means that both parties agreed to terminate the grant. I pointed out that the language—termination by convenience—was unacceptable for Artists Space to embrace. It was a matter of principle for us; it wasn't "convenient" to sacrifice our principles, nor was it "convenient" to give away $10,000, although money wasn't really the issue at that point.

The peculiarity about the way Mr. Frohnmayer handled it was that he wrote me the letter. I think it would have been smarter for him to take my advice and not give it to me, because what he did basically was to indicate that there was no cause or reason for termination. What I understood was that when we faxed the letter refusing to relinquish the grant and then demanded the cash, they had ten days to respond. We figured we might get a letter of termination by cause within that time, in which case they would have stated a reason they were withdrawing the grant. If they had done that, it would have been invalidated by his original letter. That's where he made one strategic error. All we had to do in that case was point to the first letter and say, "There is no cause here."

What ultimately happened was that we got the grant "back" and we got it back exactly ten days after we submitted the cash request. David Wojnarowicz was very angry we accepted it back, arguing that we somehow should have refused because the catalogue was defunded. I tried to explain to him that wouldn't have been possible. That was the offer we made in good faith. I don't know what I can do about the fact that it was accepted for the wrong reason. That's just the way things happened. I wish it wasn't like that. But the ball was in their court. They gave us the grant back. For us to say: "We won't take your filthy money because you won't fund the catalogue," made no sense. We had already told them they didn't have to fund the catalogue.

In an odd way, maybe nothing happened at all. Maybe there was actually no withdrawal. There was just a strange controversy in which a bunch of people said a grant was withdrawn which ultimately was not. In fact, as much as a year later I asked Art Warren to explain it to me, and he would only say that we should let sleeping dogs lie. I don't know what Frohnmayer was intending or what he thought and that's one thing I've puzzled over more since I read his book. I really didn't understand what he was thinking—if he really miscalculated and thought we would give the grant back or not. Perhaps somehow he got a sense we would give it back. I tried, however, to be as clear as I could. Obviously I couldn't make commitments on the spot—I was beholden to a board and had to run things through them.

After the story was on the front page of the *New York Times*, the controversy was all over the country. We were just inundated. Another thing which occurred was that the Visual Artists Organizations panel at the NEA, which was the category in which Artists Space was considered every year for funding, was about to meet. It was the panel which handles all of the artists organizations across the country. I was terribly concerned about that. I spoke to five of those panelists who called me and were persistent enough to get through our jammed phone lines. I made a special point to try to talk to every panelist who called. A number of them were considering not serving. I was concerned because I didn't want to see the whole field of artists organizations defunded. I didn't want people not to serve and not have the panel show up. I didn't know what would happen to that money.

I told them to go ahead and be panelists and make decisions about the funding of different organizations. If the NEA process fell apart, I thought it would be a very bad thing for our whole field. It seemed as though the whole agency could fall apart if panelists weren't willing to serve. I was

also especially concerned about our particular field, which seemed so vulnerable. I didn't know what Mr. Frohnmayer might do, whether he might eliminate that category of funding and use the money elsewhere. I did not want to see the whole agency crumble from within.

I'm not used to feeling like a celebrity but, when I was at the National Council meeting, all eyes were on me every time I walked in and out of a room. I got so self-conscious about it that I finally figured out how to go in the back door. People from the NEA whom I had never met before instantly knew who I was. There seemed to be a lot of support for Artists Space among NEA staff. When the publicity began, we started getting checks and letters in the mail. We had an overwhelming amount of support. We got a $10,000 check from Arnold Glimscher at Pace Gallery. Chuck Barris from the Gong Show called to offer $10,000 as well. Three people I know of offered us $10,000 as replacement for the grant, all of which we refused. We told people that we were holding our ground that we had received the $10,000 grant. We did not want to accept substitution money. If we had accepted a substitution, we would have had to drop our claim to the grant. That was something we weren't prepared to do at that point.

We were also beginning to investigate the legal ramifications and what recourse to take. From what I understood, it was up to the NEA to make the next move. If they weren't going to honor our cash request, they would have to tell us for what reason they were withdrawing the $10,000 grant. We also received a lot of offers of legal help. It seemed to me at that time— and I think the board felt the same way — that we did have a legal case but that taking on that legal case would be a very long-term project. And we were basically in the business of being an artists' organization and not a civil liberties organization. The board had had some preliminary discussions about legal remedies, and as I noted we were seeking proper legal representation. We knew we would have had to make a decision about pressing ahead legally eventually and that a decision to do so would have been something which could have really drained the organization and possibly jeopardized our ability to continue our artistic mission.

What we were looking for was a political solution. We were looking to put as much pressure as possible on Mr. Frohnmayer to change his mind. That seemed to be the only way out. We had given him the perfect out, the opportunity to say the catalogue wasn't funded by the NEA. That was one sad aspect of the controversy. After we got the grant back, the board—in a statement—described it as a limited victory. What Mr. Frohnmayer did was take the offer we had made in good faith—to privately fund the cata-

logue— and twisted it around and used it as an out to extricate himself from the sticky situation he had gotten into. It would have been perfectly legitimate for him to say he deplored the catalogue text, to tell Congress that, and to explain that therefore they had not funded that but had gone ahead and funded the exhibition because they thought it was valid. We offered him that option in a positive way and he ultimately took it in the wrong way.

During the days after we sent in the revised budget and the cash request, we tried to garner as much support as we could. I talked to as many people on Capitol Hill as possible. By that point, I had already made some contacts but I was getting calls from people like Senator Metzenbaum and Senator Pell, people who really wanted to be supportive. Senator Moynihan's office was supportive, and I was in regular touch with Congressman Pat Williams. The mayor of New York issued a letter. We contacted the department of cultural affairs.

Meanwhile we were trying to get the show up on the wall. When Charlotte, Inverna, and I had met initially with Mr. Frohnmayer, we had suggested arranging a tour for him of New York's alternative arts spaces. He didn't seem interested in that, but he was very interested in holding a town meeting with artists. Within a day or two of the front page story in the *New York Times* I got a call from Julie Davis who said they would like to set up this town meeting. I don't know what they were thinking. We couldn't do it. If we had, everyone would come to scream at him. Artists were just furious at Frohnmayer and at the NEA. It would have been counterproductive. I pointed that out. We discussed it. Ultimately he decided to come to New York to see the show the day before it opened. As a substitute for this town meeting, I offered to select a diverse group of representatives of the arts community for him to meet with on the same day.

Meanwhile the National Medal of Arts was being awarded in Washington and I was trying to reach people who were being given medals to try to convince them to make some sort of statement to the president. At that point, we had already been contacted by Leonard Bernstein's manager and been told that Mr. Bernstein was going to refuse his medal to protest the withdrawal of our grant. The second Artists Space-related front-page news story—this time in four national newspapers—was Leonard Bernstein's refusal to go to the White House to receive the medal.

Many people made statements in support of Artists Space. Larry McMurtry—then the president of PEN—wrote an op-ed piece for the *Washington Post*. Until that point, the controversy had swirled around visual arts and, specifically, photography. I'll never forget seeing McMurtry's op-

ed piece because all summer long—during the Serrano and Mapplethorpe controversies—I kept wondering, Where is PEN? Where are the other disciplines? Don't they understand that this is something which affects literature and dance and theater and all of the other arts? That was the really encouraging aspect of the Artists Space event. It made it clear for the first time to the other disciplines that this was something which affected them. Peter Zeisler called and the Theater Communications Group wrote letters and a nice editorial. We basically were trying to rally that type of support in other disciplines. Alec Baldwin called and came to our opening; he got the Creative Coalition to speak out. Many groups which had not been very involved before in the NEA issue responded. It was a wonderful, incredible thing.

I had talked to the producer of *Nightline* during the summer and tried to suggest some artists for a show they did on the NEA. They ended up producing a very poor show on the arts controversy. He called me up in November to do a story on our controversy. It was exciting because it was a chance to get the issue out in a big way. Ironically, the show about the Artists Space controversy was preempted by the fall of the Berlin Wall. It was such a bizarre thing to be able to talk to anyone anytime. Just for those few days I could call almost anyone in the world and get through instantly and talk about this issue. It was amazing but scary, too. It's an incredible responsibility when you realize the whole future of the public funding of art has come to rest on your shoulders. If you say or do the wrong thing, it could really screw it up for something you really believe in and could have repercussions for all kinds of people whom you've never met.

I can't really explain what that time was like. One night I remember I got home and I tried to sleep but I was just so tense. I would try to relax and lie on my bed but ten minutes later I would realize that every muscle in my body was clenched. No matter what I did to relax, there was no way. I gave up after four hours. I kept finding that every muscle was tense. So much occurred during a very short period of time. Every hour seemed like a year. So many things were happening. Mr. Frohnmayer would issue another statement and I would get phone calls saying, "Now he's done this, now he's done that." I had to respond and deal with it. I had to be on television, which I wasn't sure I could do. It was all so tense. And many days I felt it was very bad. After a couple of days I did realize there was some real support out there. Before that I felt like there was a huge dagger moving closer and closer to my back.

To marginalize Artists Space and make it seem crazy and wacky was the strategy which would kill our chances for success. Unfortunately, that's

what has happened since then with a lot of other people who have been involved with this controversy. I was determined it wouldn't happen to us. That was why I made the comparison to the Metropolitan Museum. I was trying to align Artists Space with the Met and to explain that while we were showing different types of work and had different purposes, we were both organizations that existed to present artwork. Some of the work in the "Witnesses" show would eventually be in the Met and the Whitney and other museums, and already is, four years later. I was trying to make that point. That was part of what I was talking to my colleagues at the NAAO conference about, that this was an issue which didn't affect just a few. If Artists Space's freedom to present a show about AIDS was going to be threatened, then so was the Met's or the Whitney's or anyone who received a grant to present a show about AIDS. An infringement on one affects everyone and that was the point.

Many, although not all, of the people in the more established organizations had thought the controversy was not something which affected them. "It's just these crazy people on the fringe," they might say. "But we're not like them. We're doing dance, we're doing poetry." As a strategy and as a matter of principle, what I was trying to convey was that we were just the same as the Metropolitan Museum of Art, just the same as the Whitney, just the same as Lincoln Center. I'm a person who dresses in a fairly conservative way. I love Martha Wilson, but we are very different in style and appearance. That difference was a tool I could use. It was important to me to appear publicly as someone who was comfortable wearing pearls, who had Republicans as parents, who could be anyone's daughter, who was suddenly thrust into this situation. That seemed to be the best strategy—and was also the reality—of the situation.

I made hundreds of visits on Capitol Hill. I wore dresses by Laura Ashley, when the people in Congress and their aides would be expecting someone with a strange hairdo wearing black leather. It was important to me to present an image and an argument and a rationale which could effectively reach people so that they would be moved. That was my intention and my goal. It still is. There are people who criticized me for that. I know this strategy worked, as did my advocacy on Capitol Hill. I know because Artists Space was never ridiculed in the *Congressional Record* as were so many other similar organizations. A few examples include the Kitchen, Highways, and Franklin Furnace, and even recently, the Whitney Museum. Even those who vehemently disagreed with me did not criticize Artists Space. Too many members of Congress and legislative assistants

had met and talked with me and knew I was a rational, sane, and measured person, whether or not they agreed with me 100 percent. To attack Artists Space would not have been effective on the part of NEA's critics. It was easier to demonize others with whom they were unfamiliar and whose language or style could therefore be more effectively portrayed as alien and, as a consequence, evil.

One of the questions the press asked over and over again was: What's problematic with the show? They wanted to know if the art was homoerotic. But I didn't want to use that kind of language. If I said, "Yes, this is a show about homoeroticism" it would immediately be quoted and the show would have been portrayed in this way only. I was asked over and over again whether there were individuals involved in "sex acts" —that was one of the phrases in the Helms language—and I finally came up with the answer. I asked if Rodin's kiss was of individuals involved in a "sex act." I wanted to make that kind of comparison so that the work wouldn't be marginalized, something which could easily be dismissed and regarded as kooky or bad. I tried to explain that I didn't know whether male nudity was homoerotic. I had nothing against erotic art but I couldn't necessarily categorize the art that way. I explained there was nudity in the show; but there's nudity in Michelangelo's Sistine Chapel. I said the work in the show was classical, and it was. Everyone wanted to pigeonhole it a certain way, and I tried to deal with those expectations the best way I could so that the show wouldn't be characterized in one very particular way and then dismissed.

The show wasn't even up when the negotiations were taking place and the press coverage started, so no one could see the work. There were a lot of preconceptions about what it was going to be—writhing sexuality. People had images in their head which had nothing to do with any kind of reality. The show was a great disappointment from that point of view. It was really very mild. Only one reporter, who wrote for the *New York Times*, finally got me to admit that there were individuals involved in sex acts. He came to the opening and he said, "Susan, where are they?" I had to take him over to David Wojnarowicz's pieces— the "Sex Series"—which had these extremely grayed-out peep hole sized images. I had to point them out to him. Even then, they were barely visible.

Mr. Frohnmayer had come to Artists Space very shortly after Bernstein refused the National Medal, the day before the show opened. The NEA announced to the press that Frohnmayer was coming to New York. I hadn't wanted to tell anyone because we wanted to have a genuine dialogue and

not a charged situation with a lot of press hanging around. We wanted him to be able to come and genuinely see the show, have a frank and positive discussion and leave, and not have it be an intense environment. But the agency announced it to the press and we started to get calls asking what his plans were. Then he accepted an appearance on the *Today Show* as well as *MacNeil-Lehrer.*

Since we had no one on staff to deal with the media, and realizing that his trip to New York would be some kind of event, we hired Roberta Sklar, who had previously done press work for the New York City Department of Cultural Affairs. "If he starts his day off on the *Today Show*," Roberta said, "they're going to invite you. And it would start the day off with two polarized positions. It wouldn't be moving toward reconciliation." She actually called the NEA and convinced them it would not be a good idea to do that. The NEA also called a press conference at Artists Space which we were not prepared for at all.

Roberta was a big help. She had a sense of which press people were the most important to get back to. I briefed her and she was able to deal with a lot of the press calls and begin to winnow through things. One of the first things she asked me was, "What do you want out of this? Do you want publicity? Resolution?" And I told her we wanted a resolution. She was very clear and very good about figuring those things out.

By that time, the artists in the show were really freaking out. They were worried their work was going to be manipulated and they were concerned about the type of press we might get. They didn't want their work photographed. Nan Goldin, the curator, didn't want anyone in to see the show before it was open.

The *New York Times* really rallied to our support. One day we had about seven different phone calls from seven different departments at the *Times* and John Russell wanted to do a review that would come out the day the show opened. It was pretty clear it was going to be a supportive review. I had to argue with Nan almost a whole day about whether to let him in. It wasn't really her decision, but everyone was very riled up by that point so I tried to consult her as much as possible.

Frohnmayer's viewing of the show and the informal discussion were closed to the press. I wanted to pull together a fairly diverse group of people from different disciplines, not all visual artists organizations and not all small organizations. We had a representative from the New York State Council and the Department of Cultural Affairs. Cora Cahan came from the Eliot Feld Ballet. We invited Alberta Arthurs from the Rockefeller Foundation but she didn't attend. David Wojnarowicz was there and so

was Andres Serrano. There were a couple of other visual artists organizations. Holly Block, director of Art in General, attended as did the president of NAAO. We wanted to get the point across to Frohnmayer that this was something that affected everyone, not just the "radical extreme."

We didn't know where the press conference Frohnmayer called could happen. We didn't want to have it in the gallery because the show wasn't completely up and Nan wouldn't have stood for having troops of people in the middle of the installation. The artists were concerned that we were spending too much time on other things and not enough on their work. But we had to accommodate this press conference. We thought about doing it somewhere else but that didn't make a lot of sense. We finally did it in the Artists Space basement. We didn't know what Frohnmayer was going to say but we couldn't say he couldn't do a press conference because we thought it was possible he would announce he was giving the grant back. We had to provide the platform.

One of the things which made me extremely angry about the way Frohnmayer described the press conference in his book was his claim that it was a setup. The truth was that it was his idea to have it. I really had nothing to say about it. When he wanted to come, I wanted to set up a situation that was most conducive to a positive experience which would cause him to change his mind. Scheduling a press conference would not have been the way to do that. There was a press conference because he called one and notified the press. We started getting press calls about it and we had no idea what they were talking about. It wasn't our goal to set up that type of situation.

It was quite a day. He came in the morning and looked very briefly through the show. We had a two-hour meeting with the people I had invited. He told me afterwards that he thought it was a very good meeting. It was intense and not easy but I thought it went well also. There were some very angry people, including David Wojnarowicz. But it was productive and I think he learned a lot; or at least I thought he had. Because they had notified the press, there were members of the media all around the gallery trying to figure out what was going on, trying to interview people as they left the meeting.

Later that afternoon we taped *MacNeil-Lehrer* and the next day we got the grant back. Congressman Pat Williams had agreed to come to a press conference the next day before the opening of the show. We announced the press conference and I believe Mr. Frohnmayer called Mr. Williams and asked him not to come. Williams later canceled his visit. Four members of the National Council came, however, and many others attended and spoke.

State Senator Roy Goodman had come the night before the show opened and spent an hour with our curator going through the entire show, looking at all the work. I also spent about an hour and a half talking to him about the issues. He was just terrific. He left and then called me back thirty minutes later and thanked me for my courage. He said he would be at the press conference with the three other National Council members "with bells on." That kind of response was great. One of the most significant things that made a difference in getting the grant back was Leonard Bernstein. His refusal to accept the National Medal of Arts was an incredible event and a real slap in the face to the president and Frohnmayer.

We got the grant back with the condition that we not use any of the money for the catalogue. We had stood our ground and got it back. In the months and years after—especially the first year—I spent an incredible amount of time discussing the issue on Capital Hill. Because I had a certain notoriety I could get in to see a lot of people there. What I could also do—which I couldn't have done before—was go to a meeting of all the directors of New York City's museums to talk about these issues. Artists Space's board made a decision that because we had taken this thing on, we had a responsibility to follow through. I tried very hard to utilize everything about the event in a positive way.

The most exciting thing for me was seeing the kind of support there was out there for the issue. It didn't just come from different disciplines in the arts community. We got letters from all over the country with $5 bills and $10 checks. The response was amazing. The fact that the show was about AIDS helped. The other wonderful thing that happened was that it made so many more people come to the show. The first Saturday the show was open we couldn't believe it. Nan was there and I told her it looked like the Vatican show at the Met. We had never had so many people there before. The show was very moving and, as far as I know, really the first show that dealt with the topic of AIDS. There had been shows of work of people who had died of AIDS, but there hadn't been, to my knowledge, a thematic show that dealt with that topic. And there were a lot of people who came who had lost friends and relatives. Lots of little old couples came from New Jersey, just a whole other group of people that normally didn't attend exhibitions at Artists Space.

The response was overwhelmingly positive. I don't remember anyone who came to see the show who was upset. We did get a few angry phone calls before the show opened and I tried to talk to as many of those people as I could. After the show had been open a couple of weeks, there was a

very negative op-ed piece in the *New York Post*. It quoted parts of the catalogue. That's the day we had a bomb threat and had to evacuate everyone. But that was the only incident like that. We had almost no hate mail. I would be surprised if there were even ten negative letters. It was just incredible how much support there was. Even Cardinal O'Connor said he didn't think the grant should have been withdrawn. The upshot was that a lot of other disciplines got involved and understood this was an issue which affected them. The controversy raised consciousness about the issues involved in a very positive way within the arts and more broadly within the general public.

I'm not sure what impact this controversy had on the directors of other arts organizations. However, included in the group of grants under which "Witnesses" was funded there was a retrospective of Andres Seranno's work. That show never happened. I just wonder how many "terminations by convenience" there were. I suspect that was one, and that there may have been others.

The other thing that was happening at the time, which didn't receive much publicity, was that Group Material was doing an AIDS timeline at the Berkeley Museum—a show which was also funded by the NEA in that same group of grants. Drew Oliver went out to inspect that show as well. While our show was still up, the director of the Berkeley Museum came to see it. I said hello and chatted briefly, and she said, "You saved us." That was really nice to hear, and I think it was true. Frohnmayer stepped in a hornets nest when he decided to make an issue of our grant. And he didn't have a clue that was what he was doing. I tried to tell him not to but he didn't believe me. He found out for himself. There were some artists and some of my colleagues who believed that in my handling of the situation, I was more concerned with protecting the institutional interests as contrasted to the artistic interests. In other words, they suggested that I was looking out more for Artists Space's interests and not enough for the interests of the artists in the show or for pressing to the limit the issue of freedom of expression. Artists Space's decision to remove the catalogue from the scope of the grant was for these critics a sellout. I think these Monday morning quarterbacks conveniently ignore that if I had truly sold out, "institutional" interests could have neatly and cleanly been served by a quiet termination of the grant and no one would have ever been the wiser. The difficult but important path to forge was to try to balance the different interests and work out an equitable resolution. Artists Space did that. As Artists Space's board noted, it was a "limited victory," but a very big vic-

tory nonetheless. The Artists Space controversy was an early but critical milestone on what has proved to be a long road, which promises to be longer still.

In some ways, the Artists Space controversy has been since swept under the rug because Frohnmayer had only been in office for a few weeks and it was a terrible blunder. After what happened with Leonard Bernstein, the president could not have been very happy with Frohnmayer. A lot of people who wanted the NEA to get on with it and bolster Frohnmayer up as a passable chairman, wanted to forget Artists Space as soon as possible because it was a horrible embarrassment, like a horrible wart in the middle of his face. He had totally blundered when he had every opportunity to avoid it. I went to the next National Council meeting and no one ever mentioned Artists Space once. No one said the words out loud. Maybe once or twice there was a vague mention of "the events of November," but that was it. No one wanted to bring it up. A lot of people were surprised that there's a lot about Artists Space in Mr. Frohnmayer's book. But not me. It was a major event in his tenure as chairman and a turning point in the history of this chapter of the "culture wars."

I don't know what I was expecting from Frohnmayer's book, but I wasn't surprised there was a lot about Artists Space because it was one of the few cases in which he had an ongoing negotiation with anyone. The only other person he had a similar kind of negotiation with was Joe Papp, whom he talked to when Papp refused to sign the restrictive conditions for a large grant in 1990. Papp did have correspondence and discussions with him. Papp's descriptions of those discussions were very different again from what was published in the book. Frohnmayer tried to downplay the real clash that occurred—maybe because Papp was so respected; maybe because Papp had since died; maybe a combination of those things. From what I understood from talking to people at the Public Theater and to Papp himself, that dialogue was quite different than Mr. Frohnmayer described.

What Mr. Frohnmayer did in his book (with regard to the Artists Space controversy) was exactly what I had tried so hard to avoid during the controversy itself. He marginalized Artists Space and me and painted the board and me as radicals who had sought to provoke the controversy. What is so ironic about his portrayal is that Artists Space bent over backwards to try to accommodate the NEA and tried to find an equitable resolution which would work for Artists Space, the NEA, and the artists in the show. It wasn't perfect for anybody, but it worked. It worked. I'm not sorry about what happened, and I would do it all again. I don't see any other viable options. I made a real attempt not to rub it in about his errors because I was

trying to keep the NEA together and Frohnmayer together so as to give the appearance of leadership and solidarity because the NEA was under such attack.

In all of the other controversies that have happened, there has never been a situation in which a grant was withdrawn after it was given. The NEA Four situation was different; Mel Chin's situation was different; MIT was different. By this time, I have done a great deal of research and there hasn't been another such case, before or since. I hope there never is.

7

The P Question:
A Satirical Examination
of Self-Censorship

by Joyce J. Scott

Scott is a visual/performing artist whose art has been exhibited and performed internationally. Her work with "The Thunder Thigh Review" and her one-person performance "Generic Interference, Genetic Engineering" constantly challenge society's response to freedom of expression.

Let's face it: we're scared of change. The apprehension of looking at others' behavior, their joys and profundities helps us see ourselves through them. This kind of self-perusal might require doors to unlock, modulation, transformation even. Damn! So what makes self-censorship in the arts any different than in other facets of society? We try to check our statements at lip's door, employ diplomacy without running roughshod. But, why would I believe that the same folks I was raised with, called me silly names in the playground, would be any more tolerant because they have entered the realm of art? It's the belief that the art arena is this rarified place where villains fear to tread, an environment that efficiently weathers all storms because of our purity and distaste for mendacity. Not!

The arts are a microcosm of the larger society, where all ilks mingling can be a tenuous affair. We're talking about your friends and relatives. Artists aren't from another planet. We're raised with the very people who find us offensive. What's that about? Why are we speaking incompatible languages? Why must I be muzzled when there's so much to discuss? Who actually believes there's only one way to say "anything"?

That old adage about "catching more flies with honey than vinegar" still holds sway. I've held audiences enraptured (okay, a grandiose assertion), the listener realizing the contents (emphasis on "con") held rancor only after their joy turned to suspicion. Is this situation sticky because of the

honey or the fly's escape? If honey is knowledge, then better for the fly, right? You know, just the hint of "new" changes some "good Americans" into "there's something lurking" naysayers. Many escape the boundaries of ethnic and social pressure. Try to realize that thought and understanding are inclusive, not exclusive. Needed armor in the war for freedom. Others relinquish the quest, stay guarded in innocence, too frightened for the trek. I'm calling on Mr. Spock.

I like to talk about all kinds of things, stuff that polite company tends to frown upon. Even though we all think and make jokes about these very basic matters. So I'm going to tell you this story about . . . it's . . . I . . . I . . . You see if you can't talk about ideas even in a covert or humorous manner, how do you get them out? Hell, better out than in. What about the ability to express thought with abandon, watch others respond, challenge, hold court, and even find solutions? I'm talking tackling the beast of unpopular opinion. How can freedom of expression be so out of favor when warnings from those suppressed for decades, having their lights hidden under baskets, probably made in reeducation camps, are finally heard? Why are we so angry when someone speaks up? The twenty-first century is around the corner, inventive strategies for global communication are necessary. You don't lose or become less by seeing more. Sometimes these hard-to-take themes, the kind that make you wince, squirm, and embarrass can explain ideas and conundrums plain talk cannot. They're not anecdotes devised by extraterrestrials or inconvenient utterances slicing secret silences in railway stations during an exchange of forbidden documents. These are everyday stories with a little twist. Anyway, my story poses one simple question: What happens if your pussy drops off? I bet you're looking at this page and trying to figure out if I am talking about a cat. Just what would happen if one day, while walking, your pussy dropped off and I'm not talking tabby here?

This is a difficult question for more than one reason. The idea alone is startling. Women would have to have a screw loose or have screwed loosely. . . . It's veritably impossible, so women laugh a lot; men on the other hand believe their penises actually could drop off, slip through their pants leg while writing a bank's withdrawal slip. See, the dangly part seems to make guys feel more vulnerable.

What could be more vulnerable than a pussy and why is it called that? This story I am going to tell you uses the word pussy a lot. I asked women to provide a substitute. Something packed with power, hilarity, that underlying punch. I got yonny (great in the hood), box, patch, and little mouse. I think the term "pussy" was made up by a man. Every time I use it I re-

linquish a bit, like giving him "some." But those examples lacked the ability to unnerve. What's wrong with nerves jangling? I know we're looking for an "I'm okay, you're okay" world. Hell, no pain, no gain. There's something to be said for secondary experiences. Like viewing a work of art. It can ignite you. If you combust spontaneously, it's from joy and insight and confusion, even disgust. The psyche bending pursuit of knowledge.

Somewhere down the line, it matters little who gave the name. It's power. That's the thing about this story or any that uses words or symbols that offend. What doesn't? For ideas to be ghettoized, squelched, is totalitarianism, thought control. Now that's terrifying.

This story needs a word that designates the area of the body as a place of mighty wonder and trembling. A region where great concern would be shown if it were lost. While I was a visiting artist, performing and giving critiques for grad students in Chicago, this story popped right out of my head. These grad students' underlying traumas were always in fear of what seemed to be super-simple problems, easily solved. Ideas like loneliness, being stupid to peers, unemployment, lack of creativity: you know, the same stuff the mailman feels.

Let's be practical. The outcome is seldom as dire as our dreams. Would your adviser actually set fire to your diploma in front of your parents, who mortgaged their future so you could have a better life? Nobody had anything that could justify such dread. Nothing like your pussy falling off right in the street. You don't know what to do. You didn't even know it was loose. You're pissed, which you can't even do now. This would be the day you decided not to wear pantyhose. "Yes it is a big birthmark!" In the middle of the sidewalk, looking down at your . . . of course, you do not admit it is yours. Isn't it funny how we can disassociate ourselves from our deepest possessions, epicentral, and we feign ignorance or indifference.

Men, you know guys, move it around with the toe of their shoes. "Is that a toupee or a . . . ?" But this is an actual part of your body, something you cannot lose. Just when you are about to reach for it, just when. . . . A dog comes by and picks it up. Just when it is clear that others' opinions are less important than salvaging a part of your sorely needed self. Crystal in your mind. . . . A dog runs away grasping your pussy in its mouth. You cannot catch him. Grabbing pedestrians' shoulders yelling, "That dog's got my pussy." No help to be found as the dog becomes a pinpoint on the horizon.

What shall you do? Off to the police station, where you are repeatedly ejected until you lift your skirt. The precinct is a mixture of pity and sarcasm as those jokes about sexless women ring true. Finally you make out

a missing pussy report. They show you canine mug shots. Lineup after lineup. Soon you don't know a terrier from a dachshund. You are desperate. This attachment is worth more than a body part and its physical function. Hell, your identity is involved here. A dragnet is established. They let search dogs smell your undies in hopes that the missing pussy is sniffed out. A description of a dog with a really good computer-generated image is hung at post offices. A Polaroid you happen to have of your pussy is reproduced on milk cartons with a caption saying, "Have you seen this pussy?" Details with dimensions as best you and a few close friends can remember are listed. You suffer the indignity of a reenactment on *America's Most Wanted*. Painful for you, especially choosing props. But, you were paid, given artistic input as a technical adviser, even a cameo appearance like Hitchcock.

I cannot imagine what you are thinking of me now. How could I say this to unsuspecting readers. Let's face it, who would expect this? That's part of the joy. Admit it, this story has verve. We're talking gusto here. Albeit the mutant kind. I bet you laughed. Drollery can transmit insight, empower. Humor seldom makes you suicidal, isn't disease ridden. So go for it. Push the envelope. Live out your dreams and get new ones. Yes, you may feel like a gyroscope sometimes. Isn't that spin part of feeling, living life? And your pussy definitely will not drop off!

8

A Brand of Censorship Called Racism

by Kimberly Camp

Camp is the executive director of the Museum of African-American History in Detroit, Michigan. Prior to this, Camp served as director of the Smithsonian Institution's Experimental Gallery, an initiative which encourages risk-taking in exhibition technique and style to help take exhibitions into the twenty-first century. Camp has served internationally on numerous panels about the arts and cultural diversity. She is a practicing professional artist who has been exhibiting her painting and dolls for over twenty-five years.

The controversy around art censorship and freedom of expression exploded in a mushroom cloud of sexual politics, public support for the arts, and moral outrage. Artists and arts organizations rallied to champion First Amendment rights for freedom of expression. Arts service organizations and artist-run organizations formed coalitions with arts leaders and activists in an attempt to create solid, forward-moving blocks of support to fight censorship as manifested in the elimination of public support of controversial artists and the presentation of their work. These were the new champions of the avant-garde. Many in the arts community agreed that First Amendment rights and the freedom to express our feelings, thoughts, and emotions were central to our existence as artists. However, the circumstances around which the controversy arose have created a silent, ticking bomb that may still yet explode.

As the dialogue about freedom of expression and censorship intensified, attention continued to be focused on homosexuality, feminism, reproductive rights, and patriotism. Although some of the artists creating these works were artists of color (African American, Asian American, Native American, and Latino), the controversy around these works was separate and distinct from that of racism and racial oppression.

The arts community actively sought the support and participation of African-American artists and arts administrators in this battle for First Amendment rights and freedom of expression. We seemed to be natural allies in the fight to end the suppression of these rights. Organizers thought that we would know what it was like to be censored and that we should naturally join their cause. Artists of color, in general, had a responsibility and an obligation to support artistic freedom, even though these same artists were as offended and distanced from the works as other conservatives. And, because the battle for cultural diversity and cultural equity in the arts was being waged with some small success, we were seen as a constituency with an already established network of advocates, workers, and leaders. We used a model of coalition-building that was popularized in the civil rights movement of the sixties. Indeed, we had mobilized to bring the arts establishment a message of hope for the enhancement of the arts industry in this country through embracing its diversity.

Whose Fight Is This?

African-American artists agree, in principle, with the need for First Amendment rights for all artists. There is no question about the quality or value of the works at the center of the controversy. However, work of a high aesthetic and artistic standard about controversial subject matter is in direct conflict with the values and moral standards of the African-American arts community. Our communities are morally offended.

In the African-American community, the struggle is still very much about 13th and 14th Amendment rights—the ability to participate in this democratic society without oppression and racism. Our needs are basic— the right to have access to publication, presentation, exhibition, and criticism from the public arts sector. Where are these new champions in our fight against an even greater institutional censorship called racism? These same champions who wanted all of us to have freedom of expression have been silent while artists of color continue to be eliminated from the mainstream of public support. Could it be that their issues are incompatible with ours? If so, why are we now looked at as natural allies?

Racism and Censorship

Suppression of African-American artists is nothing new. The history of our censorship is as old as our coincidental history with Europeans in the

Americas. It is as much about the denial of access as it is about the removal of enabling support.

In recounting the early history of jazz in America, A. B. Spellman, director of the Expansion Arts Program at the National Endowment for the Arts, tells of a time when it was illegal to play jazz after dark. The morality policemen of the twenties decried jazz as the devil's music. Jazz was blamed for birth defects and madness in women. In one specific instance, a cruise ship had set sail from a port in New York. Safely at sea, the musicians felt secure in their presentation of jazz melodies for the would-be vacationers. After all, they had been out to sea for hours, far from New York shores and the laws banning jazz after dark. The captain of the cruiser ordered the ship around and the musicians were arrested when they reached port later that night.

In the eighteenth and nineteenth century, laws were enacted in the United States to ban the use of drums and other forms of traditional cultural expression in the pogrom to destroy and decimate African diaspora culture. In 1817, laws were enacted in Louisiana to prohibit dancing by Africans in New Orleans' Congo Square. As slaves gathered to celebrate their cultural traditions, dancing in the round and drumming, they were met with the long arm of the law. The fetes were declared illegal and punishable by imprisonment and whipping. These African artists were quick to develop new forms which allowed them to stay within the law, while maintaining some aspect of their traditions. For instance, when local laws made it illegal to perform certain steps, dancers modified the dances so they could still perform.

In 1891, Henry Ossawa Tanner, an African-American painter who studied with Thomas Eakins at the Pennsylvania Academy for the Fine Arts, had to leave the United States to gain access to exhibition spaces, aesthetic dialogue, and criticism. In 1939, the Daughters of the American Revolution (DAR) refused to let operatic singer Marian Anderson perform in Washington, D.C.'s Constitution Hall. An artist of international renown, Anderson ran into the brick wall of racial segregation commonly practiced during the time. To the DAR, this was a way to prevent her artistic contribution from becoming part of the Eurocentric cultural heritage exemplified in our nation's institutions. Undaunted, Anderson performed beautifully on the steps of the Lincoln Memorial to tremendous acclaim.

These are just a few examples of the countless situations where African-American artists have been excluded from the societal dialogue of art.

Even now, only a handful of African-American artists are invited to exhibit in major institutions, fewer are written about, and an even smaller group invited into an aesthetic and critical dialogue with their European-American counterparts. The stories of artists of the African diaspora continue to be conspicuously absent from the documented cultural history and aesthetic traditions of our nation.

In 1987, a group called PESTS produced an exhibition list published in the "Art in America Annual 1987–88." Listed inside were numerous announcements of exhibitions featuring artists in New York and other cities. The artists listed were those of note: Howardina Pindell, Ana Mendieta, Pepatian, Camille Billops, Benny Andrews, Jacob Lawrence, among others. Interspersed in the listings were announcements titled "Pest-a-cide" and "Pestwatch." These announcements illustrated the lack of diversity in major art exhibitions, programs, and publications.

An example of an announcement from the listing is as follows:

Pestwatch: Why do these critics and curators consistently avoid investigating the work and accomplishments of artists of color:

Richard Marshall - curator, Whitney Museum - *50 New York Artists*, with Robert Mapplethorpe, Chronicle Brooks, Chicago, 1986 (100% white)

Donald Kuspit - critic - *Monumental Space, Variation*, One Penn Plaza, 1986 (100% white)

Charlotte Kotik - curator, Brooklyn Museum - *Monumental Drawings*, Brooklyn Museum, 1986 (100% white)

Howard Singerman - editor - *Individuals: A Selected History of Contemporary Art*, a collection of essays by Kate Linker, Donald Kuspit, Ronald Onerato, Germano Celant, Achille Bonito Olivia, John Weldman, Thomas Lawson, and Hal Foster, Abbeville Press, NY 1987 (98.9% white)

Has the *Projects* Program at the Museum of Modern Art (overseen) by Linda Shearer ever included artists of color? Why has it always concerned itself with the work of artists of European descent? Can we hope to expect a broader view in the future?

This quotation is not used here as an indictment of those named. Rather, it is to illustrate an important point not missed by PESTS themselves. The point is illustrated in this quote from the publication:

> This newsletter has burned all of our financial bridges. If you'd like to keep our antennae out of the water send us a donation. It will be put to good use.

The Contemporary Reality

In the current controversy over censorship, African-American artists have been placed between the proverbial rock and a hard place. Freedom of artistic expression, access, and public support are critical to our existence. Yet, African-American artists have been asked to rally around works that are contrary to their familial traditions and values. Some artists in decision-making positions are really torn. Some do not endorse the First Amendment fight because they so strongly disagree with the nature of the content of the art. They know intrinsically what issues are at stake, but they also know they do not have the support of their communities.

In 1989, a panel was convened during the congressional Black Caucus weekend to discuss African-American artists and public sculpture. Because the NEA controversy about restrictive language was brewing, and because there had been overtures to African-American artists to engage in the dialogue, panel organizers felt the issue of public support and artistic freedom of expression would make a more timely presentation. They found instead that the audience could care less about Mapplethorpe and Holly Hughes. For the audience, basic support and access to training, materials, commissions, and recognition were more important.

Constitutional law and its implications for artists are important to everyone. However, the basic concern for African Americans is survival. There are not many black artists in policy-making positions in the national arts arena. The discussion of censorship and racism involves the decision-making process over who should benefit from public dollars used to support the arts and arts institutions. This is where the real battlefield is. And, the land mine of racism is still armed.

The Battle of Survival: Access to Public Arts Support

In the early eighties, the civil rights struggle had reached the national arena of public arts support. In 1985, reauthorizing legislation for the National Endowment for the Arts included language which addressed the need for increased support of underserved constituents among rural and multicultural communities. This change, designed to create funding equity, helped to facilitate the greater inclusion of artists of color in the decision-making process of the agency. Since that time, changes in the composition of panels and staff have aided in the greater diversity of support at the national level.

Toward the end of the eighties, it was almost as if our movement toward artistic equity and the diminishing of racism collided head on with sexual politics and public support. The burgeoning support for artists of color was eclipsed by the explosion of sexually explicit political artwork which became the centerpiece of the fight for First Amendment rights. And, it wasn't long before the numbers of artists and arts organizations seeking support for work which dealt with sexually explicit images and reproductive rights drastically diminished. At the same time, there was consistent growth among the numbers of artists of color seeking support for art about identity, ethnic celebration, and experimentation with traditional and cross-cultural expression.

What was initially thought to be an emerging, but significant movement toward an ongoing artistic dialogue about sexual politics and patriotism, seemed to crest and fall rapidly in the late eighties. By 1990, the absence of controversial works in the applicant pool contrasted with the relatively small but growing numbers of successful applicants among artists of color was noticed with grave suspicion by the new avant-garde. Had funding shifted from the avant-garde to artists of color? Could there be other reasons for the perceived shift? One reason for the perceived shift in government support might have involved the eligibility restrictions at the NEA—individual artists who received support were not eligible to apply again for three years. Maybe the movement had peaked and ebbed. Had this new avant-garde reached its high point, albeit short-lived?

Concurrently, a dangerous schism was forming in the arts community. The new avant-garde saw artists of color as pawns. Some thought that artists of color had been enticed to take grant money, thereby trading their primary concern for First Amendment rights for all with concerns for equal access and cultural diversity. This premise is devastating. First, it assumes that the work of artists of color has no merit beyond its use as a tool to dent public support for the avant-garde. Further, it assumes that artists of color cannot compete for public support with the avant-garde in the standards established at the NEA.

African-American artists, on the other hand, are feeling used. They have earned a place at the table in the distribution of public support for the arts. Hasn't there been demonstration of outstanding artistic quality and professionalism among our organizations and artists? Haven't we also been able to maintain cultural integrity in our artistic traditions, yet move into the avant-garde, experimenting with both new forms and old? Have our achievements in creating greater access to public support for African-American artists been diluted with the issue of sexual politics? Even the

form of protest and struggle used by the new avant-garde was modeled after our own civil rights movement, crafted by African-American leaders throughout our history in the Americas.

The civil rights movement in the sixties was about our survival. The African-American community formed coalitions with people of different interests, but whose personal agendas could be serviced by the central goal of social justice and equality. The methods and structure of the civil rights movement have since been used by people all over the world. Newly formed coalitions, including those in the arts community, splintered off from the central body and developed platforms for other, specialized issues. These factions made gains, eschewing the common goal of equity and social justice for everyone. More important, as these splinter groups gained momentum, they began to practice oppression and embrace the racism which they initially sought to defeat.

Many artists of color are reluctant to enter the censorship dialogue, fearful of airing their concerns about race, culture, morality, and public support. Many more are leery of alienating their colleagues with the discussion of race and racism. Any division in the arts community can be devastating. The strength of the collective rally of the arts community around freedom of expression is weakened. Without a sense of unified mission, the diligence of the conservative right is strengthened.

In 1991, the National Association of Artists Organizations planned a session for their annual meeting called "Cultural Diversity vs. the Avant-Garde." The premise behind the panel was the appropriation and decontextualization of the art of people of color. The hope was that panelists would illustrate how major institutions were exploiting the very nature of our work. However, the title of the panel was perceived to be so damaging to our progress to date toward a unified mission that the name was changed.

Race Muddies the Waters

The cultural battlefield plays host to many warriors. Among them are the warriors of Eurocentrism as the backbone of American tradition. To them, maintaining Eurocentrism is as important as maintaining their notion of our identity as a nation. The champions of Eurocentrism don't acknowledge the contributions of African-American artists in the canon of "real" or "classical" high art. They herald the self-indulgence of monocultural artistic expression.

However, most of the artists involved in the creation and support of con-

troversial work are European-American. They move freely in the main-stream, yet they attack the very basis of morals, patriotism, sexuality, and politics of their community. This is why the battle with the cultural elite and the conservatives is such a dangerous one. On both sides, there is a feeling of betrayal, of confusion about who is the real enemy. While this battle impacts the African-American arts community, it is not our fight. In principle, however, we must support everyone's right to freedom of expression.

Would the impact of Mapplethorpe's work have been different if the subjects in the photographs had been white? Was the offensive nature of these images complicated by the race of the subjects therein? What impact did its national profile as an example for First Amendment issues have on rallying support for constitutional law in the African-American community?

Yet, outside of our community, issues of race and racism have been placed in a position of lesser importance. Some might say that a work of art knows no color. Others feel that censorship is often manifest not in the judgment of the work itself, but rather in the color of the artist. There are stylistic and symbolic clues—cultural coding, narrative, biographical forms, colors—which define the culture of artistic expression.

Conclusion: What's Next?

Access to major institutions and influential galleries for African-American artists is still severely limited. We are a long way from the elimination of the problems caused by racism in the arts. The arts industry in the United States is just experiencing the beginning of its own civil rights movement. Arts institutions are one of the last bastions of Eurocentrism. Its icons, traditions, and members are an institution they mean to preserve unchanged.

The network of cultural institutions is part of a societal system designed to perpetuate existing morals and beliefs. The cultural institution is designed to withstand and resist any and all change. The nature of an institution is not dynamic, contrary to the very nature of the arts. Arts institution policymakers continue to monopolize powerful positions. They train their sons and daughters to step into their shoes in order to maintain their stronghold while keeping others out.

Because the social and political history of the Americas is fraught with racial discrimination and oppression, a connection can be made between artists of color, as though Latinos, Asian Americans, Native Americans, and African Americans are fused at the hip. We are not. Although there are

similarities in the European-American reaction to our existence, our cultural differences and aesthetic traditions are not the same. Our experiential base is different. However, our collective cultural empowerment can lead to political empowerment.

It is important to note that African Americans in the United States are decidedly conservative, practicing traditional family values based in the canons of Christianity and Islam. Further, African Americans continue to avoid public dialogue about sexual politics. African Americans have historically been fiercely patriotic, fighting as much for the United States as they have for their recognition as first-class citizens in the country, as evidenced in the great wars of the last three centuries.

We continue to wage war against oppression and exclusion in the arts. Not to acknowledge racism as a brand of censorship is to condone segregation of African-American artists from the institutional fiber of the country. Until we can develop an even playing field where issues and values are reinforced with integrity and commitment, the arts community as a whole will be at a disadvantage. And, until we work together to identify long-term and short-term solutions to combating racism, other battles for equity will lose energy and be defeated for lack of sincerity. The impact of the exclusion of African-American artists and art forms is a lack of richness and challenge in our country's artistic vocabulary. We have an obligation to lift our heads out of the sand and continue to grow from the exposure to and immersion in real artistic freedom—that which allows everyone to participate.

9

Censorship Chicago Style: A Personal Account

by Diane Grams

Grams is an artist who documented censorship cases and actively advocated for artists' First Amendment rights from her position at the Chicago Artists' Coalition (1984–1992). She is currently the executive director of The Peace Museum in Chicago.

The swift confiscation of a painting at the School of the Art Institute of Chicago by city alderpersons in the spring of 1988 happened before most anyone heard the painting was on exhibit. The painting depicted the recently deceased, beloved, first black mayor of the City of Chicago— Harold Washington—in women's lingerie.

According to the artist, the painting was not about truth (the subject that has preoccupied 2,000 years of Western art) but rumor. Rumors purportedly started by the Chicago City Police Department that the unmarried mayor was gay. Rumors that the mayor was bending over to pick up a pencil when he had the fatal heart attack. Rumors that, as the emergency hospital crew ripped off his clothes, they found him wearing women's lingerie. The painting, titled "Mirth and Girth," (the title of an overweight gay men's club in Chicago) was apparently illustrating the artist's answer to the question "What if the rumors were true, what would it all have looked like?"

The result was laughable in concept and execution. It was also consistent with artist David Nelson's twisted sense of humor. This humor is best seen when comparing "Mirth and Girth" to another of his paintings that featured the president of the school, Tony Jones, as the baby Jesus in Mary's arms. Mary is offering Jones her breast to suckle; Jones is looking out at the audience as a giggling, sexually excited baby Jesus/dirty old man.

While the Baby Jones painting did not go to the heart of several pro-

found social failures whose time had come, "Mirth and Girth" certainly revealed many. Among these were: elitism, homophobia, and racism.

Most people in Chicago were still mourning Washington's shocking death. While his death left the city in political chaos and the Progressive movement in even greater chaos, it devastated the black community. Blacks saw the painting as a predictable step by whites to posthumously discredit a great black man and deny him his rightful place in history. In fact, according to the artist, the painting was quite pointedly and consciously iconoclastic. It was inspired by a poster that featured Washington in the clouds with Jesus overlooking Chicago with text below stating "Worry Ye Not."

Only once did I hear anyone question the homophobia. Bill Stammets, a filmmaker and occasional writer for the *New Art Examiner* asked in a panel co-organized by the black and white artists,[1] "so what if he was gay, does that make him less of a hero?"

Emotions ran high. At the panel, a man stood up in the audience and reminded us of the history of whites co-opting black culture, ripping off black artists and profiting for themselves. Elvis was one example of white culture needing, then creating, a white boy who could sing blues for white girls to scream about—in order to keep them away from black men, he said.

Within all the hysteria, a local newspaper columnist, Mike Royko, labeled the aldermen who confiscated the painting as "the legacy watchers." They had something to prove. In an all-night city council session to establish Washington's successor, the favorite of the whites won. He was a black man who was labeled by some as something similar to an Oreo cookie, an Uncle Tom, or a Negro. The Harold Washington party and the person who some blacks and Progressives believed should have been Washington's rightful heir, lost. "The legacy watchers" had voted for the winner.

In seeking understanding, the School of the Art Institute apologized for the "distress" caused by the incident in full page ads in the *Chicago Tribune*. These ads, if paid for, would have cost $40,000 per page.

In the ongoing effort, a white art history professor pointed out, "Of course they'd break the law for what they believed. Black activists had to break the law to get civil rights in this country."

The ACLU filed a lawsuit on behalf of the artist against Police Chief Leroy Martin, and the alderpersons who confiscated the painting. One of the aldermen was Bobby Rush, a one-time Black Panther and member of

the Chicago Seven put on trial for crimes against the Democratic party run by old man Daley.

Some of Chicago's most prominent artists began using the word "censorship" and began organizing. Among those taking an early stand were many of the founders of the Chicago Artists' Coalition, including seventy-two-year-old activist and accountant to many Chicago artists, Ruth Talaber. ARC Gallery hosted meetings that were attended by SAIC staff and many artists including Edith Altman, Otello Anderson, Joan Lyon, Arlene Rakoncay, Frank Piatek, and others. It was the belief of many who attended the meetings that the school should have taken a firmer stance in support of freedom of expression. Others thought this was the clearest case of First Amendment violation they had ever seen. Still others did not want to blame the Art Institute for any failure. While some blacks and Latinos attended the meetings, the coalition did not appear to be supported by the majority of people in these communities. Nonetheless, the group of over 300 artists (which later called themselves the Committee for Artists Rights [CFAR]) published ads condemning the censorship and the School of the Art Institute's apology.

As charges of censorship gained support, the voice of black artists got louder. "What do you mean censorship? Where have you been for the last 200 years?" some said. Historic and institutional censorship was the charge. Censorship by cultural devastation. Censorship by economic denial. Censorship by slavery.

The once graduated segments of the left wing were distinctly different colors of the rainbow. There simply was no common ground. Few involved were able to pull back enough to realize how art controversy made a fruitful situation for political maneuvering during the Reagan/Bush era. In Chicago, there was more than a division that separated blacks and whites. There was a total splintering of the coalition that elected Harold Washington. This included Chicago's arts community, political Progressives, lakefront liberals, civil rights activists, and civil libertarians. For an essentially Democratic city, Chicago gained Republican potential. Several politicians began positioning themselves for a political leap forward.

Richard M. Daley, son of former mayor Richard J. Daley and state's attorney during the city council battle over an acting mayor, remained out of the picture. He quietly positioned himself for victory in the special mayoral election held in early 1989—sixteen months after Washington's death.

Throughout the legal wrangling that would last for years,[2] the new Daley administration was able to finagle out of any legal liability for the

alderpersons who confiscated the painting. Even though they stormed out of a council meeting where all were astir over the painting being on display, Chicago's corporate council did not have to defend them nor did Chicago's taxpayers pay for their defense. Another crumbling within the Progressive movement. Many Progressives felt the ACLU had betrayed their cause and were in cahoots with Daley as he threw the alderpersons to the lions.

While this may make for very interesting material for daytime soap opera, and, there certainly is enough material for several years to come, the off-center rotation of Chicago politics continued into the following year of 1989.

In February came Flag Flap I. Dread Scott exhibited his multimedia work "What is the Proper Way to Display a US Flag" in "A Part of the Whole," an exhibit of "minority" artists at the School of the Art Institute. The same work had been exhibited the year before at a neighborhood arts center, near Northwest Arts Council. There was a small tiff when a man grabbed the flag up from the floor, but conflict mediators immediately stepped in and diffused the potential argument.

This did not happen at the School of the Art Institute. There was no one stepping in to mediate. When controversy broke out, it appeared from the outside that the school and all people in positions of power and influence in the City of Chicago ducked for cover. The school was looking for some good press with this "multicultural thang." But instead, the walls almost came tumbling down.

I did not realize how serious it had all become until much later. From the outside it seemed like a media circus that the School was just too meek to handle. Liz Shepherd, the editor of the *Chicago Artists' Coalition News*, and I went to the School on the first day of significant protest to witness the commotion for ourselves. Upon arrival, the Chicago police ordered us to choose a side. We said, "What?" He said, "Here's the line" and drew an imaginary line separating the School and the pro-flag veterans. At the time, I thought it a smart police practice. Even though, at that moment, I was basically neutral, I thought it was a good idea to keep the two sides from scratching each other's eyes out. I later learned, in a Neutral Observer Training Workshop hosted by Citizen's Alert,[3] that this was not necessarily a productive move. In fact, the police forced polarity and created unnecessary antagonism.

CFAR was not a mediating force. Its goal was to strengthen the voice of the students through numbers and influence. It had been organizing since the previous year. Mailing lists were developed. Plans for a fall citywide

series of events titled "Inalienable Rights/Alienable Wrongs" were under-
way when Flag Flap I hit. CFAR joined student groups in organizing a
demonstration in support of freedom of expression. It was well attended
by several prominent and mature artists. Among these: Edith Altman, Bar-
bara Aubin, Chapman Kelley, and Richard Serra, the New York artist who
had just lost his final battle in the removal of "Tilted Arc."

No press releases were sent announcing the demonstration. The press
was at the School daily. State Senator Walter Dudycz performed daily with
the flag. We naively believed that it was the role of the press to cover
events. On the evening and nightly news our demonstration was virtually
not mentioned. In an act of absolute disbelief, we called and demanded to
speak to the news editors. They returned our calls the next day and in-
formed us that we were not very organized. They didn't even know we
were going to be there. I screamed, "What do you mean, do I have to fax
you a memo?" One said, "That would be helpful." At that time I learned
that camera operators were simply technicians whose work was directed
and snipped by news creators in the studio.

From that day forward, I insisted on talking with reporters covering the
event. Many in the arts community seemed to like that arrangement. While
I wasn't paid for it, I became an ad hoc spokesperson. While I worked for
a small artists service organization, I did not work for an institution, so
there was no easy target to shut me up.

In speaking with reporters assigned to cover the Flag Flap, it always
seemed they might as well have been obituary writers. They seemed unin-
formed and unable to grasp the complex dynamics within the arts commu-
nity, the black community, or Bush's Patriotism Machine. News writers
did not know how to write about the arts. Arts writers did not know how
(or were not allowed) to write about daily news events. No one seemed to
ask why this was happening. Each reporter only seemed to watch for that
moment of controversy which added spice to the day's doldrums.

Dudycz always provided the spice. There was the day he stapled the flag
to a wood stick then threatened to file charges against gallery director
Joyce Fernandez for damaging his property—the staples. Then there was
the day he put the flag in an overnight postage envelope addressed to the
president and threatened to file charges of tampering with the mail if it was
opened. Then there were the endless lines of veterans who filed into the
School to pick up the flag and fold it. There were also those veterans who
carried weapons. Apparently, the police found small explosive devices, but
were unable to arrest those veterans for possession because they were not
set to explode.[4] Momentum built for a Sunday rally in front of the Art In-

stitute Museum. Plans were made to burn AIC membership cards. Dudycz planned to read the list of corporate donors and call for a boycott. Rumors were that thousands were to attend.

Joe Medash, SAIC student president, built a huge stencil of a flag. Early that Sunday, he stenciled numerous flags on the sidewalk in front of the museum forcing the protestors to stand on images of flags. City officials called out emergency crews to clean the sidewalk, making way for the protestors to freely exercise their right to protest without having to desecrate an image of the flag. Medash was later arrested.

The Chicago City Council responded to Dread Scott's act of desecration by adopting and amending a 1909 State of Illinois law that prohibited flag desecration. The law defined a flag as "a flag, a picture of a flag or a representation of a flag . . . a flag of any nation," and it prohibited writing on the flag, trampling or destroying the flag, and "attaching a flag to a piece of merchandise to decorate or call attention to it." The law did not prohibit laying it on the floor. There was no major problem with flag burners in 1909. Rather it was directed at grain merchants. In 1909, some in Illinois thought it unpatriotic that grain growers used the flag as a logo to sell their products. The law was intended to prohibit the grain sellers from printing the flag on grain bags. In 1989, the Chicago City Council added the prohibition of laying the flag on the floor. Following Dudycz's lead, the State of Illinois similarly amended the law. They furthermore voted to instruct the Illinois Arts Council to give the school no more than $1 in grant monies.

Columnist Mike Royko pointed out that Senator Walter Dudycz used the image of the flag on plastic bags in which his campaign literature was distributed. Dudycz's literature pointed out that the bags doubled as trash bags for the car. The flag being used as a trash bag, Royko pointed out, isn't that desecration?

There was more quiet repositioning being done. In fact, the Veterans Administration was awarded a position in George Bush's cabinet during the Flag Flap.

Planning for "Inalienable Rights/Alienable Wrongs" continued. CFAR's goal was to set in motion a structure for the arts community to make a unified statement in support of freedom of expression. Artists sought to take control and set the terms of the message rather than be reactive to someone else's agenda. Arts organizations and artists throughout the city signed on. Over forty events were organized by midsummer. Included in this series were ten exhibits, nine lectures, several performances, poetry readings, and film screenings.

The Supreme Court ruled on Joey Johnson's case also in the summer of 1989. The Court affirmed that burning a flag at a demonstration was political speech and therefore one of the highest protected forms of speech. Johnson, a librarian from Texas who burned a flag at Ronald Reagan's 1984 Republican Convention, was triumphant.

In late summer, CFAR began assigning artworks that had been submitted to the series by artists in the ten exhibits it had scheduled. CFAR saw its role simply to categorize works according to themes. No works were to be excluded. Selection processes were a form of censorship.

All the artworks containing flags went into one exhibit, including Dread Scott's piece. Even though the constitutionality of flag burning had been affirmed, flag desecration laws, like all laws, stay on the books and enforceable until specifically stricken by the courts or by action by lawmakers. We inquired to the ACLU if we could show Dread's piece. They asked to see slides of the flag works. They said that not only was Dread's work still prohibited under local and state law, but the entire exhibit was illegal. They offered to represent us.

Each of the artists was notified of the potential problem. Thirteen of the sixteen artists agreed to press forward and risk a possible lawsuit. One of the artists who pulled out had a sick mother. Later his representative said she thought the suit would have hurt his reputation. Another artist said he didn't want to be "Dread Scott's whore." The thirteen artists who agreed to press forward created a dream case for the ACLU. The clients were from diverse ethnic, sexual, and age group backgrounds. Their works ran the gamut of very patriotic to revolutionary. All the works were informed and represented various aspects of the artistic, religious, social, and political dynamics involved.

Among the artworks:

- "Freedom Fighter's Last Request" (a small ceramic piece featuring a dead Contra with a toothpick flag stuck in his heart) by Cesario Moreno, an American with Mexican roots;
- "A Clarion Call" (a mixed media collage on the historical nature of art controversy featuring flag stamps and toothpick flags) by Barbara Aubin, a sixty-two-year-old art professor at Chicago State University;
- "Z-Flag" (an airbrushed image of a flag with the text "It is axiomatic that individual liberties are secondary to the requirement of national security and internal civil order"[5]) by Mark Paternostro;
- "Who Are We Protecting?" (a watercolor of a large flag tattoo covering the entire bottom half of a male body with genitals revealed) by

Katherine Rosing, a suburban woman who typically painted water-color flowers but was outraged by the flag events;

- "A Government Too Menaced by Art Becomes an Ostrich" (a sculptural piece with the lower half a female mannequin stuck in a pile of sand, the soles of the feet with flags painted on them) by David Jefferson;
- "Allies" (a large circular painting created pre-glastnost featuring the U.S. and U.S.S.R. flags balanced in a yin and yang symbol with the text "Allies" written over it) by Dennis Laszuk;
- "God, Guts and Gun" (a small painting on wood featuring Jesus on the cross with a flag for a loin cloth) by Peter Cramblit;
- "What is the Proper Way to Display a U.S. Flag?" (a mixed media work featuring photos of flags on caskets of dead soldiers and Cambodians burning flags, a flag on the floor, and a blank comment book on a shelf between the flag and the photos) by Dread Scott, a revolutionary who was raised as a middle-class black and went to the same school as Nancy Reagan.

Many in Chicago could not bear the thought of yet another controversy. A group of arts administrators asked us to cancel the exhibit. We did not know what we were getting into, they said. . . . We could ruin funding for the arts in Illinois and nationally. . . . The seriousness of the situation could not be stated strongly enough. . . . What the arts community needed to do was to communicate that the arts were good, they said.

While there were definitely moments when we considered finding a way out, the artists in the group, in general, screamed loudly that we could not pull out. Among those screaming the loudest was Judy Robbins, one of CFAR's most active members. For the artists in the group, it was a matter of personal integrity. The Chicago Artists' Coalition board, the organization which CFAR had become a subgroup of, encouraged the artists to continue with their plans.

A nonprofit organization which had boldly agreed to host the exhibit got cold feet once they learned of its potential illegality. The director immediately canceled her organization's participation in hosting the exhibit. Even though she had not received government funding in the past year, she felt she could not put an entire organization on the line for one exhibit. She agreed to host another exhibit, but not that one.

Over the next two months, four more galleries boldly agreed to take a stand, then pulled out. One gallery had street-level plate glass windows. Their insurance company said the exhibit would not be covered since they

would be inciting a riot. One gallery toyed with the idea, but decided against it for political reasons. The next gallery agreed to host it as its grand opening exhibit, but later canceled on the advice of an attorney/relative who warned them of potential unending charges of code violations to their new space. The next gallery interested in hosting the exhibit was closed down for selling liquor at their openings without a liquor license. The practice of giving away wine at openings progressed to many nonprofits accepting donations for drinks or to the selling of tickets that could later be exchanged for any type of refreshment. This gallery, the Edge of the Looking-glass, was a for-profit that openly sold liquor. Gallery Director Chris Murray would not agree to host the exhibit because he feared the politically controlled liquor licensing would be tied up indefinitely.[6]

The search for a gallery to host the exhibit was hampered by the City of Chicago's actions. In early August, ACLU attorneys Harvey Grossman and Jane Whicher sent a letter to Mayor Daley seeking assurances that no arrests would be made if the exhibit proceeded. The young Daley administration's "proactive" response was to immediately file a lawsuit against us. It was its contention that the exhibit was a commercial activity meant to market our artwork, therefore it was not afforded the same protection as political speech. Furthermore, unlike a flag burning which lasted only a few minutes, the exhibit would last a long time, forcing the city to expend thousands of dollars to protect us from the protests that were bound to occur.

We were not prepared by the ACLU for this swift action. The ACLU expected a letter back stating yes or no, or no answer whatsoever. It was shocking because the move landed us in state court. The ACLU had attempted to keep us out of state court since they have a tendency to uphold the law rather than the Constitution. The ACLU immediately filed a countersuit on our behalf.

Since the law made it a crime to even possess such works, the ACLU sought the court's permission to have a press conference to show the works we were being sued for. The court gave permission. Dread Scott sat next to Cesario Moreno at the press conference. Scott wore a Mao T-shirt; Moreno wore a Nelson Mandela T-shirt. Moreno asked that the press not assume that we were all revolutionaries. In fact, he said he did not believe in most things Dread said. In order to make us out to be rabble-rousers destined to break the law, the press repeatedly asked "What will you do if you lose? Will you go ahead with the exhibit and risk jail?" We did not think we would lose. Our response was: "The question is what will you do? If we lose our freedom of speech, you are next in line." There was no response.

Cook County Circuit Court Judge Kenneth L. Gillis agreed to hear the case based on the ACLU's contentions, not the City of Chicago's. The Judge did not feel the city had any standing. Furthermore, he felt it was unconscionable that the city answered the request with a lawsuit. He felt we did have standing since, according to him, we were being prohibited from earning a living because we were prohibited from showing our work. The court needed some logic to hear the case—to give us "standing." But, little does the court know that most artists do not earn a living off the creation or display of their work. Furthermore, most artists do not create their art for money. The driving force is to create information and influence the flow of knowledge and culture.

In a sweeping ruling at 2 P.M. on Halloween 1989, Gillis struck down the City of Chicago's law and stated that "the flag is a symbol of diversity . . ." and that "artworks clearly are a form of communication. . . . For every artist who paints our flag into a corner, there are others who can paint it flying high. . . . It is the nation's resilience, not its rigidity . . . which is at work here. Also it is the country's strength that is reasserted today."[7]

The ruling paved the way for a CFAR Halloween celebration where the public was invited to "come as your favorite censorship victim." The ruling also opened one door for the exhibit. We still had the State of Illinois's law to tackle, but prospects looked better. A gallery finally agreed to host the show. Lannon Gallery was a commercial space in the west loop warehouse district run by a young woman, Marilu Lannon.

As the ACLU pursued the state law, we proceeded with plans for the exhibit in December. It was named "Symbol of Diversity" after Gillis's statement. Twenty-three artists now wanted to be in the exhibit and more kept asking to participate.

One week before the scheduled opening on December 6, 1989, representatives of the State of Illinois appeared at the assigned court date and filed papers indicating they would not prosecute. There was now a clear "legal" path for the exhibit to proceed, but the show did not go on without further incident.

The private opening for the artists, friends, and the press on December 5 was packed. Flag toothpicks carried hors d'oeuvres, a flag cake and red, white, and blue cups, plates and napkins were everywhere. The next day, Senator Walter Dudycz announced on the radio he was going to attend the public opening and have arrested anyone who was desecrating the flag. I phoned him and asked him if this was true. He said he was not going to

create any disruptions. Nonetheless, an hour before the opening he repeated his threats. We made certain the ACLU attorneys were on hand. The ACLU demanded that high-ranking police officials attend and review the court documents.

The opening was full of detectives who were there because Dudycz, a former police officer, filed a complaint. We fantasized about who the FBI agents were.

We prohibited the press in the exhibit while Dudycz was inside. Dudycz was let in and immediately cornered in the stairwell by Grossman and Lannon's attorney who firmly stated Dudycz would be arrested if he disrupted the exhibit in any way. Disruption included picking up the flag or holding any type of press conference inside the exhibit. He could view the exhibit via a guided tour by myself and the gallery owner. He looked at everything. He met many of the exhibiting artists.

When he came out, the reporters pressed us against the door. They asked him what he saw. He said he saw some patriotic works, some good works, some he liked, some he didn't . . . then he went into his rehearsed statements about the flag on the floor. A woman reporter from the city news bureau interrupted. . . . "But, Senator, the news is what was on your face when you saw the flag on the floor." I screamed something to the effect, "So that's the news for you people. Well let me tell you this is not your party. The news is that there are twenty-three artworks made by twenty-three artists upstairs who have fought for this exhibit and despite efforts by many, the exhibit opened." Dudycz vowed to hold a vigil every day at noon until the flag was off the floor. I feared the power of the press to make me look like a fool screaming. But, they did not. Nor did they shout censorship when we informed them that they could not document Dudycz viewing the exhibit.[8] We were not giving him a forum in our exhibit.

The press was allowed in after Dudycz left. They stood by the flag and took pictures whenever someone stepped on it. The *Tribune* ran a photo of a man in a suit stepping on the flag signing the book. Their account of the event was basically balanced. I spoke to every cameraman and reporter. We sought to befriend the members of the press. The next day they showed up and mysteriously hung out from 11:30 on. Didn't film much. Didn't ask many questions. I suddenly realized they were waiting for the senator to show up. I told them he would be arrested if he came in and held a press conference. I asked them not to encourage him. Dudycz came daily at noon but did not come in the gallery while the press was there. The first day, I went down to overhear a man representing one of the unions ask him

if they should mobilize. Dudycz realized I was looking over his shoulder and said no. Only one veteran and his son showed up to protest the entire time.

We received several harassing phone calls. A man screamed at me about my patriotism. I continually interrupted him asking him his name. He refused and got more frustrated. I said I found it interesting that he was advocating censorship but refusing to identify himself. He screamed louder that his name was not important but that I was a whore and then he hung up.

On the third day of the exhibit we received a bomb threat shortly before closing. We called the police and reported it. Minutes later a drunken veteran showed up. It was clear from the moment he walked in that he was trouble. We called the police again, and then again in ten minutes. The operator answering the phone said we would just have to wait, even though the police station was only blocks away.

As a condition to being in the show, all the participating artists had to help gallery-sit, two at a time, with "a security guard" from a "crowd engineering firm." So, there were several of us there. Barbara Aubin spoke to the man for almost fifteen minutes. Then he pulled a knife, and waved it back and forth, then grabbed the flag and ran. Fortunately, the layout of the place forced him to run past the police who had just arrived. Aubin and I pressed charges and called the ACLU.

We immediately got calls from the press. They had police radios and were monitoring the situation. I asked them to leave us alone. When I got to the police station the woman from the city news bureau was already there.

We had to wait at the police station for hours. Finally, we were allowed to leave. Somehow the lock on the door entering the building housing the gallery was mysteriously broken. We could not prohibit entry into the building overnight. When ACLU Legal Director Harvey Grossman arrived, suddenly the door worked again. Then we found out that the police wanted to charge the drunken vet with a misdemeanor then let him go. He was the brother of the boyfriend of an arts rep. We did not want him released for fear he would come back. We wanted him released in the custody of a relative. Even though he had six prior weapons charges, the police refused to keep him overnight on a misdemeanor. We wondered why he was only being charged with a minor crime, when, if we had shown this exhibit without the court cases, we would have faced a felony charge. They did not want to charge him with a felony because it would land him at least a year in jail.

We waited at the police station until a state's attorney arrived after midnight to discuss the case. Aubin was asked repeatedly the position of the attacker's wrist as he wielded the knife. They were trying to determine if it was an assault on Aubin or a gesture of self-defense. The greater issue was the police department's hostility to us, and its resistance to "protect the speaker." We stayed at the police station well into the early morning. After several heated discussions between Grossman and the state's attorney, we were allowed to leave. For the remainder of the exhibition, the police were required to check on us several times a day and arrive at the gallery immediately if there were problems.

When we arrived at Lannon Gallery, suddenly the lock worked again. Nonetheless, we had to pay an off-duty cop to watch the door. The police refused to watch the space.

As we discussed the bomb threats, one police officer dismissed the threats by saying, "You don't have to worry about bomb threats. The guys that are going to really blow you up are not going to call you first." Another pointed out that since we were on the third floor of a warehouse building, it would take a pretty big bomb to blow us up. He hadn't heard of a bomb that large exploding in the U.S.

While Dudycz appeared every day, the remainder of the exhibit proceeded without controversy. A wealthy art collector purchased the flag-on-the-floor piece for $1,500. She bought it for her husband's Christmas present. He was on the board of Chicago's largest advertising agency. We all attended the signing party in their Lake Shore Drive condominium.

The ACLU filed for attorney's fees and won $25,000 for our case. It's probable that the entire year of flag controversy cost taxpayers nearly a million dollars in police protection at the school, in attorney's fees for their staff, and then the booty for the victors.

These flag controversies became national concerns in Flag Flap III after Dread Scott challenged the new national flag law by burning a flag on the steps of the Capitol Building. The Supreme Court hurriedly reviewed once again if we can burn flags. Flag Flap IV was the attempted amendment to the constitution to prohibit flag burning.

I cried when the then-new Speaker of the House Tom Foley, announced that they had defeated the move to amend the Constitution. I cried not because I valued the Constitution but because I thought there was hope that I would survive.

Most direct proponents of censorship did not gain votes. In fact Eddie Vrdolyak and Walter Dudycz, the two politicians who held almost daily press conferences in front of the School of the Art Institute while Dread

Scott's flag lay on the floor, both lost their elections. Conservative North Carolina Senator Jesse Helms did win by a very small margin.

Through the lawsuits, the death threats, the IRS audit of the organization I worked for, the fear of phone tappings, and the fear that I would never work again, I became enthralled with many of the blacks who had criticized those of us who cried censorship when the painting of Harold Washington was confiscated. I got to know Akua Ngeri, the wife of Fred Hampton who was assassinated at the youthful age of twenty-one by Chicago Police and the FBI for his empowering speeches. I got to know many of the fifties activists who lost their livelihoods during the McCarthy era. Among those were Frank Wilkerson, a community organizer from California, and Yolanda Hall, a medical technician who sued the House Un-American Activities Committee (HUAC). While Wilkerson spent time in jail for his refusal to testify before HUAC, Hall's suit, *Stammler/Hall* v. *United States*, led to the dismantling of HUAC.

In "Who's Watching," a panel discussion on privacy and surveillance in the arts featuring Njeri, Jock Sturges, and Grossman, the moderator (and National Campaign for Freedom of Expression executive director) David Mendoza introduced Njeri and asked her to talk about "the ultimate censorship—assassination."

Our culture teaches us to believe the unbelievable—that victims somehow deserve their assault. In fact the structure of our language allows few options; there are few sympathetic synonyms for the word "victim."[9] This process of blaming the artist rather than the politicians, the preachers, and the media who stoked the fire, occurs in nearly every one of the 200 censorship cases I documented while working for the Chicago Artists' Coalition.

Early on, as I got to know many of the censored artists in the United States, it was clear that the victim doesn't ask to be silenced. It is the censor who enjoys placing a hand over the mouth so the scream cannot be heard.

So who profited from the censorship wave of 1988–1992? Some organizations were able to garnish foundation money allocated to help fight censorship. The value of some censored artists' works increased dramatically. Some politicians held office a little longer than they would have otherwise. Some people had to spend more money to protect their property. The only people who lost were those who continually denied censorship was occurring.

In spite of this cynicism, a cultural change occurred. Art has played a significant role in everyday life. One cannot escape the reality that art is in-

formation. Art has the potential to carry messages that cannot slip through socially sanctioned information providers.

In fact, I'm told that "political art" is a trend. Some art students are even in crisis if they don't have a political statement to make in their work. My response is: "Get a life. If politics is not part of your life, how can it be part of your art?"

As one who tried to organize artists for nearly five years to fight censorship, I can say that the theme of "art censorship" is not a useful organizing tool. Art is not an organizing tool. If anything, art is a disorganizing tool. Art can lead to change. Art can make one realize that a change is needed by bringing to light new information. But, as the experience of censorship has taught us, art cannot make change happen. Politicians, lawyers, and conscientious people in just about every other worthy profession are re quired to make change happen.

Notes

1. Artists for Washington, a coalition of mostly black artists who had supported Washington in his election and later helped organize the Department of Cultural Affairs, a city department first instituted under Washington.

2. The case of *David Nelson and the School of the Art Institute* v. *the Alderpersons* was still not resolved in 1993. Leroy Martin was required to face trial, the alderpersons were to pay damages yet to be determined.

3. Citizen's Alert is a citizen's watch group that works for humane law enforcement and seeks to uphold the right to assembly. It has been in existence since the 1968 Democratic Convention riots in Chicago.

4. This information was revealed to me in a discussion with police about bomb threats eight months later during "Symbol of Diversity."

5. A directive from the 1981 Heritage Foundation Report.

6. In spite of fears that their reputations would be damaged or their businesses threatened by hosting the exhibit, three out of the five galleries closed within two years because the owners were unable to keep them afloat.

7. *Aubin* v. *City of Chicago* and *Aubin* v. *the State of Illinois* carved the path for the exhibition "Symbol of Diversity," an exhibition of twenty-three flag artworks at Lannon Gallery.

8. I later came to believe that the press was probably prohibited entry to events more than one would imagine.

9. From Edith Altman's exhibit, "An Investigation into the Nature of the Victim and the Criminal."

10

Long May It Wave: The Ten Commandments of the Nineties

by Jay Critchley

Critchley is an artist based in Provincetown, MA. He is the president of Old Glory Condom Corporation and an activist in the fight against AIDS.

Old Glory Condoms was created to fight AIDS, homophobia, and sexphobia, and to penetrate the cultural psyche. HIV continues to spread in a society unable and unwilling to view sex and sensuality as natural and human, rather than sinful, embarrassing, or immoral. Condoms are the medium and people and their bodies are the message. Medium is the message. We must continue our mission of penetrating all facets of our cultural landscape with our safer sex dialogue.

It's time to expand the boundaries on sex, pleasure, and human contact. Old Glory redefined patriotism to include protecting and saving lives, and was recently granted U.S. trademark protection after a three-year legal battle. We extended our mission to protest the Gulf War with our T-shirt, "MAKE LOVE, NOT WAR" encircling our unfurled red, white, and blue condom logo. What could be more sexually loaded than warfare? And recently in protest of the ban on lesbians and gays in the military, the shirt, "DO ASK, DO TELL—LIFT THE BAN" with logo. Let's put our clothes on the table: the military is a homoerotic environment. Wherever our message of safer sex, responsibility, and eroticism can be played, we will be there dutifully.

Imagine what our world would be like viewed through latex—Old Glory colors of red, white, or blue. We at Old Glory propose the ten steps of putting on a condom have become the Ten Commandments of the nineties. No one pays much attention any more to the little penis drawings in standard safer sex lit. We've become blind, lazy, and somewhat arrogant

in our sexual practices, while fundamentalist religions are flexing their muscles and reaching out to sinners and Satanists. If they are going to set the agenda then let us exploit the rising interest in the Scriptures to present our voice of compassion. The Ten Commandments of the nineties offer a powerful vehicle to bring our message of love to the masses. Let us re-create and merge these principles with a fresh and potent reclamation of the cornerstone of Jesus's earthly teachings of love, "I was once blind, but now I see."

Let us penetrate. Old Glory Condoms has won the skirmish with the government in receiving trademark protection for its name and logo. What follows recounts that journey. But the battle looms ahead over personal control of our bodymind, pleasure dome, and soul.

Commandment # 1: Condoms are easy to use.

Abstinence is the Lord thy God, and "Just Say No" is thy credo.

Being in the sex business, I naturally talk with people a lot about sex. Sometimes it seems that's all we talk about. Having been a counselor for ten years, I have a knack for getting people to, let's say, open up. Often when I meet someone and offer an Old Glory Condom, I either get an immediate, almost forced sexual history (if they don't think it's a come-on), or an embarrassed refusal to accept the prophylactic. When I suggest that they might put it in their pocket and give it to someone who might use it, there is often relief and revelation. The condoms, which are smartly packaged, also double conveniently as attention-enhancing calling cards.

Many people don't know or feel they have choices, or that some choices have been denied them. Some of it is legislated, much of it is not. We're not so judgmental about people who carry lipstick, sunglasses, and eat candy. Why can't we give the same due respect to condoms? The sexphobia in our culture is pregnant and runs deep and is usually "morally" based. Sex (and pleasure) is sinful. However, sex sells. If HIV were not sexually transmitted, I wonder if it would have received so much attention—both concern and repulsion? There is a big void between the titillation of television and the media and the sensuous contact itself. Reach out and touch. Just do it. But where is the touching, sensuality, and skin-to-skin contact? Where is the conversation about what really goes on in our own crotches and in our own brains (the most underutilized sex organ)?

Commandment # 2: Be prepared.

Thou shalt not masturbate before me.

Old Glory not only elevates AIDS to its rightful place as a top priority for our government; we also talk of sex, guttural sex. Sex and pleasure are important to our well-being. It says it in the Constitution: "Life, liberty,

and the pursuit of happiness." To the flag, motherhood, and apple pie, we now add touch.

Commandment # 3: Open package carefully, not with your teeth.

Thou shalt not fornicate in vain.

The only satisfying photo-op image from the Gulf War was of a latex condom stretched over the tip of a rifle—techno warfare relying on the lowly rubber. Desert Storm's state-of-the-art sheath giving protection from the desert sands. My fantasies revealed lots of horny soldiers finding more appropriate uses for these covert condoms. This patriotic act of valor—sex in the sand—went unreported along with the rest of the battle festivities.

But the real action is back home in the bedrooms, on the beachheads, and in the street bunkers. Let's talk about sex, baby.

If the eighties were about greed and prosperity through bankruptcy, the nineties are about the human bodymind and its functions—who controls it, who owns it, who touches it, who fucks with it. AIDS, ironically, has thrust sex talk into the spotlight, with words like hard-on, sucking, cumming, and asshole joining mainstay words in grammar school biology curriculum such as penis, vagina, and intercourse. One high school educator on Cape Cod, crossing the line in the sand, declared to an assembly of cheering students, "Let's hear it for masturbation!"

The recent frenzy about sex, art, and politics was already brewing when the U.S. Supreme Court ruled in the spring of 1989 that flag burning was okay. A national debate erupted after this landmark decision, which was won by my soon-to-be attorney David Cole from the Center for Constitutional Rights in New York City. When I received a call from Dana Friis Hansen, curator of the MIT List Visual Arts Center in Cambridge, Massachusetts, inviting me to participate in an exhibition about politics and art called "Trouble in Paradise," these issues were swirling around in my brain, along with AIDS.

Commandment # 4: As soon as penis is erect, put on the condom.

Remember, though, keep holy the Lord's Day—a pleasure-free celebration of restraint.

At the time, the fusion of sex, HIV, and patriotism seemed a little heretical even to me, but Dana encouraged the concept and the Old Glory Condom Corporation was born in October 1989. This positioned the MIT exhibition amidst the steamy debate in the country and in Congress about the proper use of the flag.

The Old Glory Condom Corporation held a press conference, which included the singing of the Star Spangled Banner, and a speech by me, followed by questions from the press and others. At the event I read the letter

which I had sent to President Bush, which included samples of Old Glory Condoms (I found out later that it's illegal to send unsolicited condoms in the mail!). In the letter I asked the president to declare war against AIDS (the word had not yet been made flesh) and challenged him to take the high road and follow our country's time-honored values of equality and justice, intelligence and compassion. I proposed a public/private partnership to creatively attack this disease.

But what was going on in reality was that congressional representatives and the president were tripping over each other filing Constitutional amendments and legislation banning flag burning and flag desecration. Enter Old Glory Condoms.

Offended by the low level of debate about national values and what it means to be an American, we at Old Glory Condom Corporation set about to redefine patriotism, elevate sex and pleasure to its rightful place, and stop AIDS. "Condoms with a Conscience" and "Worn with Pride Country-wide" expressed the company's philosophy that the highest form of patriotism was to protect and save lives. Not only was Old Glory about safer sex and condom usage, but about reclaiming sensuality and touch. With poster slogans such as a black Uncle Sam demanding "I Want You," and a radiant mix of protesters with the caption, "Condoms Won't Stop AIDS. We, the People, Will," the Old Glory Condom Corporation was a call to activism.

Armed with an award-winning research study of collegiate attitudes about condoms conducted for Old Glory by Simmons Graduate School in Boston, the company launched its "LATEX IS 4 LOVERS" campaign. This national educational crusade addressed the alarming ignorance among students about lambskin condoms, which are penetrable by the HIV virus.

Commandment # 5: Keep your cock free of grease.

Honor thy first parents—Boob & Tube.

With the electrifying response to the Old Glory Condom concept and the MIT corporate installation, including *Newsweek* defining it as "a uniquely American enterprise," a corporation was formed and trademark applications were filed for the name, the logo (an unfurled condom imprinted with a simulated Stars and Stripes), and the slogan, "Worn with Pride, Country-wide." Writing a five-year business plan over the next seven months became a blur of business meetings, marketing analysis, the identification of investors, and the procurement of capital. All from an artist holed up in Provincetown on the tip of Cape Cod, who despised the corporate culture and its consumptive influence on the media and society.

While the rejection of the trademark applications was not surprising, since part of the intention was to challenge the government's ignorant and puritanical response to HIV, the tabloid language was indeed. Declaring that the Old Glory name and logo "comprises immoral or scandalous matter," the initial ruling in the spring of 1990 stated that trademark protection "would scandalize or shock the conscience of a substantial composite of the general public." This was patently un-American. I was shocked, but Roger Ailes couldn't have written a better script. Dig the trenches, we're in for a bumpy ride.

Commandment # 6: Hold the tip of the condom, squeeze out the air.

Thou shalt not abort, but unsafe sex, child abuse, and TV contamination are OK.

Old Glory officially launched its enterprise on Flag Day 1990, in time for the International AIDS Conference in San Francisco, where its condoms were introduced to the conferees and the marketplace. The individually-packaged latex condoms contain nonoxynol-9 with the logo prominently depicted on the front and the Old Glory Pledge on the back: "We believe it is patriotic to protect and save lives. We offer only the highest quality condoms. Join us in promoting safer sex. Help eliminate AIDS. A portion of Old Glory profits will be donated to AIDS-related services." Two T-shirt designs were also created: a white beefy tee with a large logo and a condom pocket on the side with the slogan, "Worn with Pride, Country-wide"; and a black tank top with a small breast logo with the slogan, "Never Flown at Half Mast."

After the initial legal response to the trademark denial from our corporate attorney Ray Gouin, David Cole from the Center for Constitutional Rights and Georgetown University Law School became our Knight in Shining Armor and took on the case pro bono. Without this guardian angel, my little start-up would be lost in the morass of government bureaucracy and stagnation. Fortunately, the First Amendment ramifications were significant enough for this prestigious organization to put its name and resources behind the case. David had won *Texas* v. *Johnson*, beat back the Helms Amendment in the U.S. Congress which restricted sexually explicit language and images in federally-funded AIDS safer-sex literature, and defended four performance artists denied funding by the National Endowment for the Arts based on their (mostly queer) politics. We were indeed blessed.

Research revealed, much to our amazement, that the Patent and Trademark Office of the U.S. Department of Commerce had granted 1,000 trademarks just for condoms, including such brands as "Deep Stroker,"

"Mister Hard Head," "The Succulents," and "Love Gasket," and another 1,000 trademarks utilizing the American flag, one recently for a patriotic tobacco company. Ironic, isn't it? Tobacco obscenely causing death, while Old Glory Condoms are protecting and saving lives. We're in trouble.

Commandment # 7: Unroll the condom down to the hair.

Thou shalt not undermine male privilege, guns, and televangelism.

Denial of Old Glory Condom Corporation's trademark application marks the first time such an action was taken by the U.S. Patent and Trademark Office based on political content. The government made a judgment about the offensive impact such an image and product would have on the public, when in fact its sole responsibility is to determine whether the applicant's name and image would infringe upon an existing trademark. It's up to the marketplace to decide the fate of Old Glory Condoms. The government was clearly interfering with my right to participate in the free enterprise system, while denying (sexually active and politically correct) consumers the choice of doing it with an Old Glory. American values were clearly being ignored here.

Commandment # 8: After cumming hold onto the base of the condom, pull out while still erect.

Thou shalt not penetrate—except while screwing employees, prostitutes, and Mother Earth.

What followed the trademark office rejections was three years of harassment, legal jargon, and maneuvering that went well beyond anyone's definition of foreplay, and undreamed of publicity and media coverage. The legal briefs, filings, appeals, and hearings create a fascinating and often titillating romp through the bureaucratic id of the American psyche, bristling in semantics and S&M imagery. Refusing to admit that the denial was really about objecting to Old Glory's politically incorrect message, Examining Attorney Rachel Blue fabricated her case based on the infamous section 2(a), which attempts to determine what is immoral and scandalous matter. Being pushed into a corner of ludicrousness, and fearing that the statute would be turned down in the courts on First and Fifth Amendment grounds, the U.S. Patent and Trademark Appeals Board completely reversed the opinion of Ms. Blue in March 1993 and granted Old Glory proprietary rights to its name and logo. It's called covering your ass, protecting your turf.

Commandment # 9: Throw it away carefully, don't use again.

Thou shalt not screw thy neighbor unless she is poor, female, or gay.

Trademark applications are evaluated under section 2(a) as to whether they are sexually suggestive, profane, or insulting to religious groups. The

trademark office comes off less prudish than one might expect. For instance, protection was granted for: Big Pecker Brand—It's about clothes, not dicks; Acapulco Gold—suntan lotion, of course, you potheads; Moonies—dolls dropping their drawers and mooning, not the dreary automatons assaulting you for your mind and money.

Don't mess with religion comes through loud and clear with the following trademark denials: Madonna Wine—Our Lady, not the temptress; Agnus Dei Safes—money that is, not rubbers; Sensuii cigarettes—anti-smoking Muslim sect; and Messiah's Wine—self-evident. Why there is so much interest in associating religion with drugs is curious.

And trademark denial for the just plain vulgar and tasteless: Queen Mary Underwear—1938, but a timeless idea; Booby Trap Brassieres—didn't quite hold up in 1971; "Bullshit" T-shirts—totally inexplicable; a newsletter logo of a man and a woman kissing and embracing in a manner appearing to expose the man's genitalia; and the silhouette of a defecating dog for T-shirts!

Outside the purview of the trademark office, but mentioned in one of the legal briefs, is the 1975 case in which the City of Chattanooga denied the production of the hippie musical "Hair" in the municipal auditorium because it didn't meet their vague guidelines of being "clean and healthful and culturally uplifting."

Commandment # 10: Wash up well.

Thou shalt not covet thy neighbor's goods—unless you are white, male, well-dressed, telegenic, and an avid shopper.

Throughout the three-year legal battle, the media response was continuous and plentiful. What better copy than sex and apple pie. Everyone likes to get down and dirty. With the Center for Constitutional Rights pumping out press releases at every level of the process, public interest in the case was hot. Not only was Old Glory discussed on the TV shows of Jay Leno, Arsenio Hall, and Rush Limbaugh; it inspired an *L.A. Law* episode and was picked up by the major wire services and garnered feature stories in most major newspapers and magazines (except the arts journals)—the *New York Times, Playboy,* the *Boston Globe,* the *Washington Post* (front page), People, the *Wall Street Journal,* et al.

The radio talk show circuit was the most visceral, and I was on standby at all hours of the day and night to hook up with radio folks from Florida to Oklahoma, California to New York. Veterans and farmers liked the idea too. Of course these shows propagate kooks and I dealt with my share. Not to mention the numerous obscene and giggly messages on my 800 ordering line.

The height of irony and absurdity was the speech the Honorable Senator Jesse Helms delivered on the floor of the U.S. Senate, a virtual reality broadcast on CNN. Decrying the government's positive decision on Old Glory's trademark case, he held up an enlargement of the patriotic logo in ridicule, creating the world's first worldwide safer-sex infomercial.

* * *

Sexual energy is a powerful force that has mystified and frightened societies and religions throughout history. Coddling of the expression has often been used to subjugate women and men and to control the bodymind and its senses. But ultimately this journey of pleasure is a personal journey of the soul, and it cannot be constricted or shackled.

As we've learned from all the TV talk shows and 12-stepping groups, life is about opening up choices and possibilities, not restricting them. This is essential now more than ever. And I doubt that it will be solved by the projected 500-plus channels on the fiber-optic superhighway of television.

The real battle is not moral, it's spiritual. Encompassing sex and our sensate body, it's about harmony and reconnection to ourselves and the Earth Goddess. It's creative. Sex and patriotism and religion are a means to an end. The AIDS pandemic has provided us with an opportunity to throw back the shackles of sexual illiteracy and moral prudishness and reclaim our images, symbols, institutions, and our ecstatic selves. Let us reconnect with the magic of the moon, the planets, the stars, and each other. Now that's real power!

Long May It Wave.

11

Community Standards and National Arts Policy

by Sanford Hirsch

Sanford Hirsch has been working in the visual arts since 1970 using the media of painting, sculpture, and video. He is vice president of the National Artists Equity Association and chairperson of the Arts Action Coalition. Hirsch is the director of the Adolph and Esther Gottlieb Foundation.

Throughout the controversy which raged over the reauthorization of the National Endowment for the Arts in 1989 and 1990, an argument was offered which proposed that no federal funds should be spent on projects which do not reflect "community standards." The political right still uses the phrase today, although it has never been clear what exactly community standards are or which of the many communities in the country might possess an absolute set of standards that could be applied.

As it applies to the NEA, the phrase comes from a 1973 Supreme Court case, *Miller* v. *California*. That decision provided a legal standard for judging obscenity, and stated very clearly that obscenity exists when:

(1) the average person, applying contemporary community standards, would find that the work, when taken as a whole, appeals to the prurient interest;

(2) the work depicts or describes sexual conduct in a patently offensive way; and

(3) the work, when taken as a whole, lacks serious literary, artistic, political, or scientific value.

This definition of legal obscenity, it needs to be noted, is meant to be read in its entirety. It is not enough, according to the law, to apply one part of the ruling; in order to be determined obscene under the U.S. law, a project must meet all three tests. This was the standard by which a

145

few photos from the Robert Mapplethorpe retrospective exhibition were judged in Cincinnati, in a trial in which the accused were a local museum and its director. Some details of this trial are important to a consideration of standards, community or otherwise, in the public judgment of works of art.

The notion of putting a local museum on trial for the supposed violation of community standards is an exercise in irony. The museum's professional staff is made up of local residents—residents whose professional association with this community is that they were hired by the community and are paid by the community solely to offer their considered judgments in selecting works of art for that community to think about. In an unsurprising decision, the jury found the defendants not guilty on the charges of obscenity. But in selecting that jury, a local judge ruled that the jury pool was to be expanded to include people from outside the city of Cincinnati, with the probable rationale that such people would be free of any bias toward a local museum. Of the final jurors, only one had ever been inside an art museum. In terms of this discussion, the standards of this community were to be decided by individuals from outside the community, on the theory that members of the community were too biased to know their own standards.

If we are to make decisions about anything as a nation, we must have some basis on which to make those decisions. If we are to choose art, or anything else, there will be compromises and not everyone will agree or be pleased with the results. The two concerns which should guide such decisions are fairness and effectiveness.

For the purpose of this argument, change the object being judged from works of art to local services. Can we develop a way to select the best local services to be provided nationwide in a given year? Because there are many types of service, and because various regions have their own standards of determining which are most needed, and because those needs and standards change over time, the seeds are sown for disagreement with any result. We can, however, have a system which is fair. We can select a representative group of mayors, council members, local activists, state representatives, and similar "experts" from all regions of the country. These individuals can meet together and review all the different types of services available and the needs which must be met. They will apply the standards that their training and experience tells them are most determinative, and will discuss them with their fellow panelists. The decisions they reach are not likely to be perfect for any one locality, and there will certainly be

many people, some with excellent credentials, who will disagree vehemently with the results. But does such dissension mean anything more than that honest and thoughtful people will sometimes disagree? Should it be allowed to so cripple a process of decision making that we are left with the only alternative—to appoint one individual to make all decisions for the rest of us? Doesn't that guarantee even less sensitivity to local concerns and greater opportunity for error?

The process of consensus-building described above is, in brief, the way decisions have been made at the NEA. Successful applications to the agency must be reviewed by panels, then by a group of presidential appointees known as the National Council on the Arts, and, finally, by the chairperson of the NEA. All things being equal, the system should, and experience shows that it does, assure successful results most of the time.[1] If such a system were forced to meet the "standards" of every "community," however, its ability to function would be greatly challenged.

A work of art is created, in most cases, by one person or a small group of people working in one community. The artists represent the standards of their community. Or do they? Some would determine that artists are, by definition, a minority group in any community and, therefore, not representative of the standards of the majority. Others would argue that there are communities of artists which have their own sets of standards different from those of the nonartist community. To add to the confusion, a national program is charged with selecting works of art which originate in many different communities and will be seen in various other communities all across the country. Which community standards will then apply? Will they be those of the community in which the artists live, or those of the community of artists, or those of each individual community in which the art is to be exhibited? Or, should there be a panel formed to evaluate the standards of each community and develop a joint standard?

If this argument sounds absurd, reality is even stranger. The NEA project most often referred to as controversial is the retrospective exhibition of photographer Robert Mapplethorpe. In that instance, the work of an artist who was a resident of one community (New York), was organized by a curator and staff of the Institute for Contemporary Art, a part of the University of Pennsylvania in Philadelphia, another community. The project was evaluated by a six-member panel for the NEA (six other communities), and then reviewed by the National Council and chairman (either representing twenty-seven communities, or two levels of judgment for a national community). Using their own, independent review criteria, and

utilizing none of the NEA's funding, seven museums in seven different parts of the country (seven communities, one of which was Cincinnati) chose to pay a fee in order to show this exhibition. The primary objections to this exhibition were raised by a senator from North Carolina, where the show was never seen, and a special-interest group called the American Family Association located in Tupelo, Missouri, another community which did not see the exhibition.

Is there such a thing as a "community standard" and can it apply on a nationwide basis? How do we define a community? Are communities, and their standards, defined by geography? If so, how local is the geography of a community—is it one block, one city or town, one neighborhood, county, or state? Or are communities defined by shared interest, or by racial or ethnic background? Is there some other mysterious standard by which communities define themselves, and can it apply nationally?

Some communities like to be defined by common interests or religion. Those are the communities with standards which are more easily defined. It is less clear, however, that any one of those sets of standards is more valuable, or more legal, than any other. For example, another NEA project which drew national attention was a grant issued, then withdrawn and subsequently reawarded by the NEA chairman, to the New York gallery known as Artists Space. The project involved a group exhibition titled "Witnesses: Against Our Vanishing," and was an attempt to show the anguish and suffering of people with AIDS at a time when there was little public support or sympathy for people with the disease. For the community standards, anti-funding argument to hold, one would have to assert that the interests of a community far from that involved in organizing, exhibiting, participating in, or viewing this exhibition, has a greater voice in the disposition of NEA funds than those directly involved. The only other possible argument against funding the show would be to assert that there is a national set of community standards which are more important and more valuable than those of a local community.

In other words, the "Witnesses" show was organized to represent at least one community's view. Private funds were raised,[2] an exhibition venue was arranged, and artists were selected to participate based on some set of shared standards. The neighborhood and city in which the exhibition was held were certainly supportive, as were the members of the grant panel and the National Council on the Arts, representing a broad range of communities from across the country, which approved the project for funding. It is not reasonable to assert that an abstract set of standards can be applied

simply because an opposing view can be argued, especially not after the fact of review and approval and without any requirements that those establishing such standards view the project and take the time, or have the basis, to understand the work being funded. If there is any merit to the notion of community standards, then the standards of the communities most directly involved should take precedence.

There are currently several groups in this country which define their opposition to abortion and/or the civil rights of homosexuals as a reflection of the community standard which unites them. Most of those groups have religious affiliations, and among them are members of major religions. Yet not all adherents of the religions which have adopted such positions agree with them. There are also major religions which hold the opposite view—that the right to choose an abortion is the moral judgment of the woman, and that people are to be considered and respected as individual children of God irrespective of their sexual preferences. Several major Christian denominations have ordained gay and lesbian priests and ministers. Most important, not all citizens choose to follow a religion.

Can we seriously argue about what amounts to a test of religious values in this country? The reason individual artists have been so outraged about the debates surrounding the NEA has nothing to do with their being artists. We object as citizens who are being deprived of a fundamental right, the right to form and hold an opinion which may differ in some respects from that of the majority, without regard to the teachings of any religious or moral code but our own. This belief in a basic guarantee of the American political system is challenged by those who would establish some "standard" which, by its very presence, would prefer the beliefs of some over the beliefs of others. The imposition of one set of moral beliefs on all NEA applicants, whether they are individual artists or museums, symphonies or dance companies, or their audiences, carries with it the assumption that any who do not ascribe to that particular standard hold to a lesser standard, or no standard at all. The result of such an exercise is to marginalize good and serious people who choose to follow their own beliefs.

The issue we must address if we are to evaluate the notion of a community standard is that there are many kinds of communities with many kinds of standards. Not all are desirable and most change over time. Usually, the strongly held opinions of one group are in direct conflict with those of another. As individuals, we are guaranteed the right to hold and voice any opinion. The tough question is how such rights are to be preserved when making government policy which affects everyone. Ultimately, we are

faced with the reality that we must make choices and must be responsible for the choices we make. In the process there will be some groups, usually with narrowly defined interests, which will be unhappy with the results.

When art offends, and progressive art by its nature will offend some people, does it make sense to simply make it more difficult for that art to appear? Can a government program be slanted so as to yield that result without setting a precedent by which the government will prefer those ideas which are politically acceptable over those which are not? To do so would be in violation of the basic principles of the Constitution. That is one of the very real dangers inherent in the community standards argument.

That we have seriously considered the notion of applying a "community standard" in a program of the federal government is a bitter irony. The political society we belong to was founded on the unique belief that there is no one standard of values, but that people will form alliances, political and civic, along many different lines for many different reasons. The American system has been the world's leader in establishing a political system that allows for these sorts of differences. Tolerance of the various personal beliefs of individual citizens was one of the fundamental demands made by the founders of the country. The notion of a national values test is addressed in the First Amendment, in the same manner it was addressed in Thomas Jefferson's Bill for Religious Freedom presented to the Virginia Legislature in 1779. It is not by accident that the First Amendment states "Congress shall pass no law respecting an establishment of religion, or prohibiting the free exercise thereof; or abridging the freedom of speech . . ." It does not say that Congress shall pass some laws restricting the freedom to allocate funds because a small portion of those funds may assist the presentation of unpopular speech. That principle was underscored in June 1992 in a decision of a Federal District court, which ruled the language written into the 1990 NEA authorization advising the chairperson to consider "general standards of decency" in allocating funds to be unconstitutional.

The phrase "community standards" as it has been used by NEA opponents adds up to nothing more than censorship. It has not been used to assert a set of principles or relevant criteria by which works of art can be judged. It has been used only as an argument to suppress works of art which deal with sexuality, especially those which deal with homosexuality, or with themes which some understand to be politically unpopular. The claim of community standards proponents is that there are matters of

concern to some communities which, although not against any law, should not be considered for funding by a national program simply because other communities object. The clear implication of such reasoning is that some communities have greater rights than others—even greater rights by their unproven assertion of majority status than allowed by law. The broad question we are dealing with, then, is whether the self-proclaimed representatives of one community should be able, without regard to established procedure, no further demonstration of fact, and no basis in law, to prohibit federal funding of the exhibition of art projects which are created, sponsored, and requested by representatives of other communities.

The argument suggests that the opinions of a majority (at least, of those who claim to be a majority) should be imposed on all others through the policies and actions of a federal agency. When Dennis Barrie was acquitted in Cincinnati, some members of Congress used this reasoning to argue that the law is flawed, and implied that there are "community standards" of greater importance than the law, which need to be enacted into law. But if we legitimize the theory that a majority has greater rights to the benefits of government than minorities simply by the fact of their majority status, we will have turned the theory of American government on its head. If we go further to allow proponents of a community standard a superior right to government funding for no reason other than their ability to claim majority status, we fall into a common and insidious trap.

The claim of a community standard is not new. Throughout history, demagogues have claimed their authority stems from a reflection of community values. Joseph Stalin's professed interest was in the good of the common people; the social-realist art he promoted glorified what he determined were the proper standards for his national community. The promotion of this national standard led to the death of what was one of the most vital and progressive art communities of the century. It brought us the kind of art American painter Arshile Gorky termed the "poor art for poor people." More than that, the claim of a community standard sets up an "us versus them" mentality. It poisons the minds of many people against their neighbors and encourages prejudices we simply can't afford. Can we seriously talk about the need for government to promote a desire for education in our country when we validate a claim that the fruits of education, the ability to think about and consider views of all kinds, are poisoned?

Unfortunately, simplistic "solutions" have been proposed with regard to government funding through the NEA. My purpose in citing these examples is to remind those arguing against the NEA, especially those who

argue that the solution to its problems is to cede all authority to a chair-person who would be directly answerable to political pressure, where such actions may lead. Some politicians will be attracted to an abstract, Populist message of community standards. For those who use such terms, we must insist they define the standards they intend to apply, so we can judge the merits of their argument. Slogans are simple, but they do not present issues.

It's time we moved this discussion along to a more serious and more helpful plane. We can, and do, have a national funding mechanism for the arts which succeeds at everything except pleasing all of the people all of the time. We can, and should, debate the merits of Endowment policy and the work which it helps to present. But we must keep the discussions within the bounds of our system of law and respect for the opinions of others. The attempt to impose an undefined standard on individuals and institutions ignores the benefits and successes of NEA funding, and disdains the most personal decisions about moral issues which are the fundamental right of individual citizens. Restricting funding doesn't really limit the ability of artists to produce, it limits the ability of other interested people to see or hear what the artist has to say.

That may be the final question on community standards. Does any one community have the right to prevent another from seeing or hearing or thinking about anything they may choose?

In 1773, Benjamin Franklin wrote from England, expressing his hopes for a new kind of political entity:

> May our virtues public and private grow with us and be durable, that Liberty, Civil and Religious, may be secured to our posterity, and to all that take refuge among us.
>
> The guarantee of civil and religious liberty can apply no less to those citizens who work in the arts than to any other citizen.

Notes

1. The usual numbers cited are eighty-five controversial grants out of more than 100,000 awarded over twenty-seven years. Many of the eighty-five controversial projects referred to were not funded by the NEA. In several instances, objections were raised to parts, rather than all, of projects—for example, objections were raised to seven of the 125 images in the Mapplethorpe show. But, just using the number eighty-five, the NEA has compiled an enviable record. At the most, its opponents can cite a failure rate of .00094. Although I haven't studied the statistics,

I would be surprised if there is a government agency anywhere in the world that has succeeded to that extent.

2. Another common misunderstanding about NEA funding is the belief that it underwrites a given project. In fact, all NEA project funds must be matched at least two-to-one by privately raised money. The aggregate for 1989 funding showed that NEA funds were matched eleven-to-one by private funds. One could make a persuasive argument that the standards of a community are expressed by the community's willingness to raise private monies to support a project. The NEA's assistance comes in only after such funding has started developing.

12

Beyond Mapplethorpe: The Culture War Continues

by Dennis Barrie

Dennis Barrie, while director of the Contemporary Arts Center in Cincinnati, was indicted and subsequently acquitted of pandering obscenity and illegal use of a minor in nudity related materials in 1990 after presenting the exhibition, "Robert Mapplethorpe: The Perfect Moment." Since then Barrie has traveled to universities and other organizations across the country speaking out on issues of censorship in the arts. He is currently president of his own exhibition development and cultural events management firm, Dennis Barrie & Associates.

The election of Bill Clinton brought a quiet euphoria to the American cultural world. After three years of open warfare which pitted the arts and artists against various politicians and the religious right, it was the hope and belief that the war was over. A new administration meant new attitudes about the National Endowment, the role of culture, and the necessity to preserve freedom of expression.

Even prior to the election, I noticed a lessening of political fervor in the artistic community as other issues early on in the campaigns seemed to supplant any direct attack on the arts. Pat Buchanan briefly took on the NEA in the Georgia primaries and prompted President Bush to fire NEA head John Frohnmayer in reaction to charges that he (Bush) was somehow encouraging pornography and homosexuality through federal art funding, but that issue faded with Buchanan's rapid elimination as a viable Republican presidential candidate. And when the culture war reemerged in October as Dan Quayle went after Murphy Brown, the focus clearly shifted away from the arts and toward Hollywood and somehow that was different from the "old battle."

Like most of the art world, I too wanted the culture war over and wanted

to believe that it really was. Yet it became evident to me that the "war" had just begun. The battle for the survival and "soul" of the NEA, the rantings of Jesse Helms, the persecution of Robert Mapplethorpe and the prosecution of Cincinnati's Contemporary Arts Center were but the first skirmishes of something much, much larger. The late 1980s had seen the opening confrontations of two value systems in America that were far from finished with each other.

The principal preview of things to come was the 1992 Republican National Convention. At that convention, a host of speakers including Pat Robertson, Jerry Falwell, Marilyn Quayle, and Pat Buchanan articulated the issue and it all came down to an "us versus them" state of mind. Aspects of the campaign took on the tone of a moral crusade against Hollywood, homosexuals, people of color, new ideas, intellectuals, the media, and anything that threatened the world as they knew it or wanted it.

Most significantly, the then-vice president recoined the term "cultural elite" and used it with disdain to discredit the actions of anybody involved in cultural endeavors. Furthermore, he, and others, placed this "cultural elite" in direct opposition to "family values," a vague term signifying some sort of white middle-class wholesomeness.

The battle cry against the "cultural elite" and for "family values" played well in the press for a short while but fizzled as a campaign issue and after a few weeks dropped pretty much from sight. Yet, it was evident from the rhetoric of that moment that a powerful political faction, the religious right, was very anxious to expand the fight that had previously engulfed only the arts to take on the whole direction of American society. What was less evident was the fact that the "loss" of the presidency was only a setback to this faction and not, by any means, a mortal wound.

The political strategy of the religious right shifted in the early nineties with a new emphasis placed on winning local elections—school boards, city council, delegates for the national party conventions—and through this method building a political base for their agenda from the ground floor up. This strategy, focused on small, incremental political victories, by its very nature meant a long, protracted struggle to gain political ends. It also meant that the future battles over censorship and any other issue with which they were concerned would often be contested on very local levels. First Amendment battles would, as a result, just as likely be over high school textbook content and a neighborhood video store's selling practices as they would the policies of an organization like the NEA. Small victories would eventually be as effective as a knockout blow against the Endowment. Regardless of who was in the White House, there would be a thou-

sand places around the country where they could and would test and limit the boundaries of free expression.

Whatever the strategy, it does look like the issue for these people has moved on, for the time being, beyond the so-called fine arts. The media—film, TV, records, radio—is where the real confrontation is seen. In truth, the "arts" never reached enough people. Where museums, galleries, playhouses, and the like might draw millions each year, everyone in the country has access to a TV, radio, CD player.

Furthermore, it has been in the areas of the mass media that the boundaries are really being tested. In 1992 alone we witnessed the publication of Madonna's best-selling book, *Sex,* which provocatively examines homosexuality and sadomasochism. Rapper Ice T released an album which suggests that killing cops is justifiable. *Basic Instinct*, a mega-hit movie, had for its protagonist a bisexual who kills at the moment of sexual climax. Howard Stern used the airwaves to present "humorous" commentaries which sank to new levels of bad taste on matters of race, sex, and religion. With all this and more, homoerotic photographs pale in impact and importance as the most important target for would-be censors.

This is not to say that the work of individual artists and the programs of playhouses, contemporary museums, and the like will go untouched in the cultural battles of the nineties. There will be conflicts but they will not be able to grab the center stage as easily as they have in the last few years. Emboldened by their political power within one of the two main parties, by their growing understanding of how to manipulate political opinion through sophisticated organization, the religious right (and other censorous factions) will join the fight whenever they see "free expression" or other civil rights in conflict with their sociopolitical agenda.

As I write this, Don Wildmon and his American Family Association have, through a series of full-page ads in the *New York Times* and other big city papers, called for a massive letter-writing campaign to coerce the boards of directors of the nation's largest entertainment companies into curtailing sex and violence in their programming. Pat Robertson is using his Christian Coalition to inundate Congress with letters on issues such as PBS funding and gays in the military. And would-be right-wing presidential candidates look to 1996 as a year of political combat. In the years to come, only time will tell if the forces for censorship will be better organized and more tenacious than those who fight to keep expression free in our society.

13

Behind Ivy-Covered Walls:
A Personal Account

by Maria M. Monk

Monk, a Brooklyn-based creative arts therapist, had her photographic display of nudes canceled without notification, due to an alleged religious protest regarding male frontal nudity. She has just completed her master's in Professional Studies in Art Therapy and Creativity Development at The Pratt Institute, Brooklyn, New York and is continuing to pursue photography as her art medium.

Most individuals long for freedom. And this was the desire of my family when we escaped from behind the Iron Curtain during the Hungarian Revolution in 1956–57. As a small child, I had hoped for the promise of "Freedom" that America offered. It was easy to believe my parents when they told me that we were going to a country where people could speak and act freely and not be bothered or hurt by the Nazis and the communists. It was a fairy tale come true. Or was it?

The freedom I longed for as a child, my fairy tale come true, ended abruptly as an adult when my photographs were censored. I can clearly remember that Tuesday night when I called my friend James Slattery, who was the curator of the show at Hudson Valley Community College, and he said, "I have some bad news for you." I could not believe what I was hearing when he told me that the administrators of the college had him take all of my photographs off the walls. I was left stunned and speechless. After all, it wasn't an unknown fact that my portion of the show would contain a study of nudes (male and female). I asked, "What happened?" The reply was (off the record and later confirmed by the attorneys) that some woman (no name given) walked through the Cultural Center and felt that they were inappropriate for the college to show.[1] She went to the administrators and had them removed from the walls. I was disappointed with his answer to say the least, but, more than that, my freedom of expression had been

squelched. I felt totally castrated and helpless. To whom could I turn? Where could I go? What could I as an individual do? Weren't schools supposed to encourage creativity so young minds could be enlightened? I questioned myself as to who could have so much political power at a community college that with one statement, action could be taken against me without prior notification. And why didn't the school administrators notify the president of the college to get his advice regarding their plan of action before acting? Was it because they thought I would not pursue the issue because I was just an average individual with no power? Or because I was a woman? It seemed very strange indeed that several individuals told me (once again off the record, of course) that they had previously shown some of their photographs, containing nude figures of women, in the Cultural Center. Photos taken by men. Was there a double standard? Could men take pictures of nude women, but women couldn't take pictures of nude men (no frontal shots)? I was and still am confused about this issue. Are we still in the Stone Age? Wasn't one of the purposes of a community college to encourage original thinking? Or was its purpose to reinforce rigidity in thought and block the creative process?

I was still in shock the next day when I went to talk to Linda Vega, who was the head of student activities at The Pratt Institute (where I was a student). She advised me as to what steps I needed to take toward my own vindication. I first contacted the administrator, James LeGatta, dean of liberal arts at HVCC, and asked why he made the decision he made. His answer was very unclear and confusing when he stated that personally he liked the photographs but could not allow the work to go back up on the walls because of the content. During our conversation, I mentioned that Michelangelo had painted nudes in the Sistine Chapel. His response was very condescending. He stated, "This is not the Sistine Chapel and you are no Michelangelo." Mr. LeGatta refused to compromise with me in any way and would not allow any of my photographs to go back up on the walls. I felt that I could not allow this atrocity to happen to me. Besides that, Mr. LeGatta took neither me nor my work seriously. So, to preserve my rights as a human being and those of the artists to follow, I chose to pursue legal action.

What was supposed to be a special event, a send-off celebration of my going to graduate school at The Pratt Institute, turned out to be a disastrous nightmare for me.

HVCC is not a very large campus and I had gotten to know some of the faculty. People knew me and of me. I was a real human being to them, with sensibility and feelings; that is, until I instituted legal action. They were

not expecting me to stand up and ask, Why? I was enraged and shattered by this experience especially when I found out that one of my best friends, James Slattery, could not have any contact with me because the administration would not allow it. I felt that it wasn't only me under their scrutiny, but that they questioned his judgment as well since he requested to show my work there.

It was only a short time after my photographs were taken down that I started to feel distanced from my work and rejected it. I did not know if this was because I personally felt rejected or because there was actually something obscene in the content of the photos. Or was it bad artwork? I was in doubt about my own intentions. I could not understand why I disowned my own photographs, which I had previously loved and thought beautiful. I questioned myself time and again, why—when I had put all my energy, time, and money into this project—would I reject my own work?

The questions and not knowing the full effects of the consequences of the issues at hand baffled me. And instead of answers, I only came up with more questions. And what were these issues anyway? Was the problem that I felt caught up in the system and had to fight back? Or that I felt that I was treated as an entity without feelings and emotions? Was I someone who was looking to be vindicated unrighteously? Did I just want publicity? The answers did not come without an in-depth search of my "self."

During the search I found that I had not wanted to look at any of these issues and had even set aside writing this chapter because of the deep emotional pain this incident had incurred upon me. There were several things that happened and to prioritize as to which was the most traumatic is almost impossible because these issues are too close to me and about me.

Could I say that the most hurtful thing that happened was the loss of one of my best friends, James Slattery, whom I have known for several years? I don't know to this day why he won't talk to me. At the time of this case, I asked him, as a friend, without my attorney's or anyone else's knowledge, to side for the plaintiff (me). However, I heard through the grapevine that he thought that I was in it for the money. I suppose he didn't understand the principle of the issue at hand, which was to put the photos up in the original space. I still consider him to be a dear friend, but he no longer associates with me. I hurt so much that I cried when our communication came to an end. It was especially grievous for me not to be able to contact him to let him know how I felt about the whole situation and that I understood his position. To this day, he keeps refusing my telephone calls which I continue to make so that we might have some kind of closure.

Or could I say that the most damaging thing that happened to me was

the halt of my photographic work, aside from family snapshots? I took it very personally when I was critiqued by the newspapers/art critics. It bruised my ego and I thought I was not an artist. I had gotten a lot of publicity through the media. I felt, however, that the art critics did not feel that I and my work deserved the attention because I had not been a "suffering artist" for many years. I felt belittled and humiliated by the negativity that was printed about my work. And instead of being encouraged by the art critics to explore my creativity further or to fight the system for the sake of promoting art and artists, there were written statements like, "It was undergraduate student work." Was I supposed to be ashamed that it was undergraduate work? Everyone must start somewhere. It was an end for me before I had a real beginning because since then I have not been able to continue with my photography in a meaningful way. This is one, among many, of the issues that I haven't yet been able to work through.

On the positive side, after the lawsuit was filed, Harold Lohner, the curator of the Russell Sage College in Troy, NY, offered me a show, prior to the settlement of the case. The opening of the show, which was on January 3, 1992, was well attended. Nearly 400 people showed up. Some parents brought their children, to be supportive of the arts, to show there was nothing wrong with the nude photographs. This helped boost my ego somewhat at that time since there was not much HVCC or local artist support.

While the deliberation was going on, there was one HVCC student, Jeffrey Buechler, who got involved with the case and tried to recruit some other students for support. Efforts were made by contacting the student senate to help students to understand that it was their school and their right to see the show in the original space. Unfortunately, this did not work. And as the media (*Daily Gazette*, Albany, NY) stated: "The students were not interested or worried about it. They were not informed." It sure seemed odd to me that the student senate did not feel compelled to inform the students so they could get involved since the issue of censorship could affect other areas of learning in the school (i.e., literature, theater, etc.). Although there were many attempts at getting support from the students and negotiating for putting the photographs back into the original space, my attorneys, Robert Balin and Kate Rowe, of Lankenau, Kovner and Bickford, of New York, were unable to get any sort of compromise from James LeGatta/HVCC until the lawsuit was filed in the U.S. District Court in Albany.

After the lawsuit was filed, there were several months before the negotiations ended and became acceptable to all of the concerned parties. I was given a show which took place on March 28, 1992 in the multipurpose

room, which is a room located in the school library (never used as a gallery space before), and my attorneys convinced me that it was a better space than the art classroom that had been previously offered. I felt as if I had won and lost simultaneously. I was able to have the photos shown, but there were no multitudes of supportive citizens or artists who showed up to celebrate the victory. Very few media turned out to record the event. And even my attorneys, who promised they would attend this celebration, did not show up.

I asked myself, "Is it worth all the energy—the heartache and the losses, knowing that others won't want to get involved or will turn their heads to avoid politically incorrect situations—to invest oneself and fight for the cause of freedom?" I think the answer is up to every individual, but as for me the answer is "YES." I believe that because of the few people who are willing to sacrifice and put themselves on the line, injustices like this can be avoided in the future.

Notes

1. The gallery space that was designated, the Cultural Center, where many school and local social functions occurred, was previously a church and the chapel portion (the Cultural Center) was de-sanctified when purchased by HVCC.

14

Artist-Citizen-Taxpayer

by Elizabeth Sisco

Sisco, a San Diego-based artist, has been involved in a series of tax-dollar-supported public art projects confronting racism, police brutality, and censorship. These controversial projects have been subject to local, state, and federal government scrutiny in failed attempts to censor and intimidate the artist. Sisco was a member of the first panel convened by the National Endowment for the Arts following its withdrawal of support for the Artists Space exhibition "Witnesses: Against Our Vanishing." She resigned from the panel in a protest of John Frohnmayer's refusal to reconsider the agency's actions and to guarantee the integrity of that panel's decisions.

As nightfall does not come at once, neither does oppression. In both instances, there is a twilight when everything remains seemingly unchanged. And it is in such a twilight zone that we all must be most aware of change in the air—however slight—lest we become unwitting victims of the darkness.

<div align="right">Justice William O. Douglas</div>

The reinstatement of an ethical stance becomes central to the recovery of a meaningful society and a sense of selfhood, a realism that is in closer touch with reality than the opportunism, lesser-evil strategies, and benefit-versus-risk calculations claimed by the practical wisdom of our time. Action from principle can no longer be separated from a mature, serious, and concerted attempt to resolve our social and private problems. The highest realism can be attained only by looking beyond the given state of affairs to a vision of what should be, not only what is.

<div align="right">Murray Bookchin
The Modern Crisis</div>

When I learned federal funding for the Artists Space exhibit about AIDS— "Witnesses: Against Our Vanishing"—had become a casualty in the ideological struggle between those who seek to institute a conservative national cultural agenda and those who wish to participate in a broader definition of U.S. cultural practices, I was worried. Chairman John Frohnmayer's unprecedented decision to rescind previously authorized money for an exhibition catalogue he felt was political rather than artistic in nature signaled that the National Endowment for the Arts had moved further into the twilight zone Justice Douglas described.

I was a member of the first NEA peer review panel to meet after Frohnmayer withdrew the Artists Space funds on November 8, 1989. The following Monday morning when I walked into the Visual Arts Organization panel, I did so with an understanding of what was at stake.

The public artwork I have done in San Diego, California, in collaboration with Deborah Small, Louis Hock, and David Avalos, has always encountered threats of censorship. The group's practice of using public funding to examine controversial social issues has come under fire from civic leaders, the media, and corporate interests. By articulating points of view not embraced by San Diego's power structure, our work intentionally tests the vitality of the local democracy and the boundaries of freedom of expression. The work also seeks to create a public space for a community dialogue in which a civic image might be shaped that is distinct from the public relations crafted for economic or political gain.

Our public art projects revealed that in San Diego politicians have final approval on funding to artists and arts organizations. They use their authority to suppress speech that is critical of the status quo they aim to preserve. These elected officials exercise the type of content control that congressional representatives like Helms, Dannemeyer, and Rohrabacher have tried to exercise over the Endowment.

In 1988, our bus poster project, "Welcome to America's Finest Tourist Plantation," was confronted with a number of civic actions aimed at curtailing our examination of the underpinnings of the local tourist economy. The mayor pressured the bus company to remove the poster. General managers of two of the three local network television stations went on the air to demand removal of the "offensive art work." The city council made public reassurances that city funds would never again be used to sponsor projects critical of "America's Finest City." The bus company added a content restriction to its advertising contract to prohibit the display of images critical of law enforcement officers. Finally, the California Legislative Coun-

cil was asked to investigate the legality of using public funds to support opinions critical of a city.

In 1989, working with a $100 grant from San Diego's Installation Gallery, we produced a billboard addressing the city's troubled attempt to select a fitting tribute to the Reverend Dr. Martin Luther King, Jr. Declaring that the billboard was politics, not art, Gannett Outdoor tried to get the sponsoring gallery to remove it. Two months later—and just weeks before the Corcoran canceled the Mapplethorpe exhibition—a subcommittee of the San Diego City Council voted to strip Installation Gallery of $42,000 of city funds, thus overriding the recommendation of the City Art Council. When, after public outcry, the full council partially restored Installation's budget, it restricted the use of those funds.

The lessons learned confronting the censorship of these public art projects strengthened my conviction that government must remain neutral in the realm of ideas. The review process in place at the Endowment was designed to nurture diversity in the arts and minimize political interference with the granting process. For twenty-five years, the combination of peer panel and National Council for the Arts review along with the chairman's approval had for the most part democratically distributed federal arts funding. Chairman Frohnmayer's single-handed decision to rescind a grant that had won approval at all three levels of the review process destroyed the integrity of the Endowment's granting procedures. His impound of Artists Space funds created a cloud over every grant in place, and every grant future panels would recommend.

Frohnmayer's banner statement that the catalogue for "Witnesses: Against Our Vanishing" had become "political rather than artistic in nature" was an unprecedented articulation of an alarming new policy at the NEA—the chair as the sole arbiter of federally-sponsored art. In his first action, he interpreted congressional concerns with obscenity to include art with political content. He acted as a collaborator of the radical right in their effort to dismantle the goals of the Endowment, whose mission statement reads in part that the agency "must not, under any circumstances, impose a single aesthetic standard or attempt to direct artistic content." By responding to the right's agenda, he openly politicized the funding process and destroyed the Endowment's impartiality as mandated by Congress.

In light of Frohnmayer's actions, it was evident that anyone who participated in an Endowment activity also supported the erosion of the most basic democratic ideals of United States society. I suggested to Visual Arts Organization panelists that our most effective protest would be to refuse to

make grant recommendations until the Endowment reinstated the funds to Artists Space and clarified the role of the peer panel. I felt such a protest would not be an abandonment of the NEA, but rather an action essential to restoring the mission of the agency.

Other panel members felt caught in an awkward position. The weakening economy and the growing attack on cultural institutions were causing many small organizations to fold, so there was a desire to see the funding process go forward. But many panelists felt the need to protest Frohnmayer's action. To this end we drafted a letter that stated in part:

> ". . . in light of your recent decision to withhold $10,000 from Artists Space and the grave implications this has for the integrity of all NEA panels, we feel we must confirm the premises on which we are working. . . . It is our request that you seek out substantive input of the peer panel in the event you are considering either a veto of a recommended grant or withholding funds from an already approved one. . . . The ramifications [of your decision to withhold funds from Artists Space] are serious for all the arts because the decision implies that the NEA is uncomfortable supporting freedom of expression in all its diverse forms; that the peer process can be taken lightly and overridden if thought to be politically expedient; and that art of quality cannot embrace controversial, social, or political concerns."

This letter was circulated to the press on Monday with an appended cover sheet authored by Jennifer Dowley, the executive director of the Headlands Center for the Arts. Dowley had been appointed by the Endowment as chair of the Visual Arts Organization panel, and throughout the week she conducted a misguided effort to protect the agency from further controversy. In her cover letter, which was not shown to the other panelists prior to its public release, she took the liberty of stating that panelists "feel assured that the panel process is respected and intact," thereby diffusing the impact of our statement.

After three separate meetings with Frohnmayer and much heated discussion with panelists, it was clear that panel members were not united and would not be able to convince the chair to reinstate the grant. I was further concerned by statements made by the Endowment staff that potentially controversial grants recommended by peer panels would be red-flagged and given special scrutiny by the National Council for the Arts and the chair. In his effort to enforce the congressional obscenity amendment to the 1990 appropriations act, Frohnmayer effectively asked for the complicity of panel members. He personally told us it was our responsibility to

go on record with extensive justification for funding any project that might be potentially controversial so he could go to bat for that project if the need arose. I felt the request was spurious because Frohnmayer never clarified to us why the recommendation of the original museum panel for the "Witnesses" exhibit, which had the full endorsement of the National Council for the Arts and the past chair, had not been sufficient justification with which to battle any controversy that might have arisen over the show catalogue.

Faced with being a member of the first NEA panel to award "government-issue art" or the first NEA panelist to resign in protest, my decision was clear. I resigned. I submitted my resignation on Tuesday, November 14. That day Leonard Bernstein refused to accept the National Medal of the Arts. Two days later, as a result of relentless pressure from the press and the arts community and after viewing the "Witnesses" exhibit, Frohnmayer reinstated the Artists Space grant with the caveat that the NEA's name be removed from the catalogue that had initially stirred the controversy. Removal of Endowment support from the catalogue was an unfortunate compromise that raised serious questions about the guidelines that would govern future grant procedures, especially awards given for works in progress.

In the years since the Artists Space battle the NEA has moved further away from its initial mandate. Politicians and conservative special-interest groups continue to use the Endowment as a beachhead in their struggle to forge a monolithic national cultural identity. The last two NEA-funded public art projects I have done in collaboration with other artists have been investigated by the agency. In both instances the investigations were initiated in response to complaints made to the Endowment by Representative Bill Lowery (R-San Diego). In the most recent case, NEA acting-director Anne-Imelda Radice directed us to remove any acknowledgement of NEA support from "NHI—No Humans Involved," an interdisciplinary public art project including billboards, a gallery exhibition, a performance, and a panel discussion that paid tribute to forty-five San Diego women who were victims in the largest series of murdered women in U.S. history. In explaining the decision, NEA public affairs director Jill Collins stated, ". . . the exhibit . . . does not necessarily reflect the views of the National Endowment for the Arts." The National Endowment for the Arts now marches in lockstep with a conservative minority.[1]

Under Radice's short stewardship, peer panel and NCA recommendations were overridden and a number of organizations were directed to re-

move the NEA imprimatur from exhibitions. In response to Radice's auto-
cratic and unilateral actions, two peer panels resigned, another National
Medal for the Arts has been turned down, and grant money has been re-
turned to the agency. Radice boldly continued Frohnmayer's policy of
"smart" censorship—censorship in response to political pressure.

The politicization of federal arts funding is only one front in the holy
war being waged by the radical right. Political appeasement did not pay off
for John Frohnmayer nor has it for artists. By adopting "lesser-evil strate-
gies" and making "benefit-versus-risk calculation," the arts community
has aided the right in their efforts to mandate a homogenous taxpayer and
a single national culture. The ongoing struggle over what type of art the
government should fund will not end until all involved adopt an ethical
stance. Until that time, continued federal funding for the arts will come at
the expense of a truly free and democratic society.[2]

Notes

1. The grants in question were awarded for fiscal years 1989 and 1990. In 1990,
"America's Finest?" done in collaboration with Deborah Small, Scott Kessler, and
Louis Hock was investigated by the GAO and the NEA general counsel. The NHI
project artists were Deborah Small, Carla Kirkwood, Scott Kessler, and Louis
Hock. Since my resignation from the Visual Arts Organization panel I have not ap-
plied for NEA funding.

2. The cultural policies of the Reagan-Bush era have clearly been embraced by
the Clinton administration. Examples of this include:

a. The Justice Department appeal of a 1992 lower court ruling of the uncon-
stitutionality of the NEA "decency standard."

b. The 1993 public art project, ART REBATE, that Louis Hock, David Ava-
los, and I completed as part of the NEA-sponsored "Dos Ciudades/Two Cities"
exhibition was stripped of federal funding after an objection was voiced by a U.S.
congressman. The problem was not a moral collision, but an alleged transgression
of the imaginary line between art and politics. As an all too real reification of Dou-
glas's twilight zone, the opinions and taboos of the radical right have now been
folded into business as usual at many art institutions and at all levels of govern-
ment.

Conclusion

The Future of the Cultural Landscape

by David C. Mendoza, executive director, National Campaign for Freedom of Expression

The November 1994 elections are over and those who launched the culture war have gained the majority in Congress—not that the old majority was such a stalwart advocate of the arts and humanities. Among the intended spoils for the victors is the "privatization" of the NEA, NEH, and the Corporation for Public Broadcasting—in other words, the elimination of these programs and agencies. The war on the arts is really a war on critical thinking, dissent, risk-taking, creativity, and democracy cloaked in the slogans of ending "tax and spend" and restoring "traditional values." In reality taxpayers would save only $3 and pocket change if funding for the NEA, NEH, and public broadcasting were terminated, and, an official signal would be sounded that cultural diversity, intellectual inquiry, and freedom of expression are no longer traditional values.

If ever there was an example of "killing the messenger" this is it, beginning with Andres Serrano in 1989. With disinformation, sound bites, and defamation of character, the right has demonized artists and transformed them into blasphemers and pornographers. With rare exception, the artists who have been defunded and defamed are those who express their moral vision with their talent to address the ills of our society. This art, appropriately—though disparagingly—labeled "political," attempts to give some shape to the chaos and mess we have made of our world by being critical, unflinching, and often dissenting against the majority. The late, great Japanese filmmaker Akiro Kurosawa once said, "Being an artist means never to avert one's eyes." This is one of the values that motivates art at its most profound. The challenge then is ours, not to avert our eyes from the work that artists have the courage to create. But the far right cannot tolerate dissent or critical thinking, and for them it is not enough that they

would choose to avert their own eyes from this art, they also want to control that choice for us all.

To understand what lies ahead in these final years of the century, let's first look back.

Before Mapplethorpe

Before Mapplethorpe there was censorship of artistic expression in the U.S. The censorship was both subtle and overt and it was, and still is, institutionalized. This censorship has had as its victims people of color, women, out gays and lesbians, rural "folk" and their "folk art," and at various times, people of non-Christian beliefs. This form of censorship was so institutionalized that it was almost invisible—except to those who were silenced by it. It took place quietly and invisibly within art museums, commercial publishing houses, galleries and museums, film studios, radio and television stations, philanthropic foundations; yes, within the arts community. Efforts to combat institutionalized censorship have been similarly institutionalized. One strategy was to use a big carrot: funding. What is important to the current debate is that the effort to counter censorship began with public funding.

The civil rights struggles of the 1960s invigorated cultural activity within many communities. Indeed, the civil rights movement itself was fueled by the passion, talent, and the hands-on work of artists. For them, art and politics were one and artists as community members engaged in the struggle to gain justice and equality. During these same years public arts funding began with the creation of the New York State Council on the Arts by Governor Nelson Rockefeller in 1960, followed by the creation of the National Endowment for the Arts and Humanities in 1965. Since then, public funding of the arts has expanded to every state and territory through state arts commissions, and to more than 400 local arts councils at the municipal and county level. There are also humanities commissions or councils in every state. Taxpayers are serving as "patrons" of the arts and humanities at every level of government. This relatively recent advent of public arts funding is crucial to the understanding of the current culture war.

Publicly-funded agencies have taken the lead in supporting the diversification of culture in the U.S. These agencies have slowly but steadily moved toward nurturing a cultural life that looks much more like America than it did before 1960. This did not just happen. The funding profiles of public arts agencies reflected the predominant—some would call it "main-

stream"—cultural landscape. The move to diversify support for arts programs was a political imperative in public agencies because the source of funds was, after all, money from the public, contributed by all taxpayers, who could expect (unlike in corporate or private philanthropy at the time) their equal place among the staffs, panels, and appointed commissions of public arts agencies, as well as the organizations that receive public funds.

Likewise, a variety of nonprofit organizations and artists that had never been the beneficiary of philanthropy gained access to financial support and at the same time won the imprimatur of respected public arts agencies including the NEA, and state and local arts commissions. This respect was conferred by the peer panel process of awarding public funding by which peers in one's field (dance, music, visual arts, etc.) adjudicated and awarded grants. This is a singular and powerful contribution of the public funding movement, and a fitting model within a democracy. There is more diversity in the NEA peer panels than in the Congress that derides them. Unlike private foundations or corporations where grants are made by board members with less democratic imperatives, the peer panels, which change from year to year, have served to insulate the grants process from the political pressure of elected officials (Congress, state legislatures, city councils, etc.) and even to a large extent from the members of the commissions appointed by the president, governors, or mayors.

The last thirty-five years have witnessed the birth and flourishing of Off-Off Broadway, regional theaters, modern dance, alternative visual arts spaces, independent film and video, performance art, new music, as well as a revival of folk arts. During this period, the increased sociopolitical emphasis on ethnic pride and the intertwined roles of politics and culture in communities led to a proliferation of new cultural organizations such as the Negro Ensemble Theatre, Pan Asian Repertory Theatre, El Museo del Barrio, the Mexican Museum, Puerto Rican Traveling Theatre, Teatro Campesino, Guadelupe Cultural Center, Dance Theatre of Harlem, Kitchen Table Press, and many hundreds more in every state. Arts organizations presenting and supporting lesbian and gay work have also come on the cultural scene in conjunction with the post-Stonewall movement for civil rights: Alice B. Theatre (Seattle), Creative Time and Glines Theatre (NYC), Theatre Rhinoceros (San Francisco), Highways (Santa Monica), and JumpStart (San Antonio). Openly gay and lesbian artists of all complexions have expressed their lives and, with the tragedy of AIDS, their experiences with illness and death: Bill T. Jones and Arne Zane, Essex Hemphill, Tony Kushner, Dorothy Allison, Marlon Riggs, Tim Miller, Holly Hughes, and Robert Mapplethorpe.

By 1989, the year Robert Mapplethorpe and Andres Serrano came to national attention, considerable progress had been made toward the diversification and democratization of American culture in both the nonprofit and commercial sectors. More people of color, women, and out gays and lesbians were working in the government funding agencies, foundations, arts institutions. More artists of color, women, and gays and lesbians were gaining access to support for their work and to audiences for their work. The culture of America was finally beginning to "look like America."

While overt expressions of racism had become socially unacceptable in the post-Civil Rights era, homosexuality and blasphemy were still acceptable targets. Within weeks of each other in the spring of 1989, Mapplethorpe (a gay male photographer who had died of AIDS) and Andres Serrano (of Afro-Caribbean descent) were made the whipping boys of the radical right—Mapplethorpe, because some of his work portrayed gay sadomasochism, and Serrano, because he commented on the commercialization of religion by photographing a plastic crucifix in a jar of urine. First denounced by the then little-known "religious right," the political opportunity caught the attention of Senator Jesse Helms and, through him, the media. The rest is history.

The National Campaign for Freedom of Expression (NCFE), founded in 1990, was created by a network of artists, arts activists, and administrators of the organizations who had supported, produced, and presented the works of those artists under attack. This network consisted of members of the National Association of Artist Organizations (NAAO), alternative arts spaces, the National Alliance for Media Arts and Culture (NAMAC), and media (video and film) centers that received some public funding. These organizations represent part of the cultural expansion described above and they are based in Seattle, Miami, Minneapolis, San Antonio, Phoenix, San Diego, Buffalo, and Boston—not just New York City and Los Angeles.

Its sui generis was the realization that the established arts community was not leaping to the front lines to defend the attacks on Mapplethorpe and Serrano. The scene we encountered in 1989–90 was an arts establishment reticent to come forward to defend those artists and organizations that were addressing controversial and complicated social issues. The initial defense came from those directly under attack, the artists and the organizations that support and present their work. Support also came from our colleagues in the civil liberties community who had a history of fighting censorship. This was the first of two important lessons we have learned.

In fact, the silence on our side was as deafening as the outcries from the other side. The Corcoran Gallery, a leading visual arts institution, backed down in the face of the attacks and canceled the Mapplethorpe exhibit due to fear of funding reprisal from Congress. This move set the stage by showing the arts establishment to be vulnerable to such attacks, and the fault lines were clear.

One of NCFE's first actions was to initiate a lawsuit against the NEA on behalf of the four artists (John Fleck, Karen Finley, Holly Hughes, Tim Miller) whose grants were denied by then-NEA Chairman John Frohn-mayer for political reasons. Part of the suit was settled out of court in 1993 in favor of the artists, now known as the NEA Four, who subsequently received the grants they had been denied. The suit was amended to include a constitutional challenge to the "standards of decency" clause included in the reauthorization of the NEA by Congress in 1990. A federal district court ruled that language unconstitutional in 1992 and the Clinton administration appealed the decision. The arguments have been heard by an appeals court and a decision is awaited.

The second lesson we learned is that the arts are only one target in the culture war being waged by the radical right in America. This domestic war on culture was conceived to replace the Cold War after the fall of the Berlin Wall and has provided the far right with a means of gathering supporters, raising dollars, and increasing votes on their side by identifying a series of wedge or hot-button social issues around which to organize. Besides the arts, their other targets in the culture war are feminists, reproductive rights, school curriculum, immigration, welfare, environmentalists, gays and lesbians, low-income people, and people of color via welfare, immigration, and their coded attacks on multiculturalism.

And it is those artists that deal with any of the aforementioned issues in their work who have been the targets in the culture war. The debates are over the content—subject matter—of art, not the artistic merit. Despite the focus on composition, proportion, and form in the testimony of the witnesses on behalf of Mapplethorpe's photographs at the Cincinnati trial of Dennis Barrie, the real issue at hand was the subject matter of a few of the images. Defending an artist's right to address certain subject matter is central to the controversies. In the decision of the National Council on the Arts in August 1994 to reject visual artist fellowships in photography, recommended by the peer panel for Andres Serrano, Barbara DeGenevieve, and Merry Alpern, the real concerns (as expressed in the recorded transcripts of the meeting) were political problems that might result due to the content

of the work. But this concern was disguised as discussion of "artistic merit." In other words, since the NEA Four and since the court ruling on the "standards of decency," the chairman and members of the National Council on the Arts have learned to use "artistic merit" to thinly veil the real concern: content. The vote against these three grants was 16 to 6. Of the eight new Clinton appointees on the Council, six voted against the artists, including Trisha Brown, an artist herself.

The Chilling Effect

In 1991, when I testified before a House subcommittee chaired by then-Congresswoman Barbara Boxer (D-CA), I said that it was so chilly these days that you could always see your breath. Now, two years later, a thin coat of ice has formed. What began as attacks on homosexual art and so-called blasphemy has now shifted to embrace nudity in art, a subject for art since the beginning of time. There are an increasing number of censorship efforts directed at removing depictions of the nude body from view in public galleries and on theater stages. The works of art in question usually are not erotic, but traditional, classical representations. These days censorship is often exercised by previously well-intended arts officials who have become nervous after the controversies of the last few years. A synopsis of the chilling effect goes something like this: Better not to show something that might offend someone rather than risk the possibility of a battle with elected officials or taxpayers which might lead to losing all the public support for the arts (or "my job").

Another variation on this theme took place in Cobb County, Georgia in August 1993. First the Cobb County commission voted to express disapproval of the "gay and lesbian lifestyle . . . as violating traditional family values." Then, a complaint was lodged against two plays presented by the Theatre in the Square in Marietta, Cobb County's metropolitan center. The plays were the Tony award-winning *M. Butterfly* by David Henry Hwang (made into a recent motion picture) and *Lips Together, Teeth Apart* by Terrance McNally. In the latter, there are no gay characters on stage but reference is made to the gay brother of one of the characters and to neighbors who are gay. Members of the county commission tried to insert content restrictions in county arts funding that would prohibit money from going to art that violated traditional family values (gay and lesbian art, for example). Threatened by NCFE (based on the federal district court ruling in *Finley* v. *NEA*) and other legal groups and with litigation likely if the re-

striction was inserted, the commission voted to eliminate all county support for the arts. The message: if we can't censor then we won't fund the arts at all. This tactic will likely appear in other places as well, including at the federal level.

The bottom line is that as more individuals have gained some access to freedom of artistic expression, there has been a reactionary backlash from the far right that attempts to force us back into our respective closets, out of sight from a culture once dominated by white, Christian, heterosexual males. As cliché as that phrase sounds it tells the tale of a nostalgia for an era when only some had freedom of expression while others were seen but not heard.

The culture war is one more result of shifting demographics, economic transition, and globalization, that has led to an international rise in fundamentalism, which in turn has led to a dangerous polarization within our society. Although the era of "identity politics" may be drawing to an end, our simplified identities have historically served as a basis for politics. Until recently the allies, coalitions, and alignments have been familiar. For example, the now-defunct Democratic Party coalition of labor, people of color, Jews, intellectuals, urbanites (including gays and lesbians) brought together under one tent a broad spectrum of diverse individuals who banded together to oppose the ruling class, support the idea that government could help make a more just society, and gain political power. In essence, these Democrats thought their party represented their interests better than the Republicans.

Today political alignments have shifted, in part due to the successes as well as the failures of the past fifty years. People of color who have attained a place in the middle class—even suburbia—have different economic concerns than people of color on welfare. And amongst people of color there are different political concerns for African, Asian, Latino, and Native Americans. The "labor" movement has also moved to suburbia and is no longer a single voting or philosophical block. Within the religious community there are big political differences between the progressive and conservative wings of denominations within the Christian, Jewish, Muslim, and other faiths.

And at both ends of the spectrum, the rhetoric and debate is growing in intensity. Caught in the middle are the majority of Americans who are confused and have no one talking to them, much less for them. They are like spectators at a tennis match watching the volleys back and forth.

In James Davidson Hunter's book *Culture Wars*, he writes:

> The conflict is over how we are to order our lives together. On political matters one can compromise; on matters of ultimate moral truth, one cannot. Orthodoxy believes that truth comes from an external transcendent authority. Progressives believe that truth is an ever unfolding process, tending to resymbolize historic faiths according to prevailing assumptions of contemporary life.

Then there is the international context. The rise of technology and multinational corporations have fostered a globalization of the economy, leading to a breakdown in borders with respect to trade and labor. At the same time, there is a rising racial and ethnic nationalism that is promoting new borders, ethnic homogeneity via forced emigration or ethnic cleansing. Underlying all this is the international rise of fundamentalism from Tehran to Tupelo, forcing an orthodox religious order on secular societies in an attempt to install theocracies. Opposing this is the rise of democracy around the globe which will likely lead to a reinterpretation of this concept in an international context. Having exported it, the U.S. can no longer maintain exclusive control of it.

Here at home there is a crisis in public education with basic literacy skills declining, the inability to cope with the massive shifts in demographics, and an atmosphere of fear and violence replacing the security of schoolrooms. This undermines the ability of the public school system to instill an understanding of civics and history along with the basic tenets of democracy—the lessons which help to ensure a civil society. And everywhere there is a free-floating anger which history has shown to be an invitation for demagogues and a warning sign for the rise of fascism.

In 1995, the script is playing itself out. Members of the 104th Congress will soon vote on the "privatization" of the arts and humanities endowments and the Corporation for Public Broadcasting. That's code for elimination. And if they succeed at the federal level, will the states be far behind? The changes proposed in the "Contract with America" would lead to massive shifts in the federal role with regard to state programs. Even if a particular state favors support for culture, will the reductions in overall federal monies pressure them to reduce and/or eliminate funding for the state arts and humanities commissions? Then, just as the advent of public funding led to a significant increase in private foundation and corporate support, will we see those funders follow the lead of the government?

My own vision of this moment is that we are experiencing the last gasp at the end of a century and a millennium of an old world order, and those who, by a slim margin, have just won power, have the opportunity to "strut and fret its hour upon the stage" and then be "heard no more . . ." Short of

forced exile, concentration camps, or genocide, the demographics are here to stay. And the foundations laid by the civil rights movement—for people of color, women, and gays and lesbians—will not crumble without a struggle.

As we don our battle fatigues, let's at least be clear about what we are fighting for. The battles over culture with the 104th Congress will not be about reducing the deficit, not about ending welfare for the rich, and not about the largesse or responsibility of private philanthropy. These battles will be about the very first contracts with all Americans in all their hyphenated diversity: the Declaration of Independence, the Constitution, the Bill of Rights. And yes, these battles are indeed about values. The value of respect for individual and cultural diversity in a nation of native peoples and descendants of immigrants that is part of a world with a global economy and instantaneous communication. The value of intellectual freedom, critical thinking, and dissent in a world where fundamentalist militants and totalitarian regimes imprison and/or issue death threats against artists and assassinate journalists. The value of accepting the moral responsibility of caring for children, even if they aren't your own and even if you don't have any. The value of our environment apart from the profit to be made from its natural resources. These values may not be "traditional" for all individuals, families, or politicians. But these are socially redeeming values and our society is, now more than ever, desperately in need of redemption.

Early Praise for *The Cultural Battlefield*

"It remains true that the arts are a crucial site for the contest of ideas and values, regardless of those who try to obscure their own political agendas by claiming the contrary. The publication of this remarkable anthology will support and encourage the necessary debate over the consequences of direct and indirect censorship—a debate which will profoundly influence our ability to emerge from this moment a stronger and more thoroughly democratic nation. This is a very important book."

> David A. Ross
> Alice Pratt Brown Director, Whitney Museum of American Art

"*The Cultural Battlefield* is a valuable addition to the literature of the "culture wars." Its unmediated testimony by censored administrators and artists reminds us that the personal is not only political but revelatory."

> Robert Atkins, Columnist
> *The Village Voice*

"The publication of *The Cultural Battlefield* is an important public service as well as a compelling read."

> Herbert I. Schiller, Author of *Culture Inc.: The Corporate Takeover of Public Expression* (Oxford, 1989)

"These essays are a previously untold, from-the-trenches accounting by key figures in the recent cultural wars over censorship and public funding. The fresh context they provide should be carefully analyzed by those currently in charge of reconstituting the NEA, as well as anyone who cares about America's cultural life."

> Ann Wilson Lloyd
> Independent curator and critic for
> *Art in America* and *Sculpture* art journals

"Whole forests have succumbed to the documents and diatribes of the current struggle over who will control American culture, but *The Cultural Battlefield* is almost alone in giving a voice to the people who have been on the front lines and letting them tell their stories unmediated."

> Nan Levinson, Photographer

"Through personal narratives and accounts, this book draws the reader into the lives of those at the center of the censorship battles. People speak clearly and calmly from the conviction of their own experiences. *The Cultural Battlefield* allows us to see the concerns and beliefs of many different individuals committed to the principle of freedom of expression.

> Trevor Fairbrother
> Beal Curator of Contemporary Art
> Museum of Fine Arts, Boston